侯淑姿
HOU Lulu Shur-tzy

目　錄

04	部長序 / 史哲
06	館長序 / 廖仁義
08	攝影家自序 / 侯淑姿

專文
- 12　**雙眸雙聲**
　　——侯淑姿，我們在此相遇以女性之名 / 王雅倫
- 26　**「冷」攝影**
　　——侯淑姿的攝影計劃作為表演物件 / 林宏璋

47	**作品**
149	**口述訪談** / 王雅倫
181	**傳記式年表** / 王雅倫
216	侯淑姿簡歷
218	圖版索引

Contents

05	Foreword from the Minister of Culture / Shih Che	
07	Foreword from the Director of NTMoFA / Liao Jen-i	
09	Preface from the Photographer / Hou Lulu Shur-tzy	

Essays

35	Double Gaze, Double Voice: Hou Lulu Shur-tzy, We Meet in the Name of Women / Wang Ya-lun
41	Cold Photography: Hou Lulu Shur-tzy's Photography Project as a Performative Object / Lin Hong-john

47	**Works**
174	**Interviews of Hou Lulu Shur-tzy** / Wang Ya-lun
181	**Biographical Timeline** / Wang Ya-lun
217	Hou Lulu Shur-tzy (Hou Shur-tzy) Biography
218	List of Works

部長序

《臺灣攝影家》系列叢書是以攝影家個人的生命史、創作歷程與藝術表現為主體，進行深入的研究、爬梳與評述書寫。文化部長期支持此系列叢書的撰研與出版，即期待藉由個別攝影家作品所展現的本土內涵、創作意識及時代文化脈動，構築一個以攝影為核心的知識體系與藝術史發展脈絡，並由此認識過去、關照當下、展望未來。

本年度出版的《莊明景》、《黃永松》、《侯淑姿》三冊專書，除了以專論文章來探討藝術家攝影實踐中的影像底蘊，亦經由深度訪談來梳理他們的創作軌跡，並匯集攝影家歷年來具代表性的重要影像作品。莊明景先生意境朗闊、氤氳靈動的風景攝影，是其不斷深入自然大化間潛心觀察、蹲點採景後，結合心境體悟的一種影像轉譯表現。黃永松先生以推廣民俗文化藝術為已任，他靈活運用與組合影像，創造攝影與文字並重的編輯報導形式，並以大量攝影作品熱忱地紀錄下臺灣特有的時代影跡。侯淑姿女士的作品關注攝影的藝術性以及其反映當代議題的能力，她探討性別、凝視、權力體系、自我與家／國及社會認同等相關議題，並在創作實踐中拋出自身對藝術及人生的思考，傳達其獨特的關懷視野。

影像可以見證歷史、召喚記憶，亦具有對應社會、文化議題並促成反思及影響的潛能；而攝影家自身的理念與訴求，則是賦予影像獨一無二的生命力，並成為傑出攝影創作的關鍵。《臺灣攝影家》系列叢書的出版，除了希望引領觀眾深入攝影家的影像視野，了解他們所視所感的臺灣文化紋理，並且以此向全心投注於攝影創作的藝術家們致敬，亦期待透過攝影家個人史料的蒐整、分析以及此系列專書的逐年出版，持續為臺灣攝影史的建構奠基。

文化部部長

Foreword from the Minister of Culture

The Photographers of Taiwan series conducts in-depth research, including the combing through of historical documents and producing written commentary, to provide insights into photographers' biographies, creative processes, and artistic performances. The Ministry of Culture is a long-term, staunch supporter of the compilation and publishing of this series. By examining the local context, creative awareness, and historic culture present in each photographers' work, the series supports photography-based knowledge systems and art history development. Readers of the series learn about the past, keep an eye on the present, and look ahead to the future.

The three books in the series this year, featuring *Mike Chuang*, *Huang Yung-sung*, and *Hou Lulu Shur-tzy*, contain articles that explore the meaning of the photography produced by each of these artists and in-depth interviews that revisit their creative trajectories. Important, representative images are included in each book. Mr. Mike Chuang's landscape photography is bright, expansive, dense, and clever. He closely observes nature, taking the time to examine a location before shooting photographs that present both his mood and experiences. Mr. Huang Yung-sung made it his duty to promote popular customs, culture, and art. He nimbly uses photography for illustrated reports that enthusiastically track Taiwan's history. Ms. Hou Lulu Shur-tzy, meanwhile, examines photography's artistic nature and ability to reflect on contemporary topics. She looks closely at gender, observation, rights systems, the connection between self and home/country, and social recognition. By using photography to present her thoughts on art and life, Hou reveals her distinct attention and perspective.

Images that bear witness to history and summon memories respond to social and cultural topics, facilitate reflection, and have the potential to effect change. The photographers who create these images seek to produce original, lively content that reaches the level of art. *The Photographers of Taiwan* series aims to provide readers with a deeper understanding of individual photographers' perspectives to show the Taiwanese cultural fabric that each photographer sees and feels. At the same time, the series pays homage to all artists devoted to photography. Gathering and analyzing personal historic data on photographers then publishing these findings in this series, year after year, continues to build a foundation for presenting the history of photography in Taiwan.

Shih Che
Minister of Culture

館長序

《臺灣攝影家》系列叢書自2016年策劃執行以來,已進入第六輯的階段。以深化對臺灣攝影家的研究為叢書編纂目標,國家攝影文化中心本年度針對莊明景先生、黃永松先生及侯淑姿女士三位攝影家進行詳實的研究,呈現出攝影家獨特的藝術視野以及創作歷程。

莊明景先生以扎實的經驗積累,仔細推敲、琢磨拍攝的時間、光、影等細節。他在翻山越嶺的自然行腳中,敏銳捕捉山川林野細緻動人的景觀律動,或運用高反差的調性呈現黑白相間的對比強度,或以高解析度的細膩色彩營造氣勢磅礡的奇觀異景。其精采絕倫的取景視角,是攝影家對大自然生命力的體會與禮敬,亦讓觀者經由他的鏡頭視野,體會作品中氣韻湧動的感性張力。

黃永松先生是位勇於多方嘗試的理念實踐者,半生投入民間文化採集與田野調查。他的攝影善於捕捉人物氣質,並巧妙靈活地運用近景、特寫、連續與停格影像的攝影形式,創作出極具敘述張力的攝影作品,生動地紀錄了臺灣的鄉土人文與民俗樣貌,也映照出其心心念念所牽掛的文化傳承志業。

侯淑姿女士是臺灣觀念攝影的先行者之一,她的作品從早期強調女性主體性、自覺意識的創作,逐步擴大為關注階級、族群、社區共同記憶等「身分認同」的主體性議題。近年來,她持續以田野調查方式,深入個體差異之身分認同經驗的分析與探討,結合長時間的傾聽、紀錄、行為構組影像裝置,建構深具個人特色的視覺政治語彙,也顯現出其對個體生命經驗的尊重與價值信仰。

本年度三冊專書,呈現三位攝影家各具特色的美感冶煉、理念形塑、創作生命折轉、以及他們對所處社會環境的回應、對話與影像詮釋方式。在此,除了要特別感謝三位攝影家對本系列叢書的支持,也要對所有參與撰述的研究學者致上最大的謝意。透過學者們的研究論述、精采的作品選介、深度訪談與大事年表,使讀者能以多角度的面向,理解攝影家的作品及其影像實踐的創作視野。

國立臺灣美術館館長

Foreword from the Director of NTMoFA

Since the start of the planning and implementation of *Photographers of Taiwan* in 2016, the series has already entered its sixth year. Continuing the series' objective of providing intensive research into Taiwanese photographers, this year the National Center of Photography and Images provides detailed information on three photographers: Mr. Mike Chuang, Mr. Huang Yung-sung, and Ms. Hou Lulu Shur-tzy. The books provide insight into the photographers' original artistic perspective as well as their creative process.

Mr. Mike Chuang leverages his years of robust experiences and careful thought to refine the time, lighting, and shadows that are part of his photography. On journeys into the natural world, Chuang keenly captures the rhythm of the mountains, rivers, and forests. Using high-contrast tones he presents the intensity that is shown by alternating blacks and whites. Using high-resolution and meticulous coloration he presents majestic spectacles and exotic scenes. Chuang's brilliants, marvelous perspectives demonstrate his familiarity and reverence for the natural world. Through Chuang's lens and perspective, viewers experience the character and sensibility present in his photography.

Mr. Huang Yung-sung, a multifaceted experimenter who puts ideas into practice, spent many years gathering information and conducting field investigations on folk culture. He is adept at using photography to portray people's manner, and nimble at using headshots, close-ups, continuous shooting, and stop motion techniques to create photographs with a strong narrative tension. These dynamic records of Taiwanese countryside culture and popular customs fulfill Huang's heritage aspirations.

Ms. Hou Lulu Shur-tzy, a pioneer of Taiwanese ideological photography, initially focused on female subjectivity and self-awareness before gradually expanding her attention to subjective identities that arise from shared memories of different classes, ethnic groups, and communities. In recent years, she has continued her field investigations to engage in analysis and investigation of identity recognition associated with individual differences. Together with her long-term practices of listening and recording, she built a visual and political vocabulary that deeply reflects her individual characteristics. This reflects the esteem and value she holds towards individual life experiences.

The three books in this year's series showcase development of the distinct aesthetic and philosophical views of these three photographers as well as their reflections on life, their responses to the social environment, and the interpretive methods they bring to dialogue and images. Besides thanking these three photographers for their contributions to this book series, I also want to express gratitude to all the researchers who participated in this effort. The research and discourse, the brilliant introductions to photographic works, the in-depth interviews, and the biographical timelines enable readers to understand the photographers' works, practices, and creative perspectives from a wide variety of angles.

Liao Jen-i

Liao Jen-i
Director of National Taiwan Museum of Fine Arts

攝影家自序

「你以恩典為年歲的冠冕,你的路徑都滴下脂油。」

〈詩篇〉65:11

忝為今年國家攝影文化中心出版的《臺灣攝影家》之一,備感榮幸。在甫屆耳順之際,藉由此專書的出版,總體回顧了自己的創作之路,真實感受「回望生命,乍成倒影」的歷歷來時路。創作的過程猶如踏入「迷宮之徑」,暗黑與光明爭相競逐,在各種創作議題中,經歷水火,但感謝上帝,最終來到豐盛之地。

自十九歲開始接觸攝影以來,攝影已成了我與世界溝通的語言,也是實踐夢想的路徑。在攝影中與自己、女性勞工、外配、眷戶相遇,也在攝影中與上帝同行。

從早年反思女性主義的《不只是為了女人》、反男性觀看的《窺》,關注臺灣女性勞工在全球化浪潮中所處困境的《青春編織曲》、探討國族認同的《猜猜你是誰》、深掘青少年的心靈狀態的《快樂是什麼》等,至2005-2009年的三個系列的《亞洲新娘之歌》,2010-2017年的《高雄眷村三部曲》,因著攝影,我走入了外配、眷戶的人生,在作品中探討他們離散的真實處境,從女性視角出發,以攝影與文字書寫,終而使被迫遷者、被歧視者、被刻意抹去與隱藏者現身發聲,感謝神看顧困苦窮乏的人,體恤他們的苦情;也期望這些作品能在時光的淘洗淬鍊後,成為影像之河中承載不凡意義的見證。

此專書的出版,有賴主編王雅倫老師傾注全力撰文、訪談,極其辛勞;林宏璋老師鞭辟入裡的專文分析作品;左右設計編輯群的協助;審查委員的指正等等,再次感謝文化部與國家攝影文化中心的支持與厚愛,言不盡意。

感謝神!因為攝影,生命更完美。

侯淑姿
攝影家

Preface from the Photographer

You crown the year with your bounty, and your carts overflow with abundance.

Psalm 65:11

I am humbled to be included in this year's *Photographers of Taiwan*, published by the National Center of Photography and Images. As I approach the age of 60 and by reviewing my creative path through the publication of this book, I have reached a profound understanding of the saying, "a glance back on life reveals the past as reflections." My creative journey was like setting foot in a maze, filled with both light and darkness. Through various subject matters, I have endured different challenges, but by the grace of God, I have reached this land of abundance.

Ever since I encountered photography at the age of 19, the art form has been my way of communicating with the world and realizing my dreams. Through photography, I have walked alongside myself, female laborers, foreign spouses, residents of military dependents' villages, and with God.

From my early work *Not Only for Women*, which reflects on Feminism, *Take a Picture, It Lasts Longer*, which reverts the male gaze, *Labors and Labels*, which features the challenges that female Taiwanese laborers are facing in the wave of globalization, *Guess Who You Are*, which explores the issue of identity, *What Is Happiness*, which digs deep into the psychological states of youths, to the *Song of Asian Foreign Brides in Taiwan* series, created between 2005 and 2009, as well as *A Trilogy on Kaohsiung Military Dependents' Villages*, created between 2010 and 2019, I entered the lives of foreign spouses and residents of military dependents' villages through photography, delving into their experience of diaspora and giving voice to those who were forced to relocate, the discriminated, the deliberately overlooked, and the forgotten through photography, text, and the act of writing from a female perspective. I give thanks to God for watching over the afflicted and those in need and for sympathizing with their pain, and I hope that, as these works mellow with time, they will bear meaningful witness amid the vast river of images.

I am grateful for the writings and interviews carried out by the editor-in-chief and Professor Wang Ya-lun, for Professor Lin Hong-john for his insightful analysis, for the editorial team at RANDL Design, and for the comments from reviewers. I would once again like to thank the support from the Ministry of Culture and the National Center of Photography and Images; words cannot fully express my gratitude.

Because of photography, my life has become closer to perfection. Praise the Lord!

Photographer Hou Lulu Shur-tzy

專文
ESSAYS

雙眸雙聲
——侯淑姿，我們在此相遇以女性之名

文 / 王雅倫

因我甚麼時候軟弱，甚麼時候就剛強了！

〈哥林多後書〉12：10

上個世紀80年代末期毅然決然赴美研讀藝術與攝影的侯淑姿，是少數臺灣中青輩藝術家中，持續以來一直致力於追求尊重性別平權，有系統地在創作中推動女性主義意識，爭取女性應有的權益及視覺政治的平等地位的女性影像藝術家。她的背影象徵著一股巨大的愛，[1] 其作品形塑一種我們如何審視自身和這個世界，及對於關注邊緣女性的藝術運動典範。儘管藝術家前行的腳步總是孤獨，但她，永遠帶著無畏、銳利和好公義的眼。

不只是為了攝影：以女性攝影家之名

侯淑姿在完成大學學業的同時，藉由社團及當時的攝影環境接觸了攝影，加上她早年的美術學習的底子，於1989年遠赴美國希望圓自己一個藝術的夢。那年8月出版了《生命的倒影——侯淑姿攝影集》，9月赴美國羅徹斯特理工學院（Rochester Institute of Technology）攻讀影像藝術（Imaging Arts）碩士。1989年是臺灣剛面臨解嚴後的一個新社會景觀，侯淑姿回望生命的倒影，選擇自由的飛翔。她在出國前出版精美的攝影集（輔以何秀煌抒情的散文），以風景居多的影像記錄了年輕歲月的足跡，

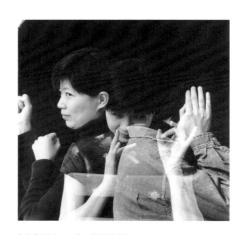

〈自我探索 A-1〉/ 侯淑姿攝 / 1996
Self-searching A-1 / photo by Hou Lulu Shur-tzy / 1996

而心象攝影的表現方式乃是向美國攝影家麥諾・懷特（Minor White, 1908-1976）致敬。這本專輯也許當時並未意會到，但它可以說是預告了侯淑姿往後創作的態度與風格：文字與圖像，社會與自身的互動。

五年的西方學習，確實使藝術家像脫胎換骨一樣，不但練就一身攝影、雕塑、行動藝術，以及「展示」的藝術表現，還跨足攝影修復技術與理論，是當時鮮少留學生會接觸到的項目。這些年雖耗去一些青春，但卻成為侯淑姿返臺後一一去實踐的命題，彷彿這些準備就是為了實現後來的道路。當然，除了這些領域的精進，令藝術家本身最大的覺悟是，身為女性的她還能為女性以及這個社會做些什麼。原來，她不只是為了攝影而來。

在美國的那幾年，侯淑姿接觸了多位女性藝術家，她們肯定的語氣或許是一種推力，勇往直前的推進力，侯淑姿開始思考女性的角色、身分與處境的起點。尤其在紐約留學時期接觸了女性主義藝術家及女性主義思潮。1960年代並持續到1980年代的第二波女性主義運動再起，有關性別政治方面的議題再度受到關注與討論，也引導了女性藝術家對自己身體的覺醒，並挑戰由父權主宰的社會與歷史所架構出的女性特質。在訪問過程中侯淑姿明白表示，在美求學期間「檢視自我內在的心理處境，有如是以女性主義者的角度自我檢視。我作為一位東方女性，在西方的環境下要如何表達出我的作品。」[2] 這應該是她的女性自覺的第一堂課，在此環境下她開始創作出早期探求自我、摸索內心的身體行動藝術作品。當然西方女性藝術家的作品早已是啟蒙的導師，除了在女性主義藝術史上具有標誌性地位的費莉・艾斯波（Valie Export, 1940-）在特別講座上對她的鼓勵，其他一些使用女性身體，通常是自己的身體，作為符號和符號的承載者，這些女性藝術家也常常同時是藝術家也是教育家，使用攝影這項媒材來表達自我存在的意義，而且往往勇於與政治正面對立。不難想像她們成為侯淑姿早期青春的攝影創作作品的精神引導，也是造就了她的表現方式從展示牆面走向人群的必然關聯性。

漢娜・威爾克（Hannah Wilke, 1940-1993）是美國畫家、雕塑家、攝影師、錄像藝術家和表演藝術家，也曾是教師，侯淑姿同樣受其啟蒙。威爾克作品《緊急求救──滿身傷痕物體系列》（*S.O.S. Starification Object Series,* 1974-1982），她以口香糖象徵女人的可塑性貼在身上，同時表現她反對女性必須讓男人看起來很舒服的偏見，透過這件作品我們看到象徵滿身傷痕的身體，以阻斷男性將平滑女體視為完美女體的投射，顛覆男性凝視下的女體被色情化，翻轉男性觀者的拜物主義（fetishism）。威爾克晚年以攝影鏡頭忠實記錄自己遭受癌症侵蝕而惡化的身體，她將與病魔抗爭的過程命名為《內在維納斯系列》（*Intra-Venus Series,* 1992-1993），記錄了身體因化療接受醫治的情形與轉變，與她坦然面對的心境。[3] 1980年代後許多女權運動因當時政治環境的改變而趨保守，許多女性主義者因社會性別歧視態度和行為的持續而灰心。但同樣以自身身體作為創作主體的朱迪・戴特（Judy Dater, 1941- ），以拍攝自己扮演的中產階級家庭主婦來質疑自己的婚姻生活的掙扎，描述現實生活中女性真實生存現狀，表達中產階級已婚婦女的平庸、瑣碎乃至壓抑的精神面貌，擊破男性視覺神話中的女性形象。陸續更有一些女攝影家為了對抗男性主體話語的女性形象，反其道而行之，拍攝或自拍肥胖、殘疾、患病的女性形象，如喬・斯朋斯（Jo Spence, 1934-1992），以顛覆男權，堅持身體再現一個個體身分，而不僅僅是男性欲望的場所。因此顛覆神話、顛覆男性消費的目光、尋求對邊界與差異的話語權、對壓迫霸凌者的批判，似乎成了初生之犢的藝術家走上不歸路的信仰起點。相對於上述這些女性藝術家的作品與行動藝術，藝評家姜麗華認為，侯淑姿結合攝影及行為表演的作品，諧擬一段五步驟掀女性裙子意外露出象徵陽具的視覺想像遊戲，直擊臺灣社會消費女性身體的視覺慣性。[4] 藝評家陳香君則對此表示那是「透露藝術家主體與性別制約機制之間的高低起伏的對話和掙扎歷程」。[5] 其中，作品《窺》〈Body Bounding〉，又象徵女性在男性欲望與權力之下無法逃脫的困境。

《窺》〈Flower 01-05〉/ 侯淑姿攝 / 1996
Flower from the *Take a Picture, It Lasts Longer* series *01-05* / photo by Hou Lulu Shur-tzy / 1996

值得注意的是作品《窺》〈Body Writing〉，侯淑姿開始在自己身體上書寫文字，如「PEEK A BOO」、「WHAT ARE YOU LOOKING AT」、「WITH A FACE LIKE THAT」，句句都是藝術家設計嘲諷男性觀者窺視女性被物化的常態。這種倚賴「視覺」（view）上「有」／「無」陽具存在來定義性別差異的論述，被女性主義學者愛蓮・西蘇（Hélène Cixous, 1937-）斥為「窺淫理論」（voyeur's theory）。[6] 她並宣稱唯有實踐另類書寫，此「書寫身體」為「陰性書寫」（écriture féminine），但強調這「陰性」必須落實在書寫／文本本身所呈現出來的女性特質上，和書寫者個人的性別完全無關。她一再強調女人必須「寫妳自己，必須讓人聽見妳的身體，唯有將身體書寫出來，豐沛的潛意識資源才得以湧現」。[7] 藝術家姜麗華認為這是藝術家以「忘我」扮演各種角色，以強調女性自覺、顛覆傳統女性角色、也是發掘自我內在與社會對抗關係的身體經驗。[8] 從《窺》之後，短短幾年，一連串的國內及國際展出，加上駐村的經驗和挑戰，有喜悅、有感動、也有挫折；《不只是為了女人》引起各方討論，批評聲也開啟，一場藝術批評文字角力已蠢蠢欲動，女性主義議題漸漸在作品中浮現，年輕的侯淑姿已走上義無反顧的一條路，且背上了十字架。

參閱西方「書寫」身體的創作已有如羅琦・馬丁（Rosy Martin, 1946-）與凱伊・古德里奇（Kay Goodridge）藝術家，她們從1983年起開始以身體來表達女性創造力和生命力，並以線條與文字投影在身上的《光療重建》使用攝影表現，促進自我意識和康復，引起熱議；或者《肆無忌憚的婦人》使用照相和錄像藝術，摧毀了有關女性性慾與衰老神話，[9] 生命亦透過此痕跡而被辨識為本質、主體、在場。以身體作為畫布來創作的女性主義藝術的觀點，直接承受自女性主義的運動思潮，因取徑的不同，使其議題的選取，在歷史發展的過程中有重點與方向上的差異。一些認識到女性主義思想的局限性的學者認為，女性主義理論走到多元性別並存的今天，已經完成了它的性別解放的歷史使命，不再適合社會思潮的發展而行將消亡。後現代女性主義構成論也發現，社會性別論的內涵在當今已經擴大，它不僅指兩性的差異，也包括種族、國家、階級、性取向等和女性解放有關的領域。女性主義運動只有和這一系列相關問題結合在一起，才能適應社會發展而存在。只是目前在臺灣持續以女性觀點出發而創作的藝術家並不多。對照飯澤耕太郎（Iizawa Kotaro, 1954-）在《論私寫真》一書中對私寫真的釋義：「所有的照片都是『私寫真』，都是從『私我』與被攝主體（現實世界）間的關係層層篩濾而成的結果。」[10] 如果這是必然要走的一條路，那麼侯淑姿便是從鏡像中走出，與被攝主體（現實世界）站在一起，揮手那理想的自我。

從前述歷史和藝術以意識形態作為抗爭的運動中，女性主義藝術運動提供了重要的經驗與論述的建構面向。1994年、1997年侯淑姿回臺後，立刻投入籌畫個展和為攝影保存奔走各界，也意外地踏入政治圈，專攻文化法案。在順應「政治正確」下，藝術思想被政治化，以至於藝術的場域性與藝術家的創作身分，亦出現意識形態的各種批評。藝術家在這樣看似挑釁又遊走在分裂身分的景況中，藝評家高千惠認為，事實上，在後現代與後殖民態度的藝評書寫中，藝術形式的美學課題不再是主要的探究對象，而是，藝術作品被視為一種多面貌的「藝術行動」。它的出現被視為某種社會訊息的徵兆，解讀它的目的，乃在於理解過去、現在和未來的一些關

聯性。這是繼過去其他學科介入藝評之後，另一種以人類（文化）社會學作為藝評依據的立論。[11] 從公部門到藝術自由，侯淑姿選擇了《快樂是什麼》，首次嘗試深入訪談五十位的青少年與教師，而完成了一件公共藝術，這種過程也展現在《猜猜你是誰》（1998）的創作歷程，並且這次跨越更多元族群的內心世界與外在表徵的辯證。攝影家首次將受訪者的心聲直接以文字呈像在每張肖像上，肖像是以一種攝影之後的影像處理方法。這個創作也想解決藝術家自身對身分、土地、國族認同等等議題的回應，同時也是一種選擇信息模型（如攝影）的利用，使得他者（Other）（歷史）的復原。

《快樂是什麼》〈可以做自己想做的事〉／侯淑姿攝／2002
You Can Do What You Want from the *What Is Happiness* series / photo by Hou Lulu Shur-tzy / 2002

雙眸：文字與影像的觀念與裝置

攝影與文本（photo-text）的並置一直是侯淑姿重要的表現手法，在圖像中採納拍攝對象於受訪時所表達的語言內容。這項特徵強化了影像提供事物本質的資訊功能，使圖與文相互成為對方的證據。維克多・柏根（Victor Burgin, 1941-）表示：「一般常見的攝影與文字並置運用就像是互相給予框架，使用文字去評論影像，例如給予一些額外的訊息說明這些影像的展示內容，或者用影像來解釋文本說一個故事。」[12] 這些嵌入的文字在展示時會再次與觀眾形成對話，觀眾會在其中找到與自己較為相符合的觀點與立場。這樣一來一回，使得觀眾自身和作品之間形成一個場域，使觀看作品不再是一種單向的指引，這是藝術家侯淑姿自作品《窺》以來的一種「視覺圖像」的建立。攝影媒材其實還涉及對於視像的知覺與再現，尤其是可視性場域的社會建構，以及（同等重要的）社會場域的視覺建構，米歇爾（W. J. T. Mitchell, 1942-）的學術研究從藝術史的「圖像學」出發，卻在很大程度上引領了當代文化研究的一種走向。他在1986年的《圖像學》那裡將文化研究的意識形態分析引領到了視覺解釋學領域，特別是在1992年提出了「圖像轉向」這個重要的當代文化問題，「視覺解釋學」的主題的確得到了深度的轉換。[13] 尤其是語言與視覺再現之間的介面上的形象（image），是視覺文化開啟的邊界通往特定的感官通道，而「視覺藝術」則必然循此運作，甚至主張暫且不必要區分出image跟words之間的界線。當代「視覺文化研究」其實倒更像是「視覺社會學」的某種延伸與拓展，特別還吸納了後現代主義某些視角。[14] 而在當代來閱讀攝影作品更無法與攝影剛發明的初期相提並論，它的符碼與結構更為複雜了，這些特性也落實在後來侯淑姿的作品中。

1997年12月，藝術家參與由張元茜策展「盆邊主人・自在自為：亞洲當代女性藝術家」聯展，應是侯淑姿走入社會，企圖讓藝術成為社會評論、並將關懷層面擴大，從而邀請觀眾一起與作品對話的開始，只不過相片裡的女性肖像此刻仍是沉默的。美國藝術評論家、展覽策展人和藝術史學家也是女性主義藝術家的阿比蓋爾・所羅

門–戈多（Abigail Solomon-Godeau, 1948- ）於2012年3月來到臺北參加國際學術攝影研討會，對於其著作《攝影之後的攝影：性別、流派、歷史》中之論點，其中提出隨著將攝影與其他形式的藝術生產區分開來的界限越來越模糊，攝影之後的攝影是對塑造攝影實踐、批評和史學的權力迴路的調查的觀念，她認為攝影、文化、性別和權力之間的關係需要重新衡量。[15] 這樣的論點，在2004年侯淑姿開始南下在高雄生活與教書時得到了揭示與實踐。在《亞洲新娘之歌》系列作品中，侯淑姿顯然希望讓藝術成為社會評論、關懷層面擴大、提醒觀眾注意從性別問題到移民或新住民問題上，同樣為打破男性看／女性被看的迷思，讓新移民在觀者之前不再僅是被凝視的客體。於是，對「外籍新娘」這個議題的探討，源於身為女性主義者對弱勢女性存在的關切，最終還原為受訪者的主體發聲的位置。

《亞洲新娘之歌》的影像裝置作品以兩兩並置的照片及錄像呈現了外籍配偶的多元樣貌與聲音，在圖像與文字的交錯並置中，浮現出來自每個外籍配偶的故事與意象。每一組（人物）均有二至三套並置或少數單張的影像。特別的是，這些映照著她們臉龐和身體的文字，有時卻說的不是自己，而是同伴的故事，是「他者」也是「自我」；作者排除僅局限於性別、經濟、後殖民或形式主義的單一觀點，也不是採用隨意曝光，或為記錄流逝的時光的報導影像式的作法。硬邊的字體破碎了畫面，失去多彩而剩下的單色照，藝術家將影像留存寫實的殘影轉譯成設計過的畫面呈現，加上雙向並置的效果，企圖主導觀者的視覺是一種雙向瀏覽並沉浸在她的文字上，時而，光亮的照片表面，文字也反射在我們臉上。展場間在垂直的照片與印刷文字與觀者目光，形成一確切又充滿不定性場域的凝視與被凝視，透過不可見與可見地替換呈現迴轉之狀態。觀者在兩兩並置處理過的畫面中（通常是在左或右其中之一）前者印刷體文字阻礙，觀者無法確定／跳過文字而直達背後單色的影像自身的角色形象，是凝視的主體或被凝視的客體，在這無法穿透的凝視中感到不安。這些照片就像一個相遇之所，是攝影者、外籍新娘與觀者三方之交會。侯淑姿的裝置作品是針對與整個身體，亦即作品、作者、觀者與展場機制之間的關係。

《越界與流移 —— 亞洲新娘之歌 I》〈貴孝 (A)、(B)〉／侯淑姿攝／屏東／2005
Kuei-hsiao (A)、(B) from the *Border-crossing / Diaspora–Song of Asian Foreign Brides in Taiwan (I)* series / photo by Hou Lulu Shur-tzy / Pingtung / 2005

仍有社會學者有不同的觀看心得，認為《亞洲新娘之歌》系列的策展無疑值得肯定，然而侯淑姿選擇的攝影創作初衷，卻也很難脫離其生長的社會背景與歷史脈絡。在臺灣社會父權的性別意識形態以及主流媒體的污名論述影響下，令侯淑姿傾向選擇以「家」為主要的策展意象，作為反抗主流污名論述的起點。[16]「但從影像作品的構圖中仍可發現，新移民女性仍多與孩子或原鄉家人在家門口一起現身，使得展示內容所賦予的性別意涵仍難以跳脫傳統父權社會的性別意識形態：女性被再現為固守私領域／家庭的意象。換言之，這很可能潛移默化地向閱聽人傳達並強化『孩子──（新移民）女性──家庭』的認知連結，鞏固閱聽人對母職的想像與道德要求，更因此讓新移民女性長期在公領域的活動與勞動力貢獻繼續被主流社會所視而不見……也是目前臺灣社會對新移民女性最缺乏關注的部分。」[17]

至於藝術家遇到這些真實生活的女人們，她要如何在這成千悲喜皆有的女人故事中看待自己？以女性之名？「如果將交遇視為關係性、連結性的美學（art as encounter），那麼我們有無機會將此交遇成就反思性的作品？以一種冷靜的、聆聽的方式來『展示』我們對他者的理解而完成此種獨特的揭露。」[18]策展人黃孫權這麼問。如此一來，我們便要再問，單張攝影是否足以説明一切圖像意義？攝影與錄像相比何者更為真實的這個老舊爭論恐需再度提出。關切女性主義發展的簡瑛瑛表示，當攝影成為有意識的自我再現媒介時，攝影便不再只是一種記錄的工具，而成為藝術家思考呈現的媒材／媒介；[19]蘇珊・桑塔格（Susan Sontag, 1933-2004）在《論攝影》中對影像的討論，也已使攝影美學從拍照的原因，轉變到相片的用途上。[20]而關於文字，桑塔格更認為它的解說性富有說服力，因為它們帶有一種文件式的權威性，被視為「現實」的片段。[21]侯淑姿此時使用圖像跟文字並有兩兩並置的圖像，迫使我們停留在作品前更長的時間，拉近並賦予了觀眾更多的思考。這是她為何使用雙眸影像的原因，觀看者或評論者恐無法從作品前快速通過或視而不見。黃孫權在策展論壇上寫道：「藝術家侯淑姿從《亞洲新娘之歌》到眷村系列《我們在此相遇》的作品，是用攝影開始了她自己的奧迪賽之旅，不同於約翰・伯格，她並非要重製自己的情感人生；不同於奧迪賽，她不是要回到自己的家鄉與愛人團聚，她將路程所遇之人當成自己的家鄉。」[22]

霍米・巴巴（Homi K. Bhabha, 1949-）認為「他者」的問題在於刻板印象和殖民話語，要看清刻板印象作為一種含混的知識和權力的模式，需要從理論上和政治上對形成話語與政治之間關係的決定論或功能主義的模式提出挑戰，同時還要向教條式和道德上的對何謂壓迫和歧視的定位提出質疑。挑戰的切入點不應該著眼於形象的認同是否正確，而應該明白刻板印象話語造就了主體化的過程，並給人貌似有理的假象。[23]

關於底層社會的介入及展示問題或許可以看看美國女性藝術家的例子，藝術家瑪莎・羅斯勒（Martha Rosler, 1943-）是一位觀念藝術家，從事攝影和錄像、裝置、雕塑和行動藝術，以及關於藝術和文化的寫作。她的藝術創作則一直在處理藝術圈內外的經濟與消費主義，並分析婦女與少數族群是如何進入資本主義的政治環境裡。羅斯勒圍繞著社會和政治理念開展工作，從公民權利到反戰努力，再到婦女權利。雖然羅斯勒曾在迪亞藝

術中心舉辦的個展揭露無家可歸者的隱蔽性，和合謀掩蓋社會弱勢群體的城市政策，但對於展覽，少數批評之一是，它實際上並沒有減少美國的無家可歸問題。當被問及讓活動家作為藝術家工作與成為活動家之間的區別時，羅斯勒說：「要成為一名活動家，你可能必須與特定社區和特定問題或一組問題密切合作，具體結果……我是一名藝術家。我做藝術。我也是一名全職教授。激進主義是一個持續的過程，我確實在那個項目上與激進主義分子合作過，但有一點是肯定的：激進主義分子並不期望棘手問題要通過展覽或政治運動來解決，而且肯定不會在六個月內解決。」[24]

另一位也同樣使用文字和影像裝置的美國藝術家巴巴拉‧克魯格（Barbara Kruger, 1945-）的圖像，也是以一種視覺和書寫的混合建立一個深刻、微妙又有力的修辭，克魯格使用一幅幅商業廣告面目的作品挑戰男性中心社會的價值觀。她在作品中追求一種文字與圖像並置而相得益彰的效果，開創了把語言納入作品的先例。她把處在西方男性中心社會中女性的處境，反抗心態與批判態度，以及資本主義金錢拜物的本質等，以極其精闢、有力的形式提煉出來，犀利而諷刺，她並認為用一種易讀的字體是可吸引人的。[25] 藝評家曾少千對克魯格作品的評論是，「傷痛場景並非依賴人道主義、道德主義的敘事或他人受苦身體的細節，來引發同情心，而是透過現成圖像和簡潔文字的聰慧並陳，觀視如此不同的傷痛場景，我們逐漸『學習透過痛苦來思考』，通過痛苦的隧道而更加了解我們自己與他人，進入生命更深刻的新頁。」[26]

他者的視覺政治學：參與式之換位與認同

影像生產工具在誕生之始即已凸顯其人類學、社會學的功能，既作為介入現實、記錄變遷、書寫文化的一種文化生產工具，同時為弱勢群體邊緣人群，謀求改變不平等狀況，對強勢媒體不對稱信息狀況的一種反制。而女性在二十世紀小型攝影機發明之後，更時常可以發現她們的身影，不論在戰爭攝影或如30年代在美國記錄南方農工的困境（以攝影、電影和文字小說等等方式）、或者在晚近電影如《姓越名南》（Surname Viet Given Name Nam）（1989），其創作手法皆以女性導演所謂「毫無顧忌地混合了理論的、戰鬥的與詩的寫作形式」呈現出來，實現了典型屬於後結構理論與解構哲學的形式之政治。[27] 從事形式的政治或書寫的政治（a politics of writing），或許不是一個有意或清楚的選擇，有時是不得不這麼做，但人類學式的訪談與近身接觸，將他人的生命史與自己在地方的移動連結起來成為一個有意義的情感紀錄，並以裝置藝術、影像裝置的藝術場域呈現，則是侯淑姿近三十年來始終不曾猶豫過的；除此之外，她還書寫大量的文字並出版，可以說是一手持照相機、一手持筆，是臺灣藝術界少見的藝術工作者。

西蒙‧波娃（Simone de Beauvoir, 1908-1986）曾主張「他者」主要亙古不變的場域是性別疆界，她認為有別於其他的己／他關係皆具有相互認定性，唯獨性別，女人永遠是他者，一向受制於男人，從無例外。[28] 如果說藝術界裡的「他者」可定義是自我、我們、同類人的相異及相反的概念，女性的確則在直到近三十年才有比較多

的藝術創作被書寫和記錄。形成女性所謂的藝術運動的歷史可早自1970年代初一批美國的女性主義藝術家、評論者及藝術史學者，在反越戰及爭取男女平權的婦女解放運動訴求的浪潮下攜手合作，有組織地推動女性主義藝術作品的創作，爭取女性藝術家的權益及地位。在藝術史的研究上，關於女性藝術史的撰述早於文藝復興時期，書寫藝術家編年史的喬爾喬‧瓦薩利（Giorgio Vasari, 1511-1574）曾收集多位女性藝術家的資料，並撰文介紹之。十九世紀中葉柏林的藝術史學者恩斯特‧古爾（Ernst Guhl, 1819-1862）也為近東、埃及、希臘、羅馬以至於十九世紀的女性藝術家立傳。[29] 女性主義學者貝蒂‧傅瑞丹（Betty Friedan, 1921-2006）為一位美國作家、編輯，在近代女權運動中扮演著重要的角色，繼承了十八世紀以來自由主義的基本主張，而同時又更加強調女性在公共領域的參與，其著作《女性的奧祕》為提倡自由主義女性主義的經典。哈莫妮‧哈默德（Harmony Hammond, 1944-）是美國藝術家、策展人和作家，是1970年代紐約女性主義藝術運動創立的傑出人物，她極力主張女性主義藝術評論應涵蓋藝術與政治兩大層面。近三十多年來隨著女性主義思潮的演變，後現代解構主義、精神分析學等的衝擊，使女性主義觀點的藝術史研究法發展出多元取向的面貌。琳達‧諾克林（Linda Nochlin, 1931-2017）是第一批開創女性主義觀點藝術史研究之先鋒，1971年〈Why Have There Been No Great Women Artists？〉[30] 一文問世後，她嘗試從社會機制等層面，檢視藝術史上為何沒有偉大的女性藝術家，並提出諸多範例來佐證，男性與女性在權力機制上的比較。諾克林的另一篇的文章〈The Invention of Avant-Garde: France1830-1880〉，[31] 則提出了藝術作品的視覺政治性問題。她認為即使是純粹形式的建構，也免除不了隱藏在視覺語言背後的政治性意涵，應該進一步對藝術作品作批判性的詮釋，把隱藏在作品背後的權力結構與意識形態搬到檯面上，就這個層面來說，藝術史是社會性的，是政治性的，也是批判性的。不過這樣的思想潮流要到好幾年後，才在臺灣的藝術與社會中發生。

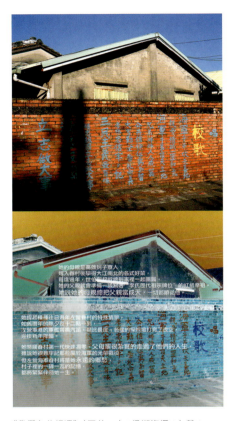

《我們在此相遇》〈回首 02〉／侯淑姿攝／左營／2012
Recollection 02 from the *Here Is Where We Meet* series / photo by Hou Lulu Shur-tzy / Zuoying / 2012

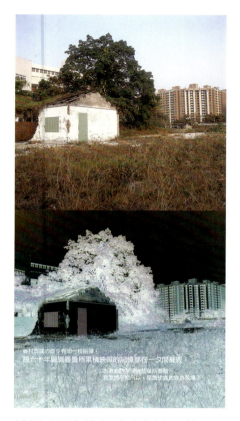

《我們在此相遇》〈餘音01〉/ 侯淑姿攝 / 左營 / 2012
Reverberation 01 from the *Here Is Where We Meet* series /
photo by Hou Lulu Shur-tzy / Zuoying / 2012

2002年侯淑姿開始參與「閒置空間再利用」案例的調查與研究，時間並不算太晚，那是從更早的一些國外駐村及華山藝文特區推動保存再利用的經驗累積而來，既不在公部門服務，單憑一些志同道合的藝文好友甚至單打獨鬥，不論推動「閒置空間再利用」、「國際藝術村之設立」或「攝影材質保存計畫」，整整十多年來，布滿她的足跡與音量，甚至可以同時處理兩種完全不同但對於藝術家都非常重要的任務。就是這樣的操勞不懈的滿滿工作，和時間賽跑，這是什麼樣的信仰與精神，將藝術工作與所見不平視為她的職志。2009年侯淑姿於復活節受洗，成為基督徒。這是她完成《望向彼方──亞洲新娘之歌 III》在各地展出之後，幾乎就在同一時間，侯淑姿以一個自稱「圈外人」（他者）的角色踏進了所謂「竹籬笆」內。藝術家本人表示，她聽到上帝的召喚，對於高雄大片的眷舍要搬移和拆撤感到驚訝和不捨，不解為何讓傳統、記憶、回憶、保存、時間不斷流失，忘了每項東西都有自己的記號，這些記號或記憶都有其代表性的價值。於是她開始倡議左營眷村保存，並進行研究與遊說，協同主持「左營眷村空間基礎資料與活化再利用屬性分析研究計畫」，並有後續幾年持續研究與發表。至此，與高雄「勵志」、「復興」、「崇實」、「自助」、「黃埔」、「明德」、「建業」新村的相遇，在藝術家的心中種下了保存與文化資產再利用的火種。那幾年她的身影與眷舍、老樹、彎著身軀的長者在落日餘暉中交錯重疊，仿如希臘神話普羅米修斯，或是薛西弗斯的化身，藝術家的心中想問的是「家」在那裡，以及「家」在哪裡？她在眷村的小路上，在村民回家的路上，在拆掉荒蕪的眷舍圍牆邊徘徊。

社會學學者提姆·克雷斯威爾（Tim Cresswell, 1965- ）提到對「家」的概念是：「家是地方的典範，人們在此會有情感依附和根植的感覺，比起任何其他地方，家更被視為意義中心及關照場域。」[32] 地方常常被視為「集體記憶的所在」──透過連結一群人與過往的記憶建構來創造認同的場址。隨著照片深入社會生活，攝影家或攝影編輯者們開始直接用照片來記述或再現社會史，當攝影家基於某種人文關懷或社會責任感，圍繞一個主題、

一個社會問題，用鏡頭做大量細緻的或追蹤性的記錄和描述，其中隱藏著歷史和政治的狀況，攝影家在用作品記敘事實的同時也做出他們的價值判斷。這種對苦難或邊緣人群的關注也開始於80年代、90年代因媒體的介入而發展到最高峰，與攝影家的工作難度和危險同時增長的是社會責任，經過一段時間拍攝後，攝影家也會盡能力所及地幫助被攝者，在臺灣解嚴以後，這波攝影題材的拍攝體現得非常充分。在臺灣《國軍老舊眷村文化保存選擇及審核辦法》、《文化資產保存法》[33] 都無法抵過商業利益的考量時，因此，道德或法律（行為規範）的社會學問題，轉化成了地方感的問題。當某件事或某個人被判定「不得其所」，他們就是「逾越」（transgression），逾越的這條界線通常是一條地理界線，也是一條社會與文化的界線。[34] 侯淑姿作為一位藝術家，她作為知識分子，聆聽且勇敢地批判政策的不義。傅柯（Michel Foucault, 1926-1984）用空間關係，説出了自我必須透過一個虛像反身之鏡，才能感知自我的存在。[35] 藝術家以兩幅影像上下並置的視覺雙關的作品，一為正像一則透過負片來追悼已消逝或即將消逝的地景，藝術家將自己與居民每日日常（訪談、陪伴、奔走）的口述歷史以文字描述匯集於照片上，多年的鏡頭紀錄性呈現了人物景物的變遷，而藝術家將其以檔案形式保存記錄，文件化自己的這場參與式的介入行動。與之前作品不同的是，藝術家不再是靜默的聆聽者，她在作品中以換位式的身分認同感同身受，對照出她的行動與吶喊：「傾頹屋舍與離去的眷村住民也許無語，藝術家成為全觀的述説者，説著地景中蒐集而來的殘留迴聲：他／她述説了臺灣不同族群結褵與城鄉移民的歷史。」[36]

高雄眷村三部曲（2010-2017）：《我們在此相遇》、《長日將盡》、《鄉關何處》，既是眷村的、也是臺灣命運以及都市發展的普遍化原則。「地方」其實是人們對於歷史與自我認同的位址，也是人們製造出豐富意義的原鄉。「地方」一詞，指涉的是一群人與某處位址之間緊密而相當穩固的關聯，時間和空間在一個場所裡匯合成一體，而社會改造著場所，賦予其記憶、歷史和符號意義。克雷斯威爾將「地方」（Place）的定義，藉由不同的

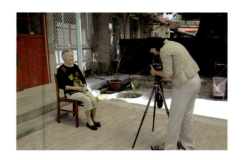

侯淑姿拍攝自強新村吳蔡友華女士 / 鼓山
Hou Lulu Shur-tzy photographing Ms. Wu Cai You-hua, Ziqiang New Village / Gushan

地理學家的論點予以區分：區域地理學家討論的「地方」，是擁有獨特生活方式的個別地區；人文主義者描述的地方，是「在世存有」的基本方式；基進地理和關照領域，對於人文主義地理學家而言，地方表達了面對世界的態度，強調的是主體性的經驗。[37] 一些社會學派提到「家」所象徵的傳統意義與不同地區文化的表徵，總是會對藝術家所展示的提出刻板印象的疑問。彷彿回到藝術史評論家提出十八世紀前的女性藝術家創作題材，亦被歸類為偏好私密的家庭情節之肖像畫、風俗畫，慢慢地才擴充為歷史繪畫、寓言繪畫，這些原屬於男性偏好的偉大風格的題材。這條漫長的路等到了攝影技術的誕生有了更大的突破。自從1990年代以來，評論家和策展人大抵上都認為，參與式藝術究其極是個政治藝術：他們鼓勵觀眾和藝術家合作，而促進新的解放式社會關係。此刻藝術家與高雄眷村的關係正是如此，他們並非在高雄眷村相遇，而是高雄眷村生產了他們之間的相識，因為每次相遇都是地方的重逢。[38] 侯淑姿完成三部曲的最後一個系列是《鄉關何處》，拍攝仍駐守原地的高雄左營明德新村、建業新村的住戶，為對抗執行不當的眷村改建條例，展開長達十三年的對抗。此系列作品既是歷史的，也是當下的，是紀錄性的，也是見證性的。展覽作品中呈現了人事全非的、房舍依舊但人回不去的、仍奮力存活的家園。藝術家的攝影鏡頭絲毫沒有遺忘一磚一瓦，一條被遺忘的鐵條、一片破碎了的窗戶，抹不去的牆上多年的同仇敵愾的字印。

「劉奶奶在作品的相框外，要求侯淑姿帶她回家，她想回家，即便看一眼也好。她想著有一天，能夠搬回黃埔新村，在歷史上，在地理上，這是她唯一的家。她若無家，我們也不會有。她並不佝僂，佝僂的一直是臺灣。」[39]

「我們在此相遇」到「此曾在」，時光的無情流逝也許能在照片中短暫閃爍，但一個國族的記憶消失過程將在侯淑姿的參與式影像公義中永存。因為攝影的所思便叫做：「此曾在」，或者「固執者」。[40]

結語

何謂他者？這個如影隨形的關注，使得藝術家總是在踽踽獨行時與之相遇：相異者，陌生人，外地人，異鄉人，移民者，邊緣人，不得其所者——儘管「相遇、以女性之名」。從開始創作到留美學成返臺，侯淑姿以一個教育家的姿態，總是不斷透過藝術創作，持著相機，時而以自己的行動演出，時而又將自身投入在一場又一場對話性的互動場域中，她始終相信影像是為人們保留最後的靈光（aura），[41] 也必然為公義代言，即使藝術被視為無用之物，攝影是二十世紀的流行。藝術家以攝影、文件、聲音記錄下與她相遇的他者存在的生命史，在敘事呈現中穿越多重時間與空間，並以自己書寫的檔案裝置重建他們的「家」。對於影像中所流露的人文細節與知識，此時侯淑姿又像個歷史學家，不斷呼籲影像保存，也親身力行呼籲一個影像的「家」，像先知般帶著犀利的眼神義無反顧。藝術家每一件作品都是獨創的，她對自己身為藝術家的定義在於，了解與對話並以持續同理心的身分認同與深入分析，誠如策展人黃孫權所說：「侯淑姿將路程所遇之人當成自己的家鄉。她宿於相遇，她往人們望向之彼方尋找私密的家。」[42]

因為她，總是站在一個城市的邊緣，試問：鄉關何處？直到長日將盡。

1　引自2018年笠原美智子（Michiko Kasahara）策展論述語意："They all share a common stance, confronting reality and contemplating their personal 'now' as they rush through life. If we were to ask what they are thinking about, the answer is love"。
　　參見Michiko Kasahara et al.: I Know Something about Love, asian contemporary photography Tokyo: Tokyo Photographic Art Museum, 2018, p. 170。
2　引言請參見本書〈口述訪談〉。
3　Hanne Tierney, Hannah Wilke: The Intra-Venus Photographs. Performing Arts Journal 18(1) (January 1996), pp. 44-49. JSTOR https://www.jstor.org/stable/3245813#metadata_info_tab_contents.
4　姜麗華，〈試論女性攝影家的私我寫真〉，《藝術學報》第104期（2019年6月），頁92。
5　陳香君，〈侯淑姿：到哪裡都「搞破壞」〉，轉引自侯淑姿，《女性影像書寫：侯淑姿影像創作集（1989-2009）》，臺北：典藏藝術，2012年，頁14。
6　Hélène Cixous, Déluge, Paris : Des Femmes, 1992, p. 369.
7　顧燕翎，《女性主義理論與流派》，臺北：女書文化，1996年，頁308。
8　同註4，頁98。
9　瑪莎・麥斯基蒙（Marsha Meskimmon）著，李蘇杭譯，《女性製作藝術：歷史、主體、審美》，南京：江蘇美術，2017年，頁130-132。
10　飯澤耕太郎著，黃大旺譯，《私寫真論》，臺北：田園城市，2016年，頁12。
11　高千惠，《詮釋之外：藝評社會與近當代前衛運動》，臺北：典藏藝術家庭，2017年，頁335。
12　Victor Burgin, Thinking Photography, London: Macmillan, 1986, New York: Basil Blackwell, 1982, p. 57.
13　劉悅笛，《視覺美學史——從前現代、現代到後現代》，濟南：山東文藝出版社，2008年，頁449。
14　米契爾（W. J. T. Mitchell）著，石武耕譯，《形象科學：圖像學、視覺文化及媒體美學》，臺北：馬可孛羅，2020年，頁27。
15　Abigail Solomon-Godeau演講於國際學術研討會「數位攝影的發明對攝影藝術的衝擊」內容，中華攝影教育學會主辦，2012年3月24日。
16　王俊凱，《新移民女性再現的策展政治》，高雄：國立中山大學社會學研究所碩士論文，2012年，頁72。
17　同上註，頁79。
18　黃孫權，〈夫／家／國間的女人們：當女性主義者遇到「她者」的對話〉，收於侯淑姿，《望向彼方——亞洲新娘之歌Ⅱ：侯淑姿個展》，高雄：高雄市立美術館，2010年，頁19。
19　簡瑛瑛、彭佳慧，〈性別．階級．族裔：跨國女性藝術的身分認同與自我再現〉，《現代美術學報》18（10），2009年，頁94-95。
20　引自Susan Sontag著，黃翰荻譯，《論攝影》（On Photography），臺北：唐山，1997年，頁89。
21　同註20，頁133、85。
22　同註18。
23　顧錚、羅崗主編，《視覺文化讀本》，廣西：廣西師範大學出版社，2003年，頁218-219。
24　Martha Rosler, Martha Rosler: Irrespective, London: Yale University Press, 2018; Cara Ober, Martha Rosler, Art as Activism, Democratic Socialism, and the Changing Role of Women Artists as They Age. Bmore Art (2019.07.04). https://bmoreart.com/2019/07/martha-rosler-on-art-as-activism-democratic-socialism-and-the-changing-role-of-women-artists-as-they-age.html.
25　顧錚編譯，《我將是你的鏡子：世界當代攝影家告白》，上海：上海文藝出版社，2009年，頁155-157。
26　曾少千，〈傷痛的場景：芭芭拉・克魯格的社會身體寫照〉，「身體變化：西方藝術中身體的意象與概念」國際研討會，國科會補助西洋藝術史推動計畫，國立臺灣師範大學，2002年3月31日，頁232。
27　帕特里夏．提契內托．克勞夫（Patricia Ticineto Clough）著，夏傳位譯，《女性主義思想：慾望、權力及學術論述》，臺北：巨流，2001年，頁206。
28　顧燕翎，《女性主義理論與流派》，臺北：女書文化，1996年，頁81-120。
29　曾曬淑，〈女性主義觀點的美術史研究〉，《中央大學人文學報》第15期（1987年6月），頁94-95。
30　Linda Nochlin著，游惠貞譯，《女性、藝術與權力》，臺北：遠流，1995年，頁187-224。
31　Linda Nochlin, The Invention of the Avant-Garde, France, 1830-1880, The Politics of Vision Essays On Nineteenth-Century Art and Society, London: Routledge, 1989, pp. 18-26.
32　Tim Cresswell著，王志弘等譯，《地方：記憶、想像與認同》，臺北：群學，2006年，頁42。
33　李廣均等著，《眷村的空間與記憶》，臺中：文化部文化資產局，2005年。另參見：全國法規資料庫（https://law.moj.gov.tw/Index.aspx）「國軍老舊眷村改建條例」。
34　同註32，頁163-165。
35　傅柯著，劉北成、楊遠嬰譯，《規訓與懲罰：監獄的誕生》，臺北：桂冠，1992年，頁200。
36　黃孫權，〈鄉關何處——侯淑姿與她的高雄眷村三部曲〉，收於侯淑姿，《高雄眷村三部曲：侯淑姿眷村女性影像書寫論述集》，臺北：典藏藝術家庭，2022年，頁157。
37　Tim Cresswell著，王志弘等譯，《地方：記憶、想像與認同》，頁163-165。
38　同註36，頁154。
39　同註36，頁161。
40　羅蘭．巴特著，許綺玲譯，《明室．攝影札記》，臺北：台灣攝影工作室，1995年，頁94。
41　華特．班雅明著，許綺玲譯，《迎向靈光消逝的年代》臺北：台灣攝影工作室，1999年，頁63、65。
42　同註36，頁158。

「冷」攝影
——侯淑姿的攝影計劃作為表演物件

文 / 林宏璋

侯淑姿在高美館的展覽「鄉關何處：高雄眷村三部曲——侯淑姿個展」，針對高雄眷村進行的影像及研究行動，此三部曲作品始於2009年，至2017年完整展出，前後達八年的時間，共有七十六幅作品。進入展場，首先是「第一部曲：我們在此相遇」以末代眷村勵志新村、崇實新村、自助新村與復興新村為拍攝對象，影像中看到的是大尺幅正方形的影像上下排列，在上面的影像為輸出正像，在下方為負像（negative）或者經過黑白染色處理的複本，某些文字置於下方，似乎為訪談錄的擷取，作為影像中出現的人「說話主體」（speaking subject）。展間影像的陳列方式如紀念碑，又像是墓誌銘的書寫，經過編輯的文字，言簡意賅的濃縮了個人在景、物流轉的生命歷史。而後進入的同展名的「第三部曲：鄉關何處」以海軍眷村明德新村、建業新村的人、事、物、景為對象，影像的處理方式如同之前正方形影像上下並置，在約二公尺之外觀看距離圍繞著椅子與植栽，時間的痕跡明顯留在這些器物上，可想像畫面中的人曾經坐過這些椅子與照顧這些植物——操作在物件上人的痕跡之「此曾在」（That-has-been），具體而微呈現在物件與影像之中的顯現與消逝。接著，在最後一個展間呈現「第二部曲：長日將盡」，展間晦暗的燈光

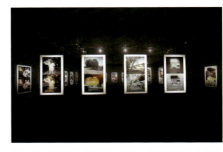

首部曲：「我們在此相遇」展場 / 侯淑姿攝 / 高雄市立美術館 / 2017
Episode I : *Here Is Where We Meet* exhibition / photo by Hou Lulu Shur-tzy / Kaohsiung Museum of Fine Arts / 2017

二部曲:「長日將盡」展場 / 侯淑姿攝 / 高雄市立美術館 / 2017
Episode II : *Remains of th Day* exhibition / photo by Hou Lulu Shur-tzy / Kaohsiung Museum of Fine Arts / 2017

三部曲:「鄉關何處」展場 / 侯淑姿攝 / 高雄市立美術館 / 2017
Episode III : *Out of Place* exhibition / photo by Hou Lulu Shur-tzy / Kaohsiung Museum of Fine Arts / 2017

設置,由於切燈聚光效果更凸顯攝影作為物件的形式;而展間中有個空的屋架,模擬著一般眷村平房的建築樣式,中間地方置放一面餐桌以及一些椅子。「空」的房子、「空」的餐桌及椅子,有著「詭異」(*unheimlich*)的氛圍,正如同詭異的德文字根所顯示,是一個非(*un*)家(*heimlich*),然而在展場中詭異氛圍,顯示出一種「在家而非家」的疏離感。¹ 在這三個展間之外,還有一個小空間呈現了有關高雄眷村的相關文獻,有如圖書閱覽室,裡面置放曹正剛將軍的書與臺灣海軍戰艦的模型,以及眷戶劉文美的家庭照片,另外有著侯淑姿對高雄眷村所做的研究報告。這些文件顯示出作品歷史的現實框架,作為作品「溢出」在影像之外的敘事。整體而言,《鄉關何處》有種「冷」的疏離感,例如負片、黑白成像的展現、歷史文件、資料、物件的擺設以及燈光設置,由「明亮」到「黑暗」的展覽閱讀情境,在在顯示出藝術家對於「溢出」常規影像之外的意義操作。

本文試圖將侯淑姿《鄉關何處》的「溢出」作為當代攝影美學的探索途徑。當然,一個重要的取徑在於詮釋侯淑姿作品二度成像的美學意義,一如黃孫權所指的「雙眸」之概念;兩個重複,但同時也是差異的影像,一部分是視覺式、文件的雙重呈現,它一方面為重複影像以加成密度化的呈現,或是一個影像本身的分裂,甚或這兩個影像中的張力與裂縫。從這個「重複且差異」影像所發展的影像美學可能性。其方法在於詮釋侯淑姿的作品以「物導向存有學」(Object-Oriented Ontology,簡稱OOO)的美學概念,將藝術作品當成可行動、可表演的「真實物件」(real object),是操作在感官經驗到藝術之間的張力:藝術作品視為一種消逝、退卻之中顯現出「真實」(truth)的途徑。² 以侯的作品探討OOO所定義之「表演物(performative object)的美學意義,利用拉圖(Bruno Latour, 1947-2022)的「行動者網路理論」(Actor-Network Theory)推演出作品的脈絡意義在於藝術所框架的現實、真實,顯現在在地臺灣與全球政經部署之「冷戰」氛圍。³ 這個交織在「表演物件」及「冷戰」之間的「冷」,一方面符合侯的形式設計——如負片成像、文件、及資料呈現中的美

學表現，另一方面也符合了「生命政治」的感知表現。換言之，本文從侯淑姿的作品，探索在外或在現實裡藝術美學形式互相轉譯的美學位置與主張，以「表演物」的概念，詮釋框架在拉圖的「行動者網絡理論」及哈曼（Graham Harman, 1968-）的「物導向存有學」的攝影風貌，在這裡的「表演物件」所強調的是藝術作為真實品質與感知之間的內在關係。

「冷攝影」加熱

當然，「冷攝影」的「冷」不是建立在形式處理上之意義，也不是展場意圖塑造的氛圍。「冷攝影」一如麥克魯漢（Marshall McLuhan, 1911-1980）利用熱力學的概念詮釋媒體「溫度」：麥克魯漢認為接受者介入媒體的程度決定了「冷」與「熱」，冷媒體需要接受者的主動參與，而被動的被接受往往是熱媒體。因此，麥克魯漢把當時低解析度和黑白的視覺效果，以及單聲道聆聽效果的電視作為「冷媒體」；相對而言的電影即是熱媒體。依循著媒體的概念，「攝影」當然也有著冷、熱的分別：後者在現代主義攝影中，尤其強調「直接攝影」（straight photography）的影像生產中，一如史蒂格立茲（Alfred Stieglitz, 1864-1946）的宣言：「我生在布霍肯（紐澤西），我是美國人，攝影是我的熱情，追求真理是我的執著。」[4] 咸信攝影技術的「高傳真」，是因藝術家作為「技術人」（homo techne）能承載「真實」的藝術；然而「冷攝影」中，往往需要圖像所承載之內容「之外」的參與與介入，以加熱「冷」質的攝影，一如後現代攝影，需要觀看者介入影像內容才能知會「別有所指」的真實品質，強調攝影是科技與藝術互相依存的「個人化」（individuation）實踐，也因此攝影者「自我意識」的向度，會隨著與時俱進的技術呈現媒體性（mediation）表現。

這種在「之外」而非「之內」的影像，需要「觀者」（beholder）介入的特性，正是哈曼所提出藝術是一個消逝「非在場」的「真實品質」，是一個建立在框架與網絡之中，具有劇場性（theatricality）且自主性的物件。同時，在網絡中的物件彼此翻譯，轉換各自物體的整體性，換言之，在網絡之間的物件互相依存，改變各自的特性。「表演物件」的概念就如同拉圖的作用物（actant），進入了網絡關係，呈現自身力量，以及其內在關係，這個網絡的操演正是物的宇宙之運作。當人類使用這些物件的時候，成為「手上之物」（thing-at-hand），主體依賴與物體的作用，依附其存在。如同物件擁有肉身性（corporeality），其生命往往強化了人們的恐懼，人的主體備感來自物的威脅。換言之，是強調人不再是世界重心的「非人類中心主義」（non-anthropocentrism），也是各式各樣美學主體論的客體轉向。

在當代藝術實踐中，有著將藝術作為「物」（thing）的方式呈現，而非將各式各樣的主體因果論作為藝術呈現的一環。換言之，「表演物件」在物的世界去發現人之外的問題，而非將藝術作品議題化以及工具化，作為人類主體經驗的體現；將藝術的純粹性作為其真實品質，不可直接掌握，但能逼進的物自身，這是發生在「物」之生態現實的存有學途徑，有著人類世生態主義的入世，同時進入物的世界的積極參與感，並且對現

實作為「物化」（reification）過程的了解與知會；藝術工作者在這個交疊地帶中了解時間性、個人化與記憶的關聯，關注以「物」作為世界中心的理解方式，進行藝術的關鍵性詮釋，並提供對於真實品質的洞察，在OOO美學概念維持在「真實物」（real object）與「感知品質」（sensual quality）之間的張力。[5] 因此，藝術的組成可以形成一個集體的詩意性組裝，開拓一個去人類中心的處境，這裡，牽涉了創作的詩性技術，以物性能（performativity）發展以物為本體所產生的組裝網絡。

從感知品質到真實物件

回到侯淑姿攝影的感知，在這些上、下區分的影像中，上半部維持著一般6×6格式拍攝的影像，放像也是如此，呈像清晰，拍攝主題多半置放在景框中央，可以看出大部分是光線充足的條件下所拍攝。畫面呈現的擺拍，顯示所拍攝的人物必定有著長時間的互動，必須在一定的熟悉的人與人互動基礎下，方能進行拍攝，尤其拍攝的對象許多是1949年後來臺的長者。

然而，在下方的圖像也是6×6的格式，影像上很有可能是以單色或是負片的形式來呈現；尤其在負片的呈現下，如果是未經過攝影訓練的人往往會無法閱讀影像。在這些還原攝影技術的下方底圖，例如底片以及黑白攝影等攝影，在作為一種科技技術的表達上，與上方圖像形成強烈反差；另一方面，穿插有如訪談摘要的簡單文字，通常兩則、或是四則、六則，這種如文件形式的呈現，可以看出是出自一長段的採訪且經過編輯的敘述與自陳，表達在自我顛沛流離至臺灣的生命歷史，但卻在晚年又必須離開自己的家園。這些文字，夾雜一些控訴話語。換言之，這些文字除了代表畫面中的人的「陳述」（statement），也因著經過藝術家的編輯及處理，同時代表著畫面拍攝的人及藝術家共同的「聲音」（voice），一如在精神分析意義之下，主體意識的「發聲」（enunciation），代表著「言說主體」（speaking subject）的話語。[6]

與其說整個影像的格式採取一種並置的邏輯，還未若說這兩個上下處理的影像，是一種「表」與「裡」的關係，在視覺性消逝的下方圖像，有著一個更為本質的陳列，一如上方是一個屬於現象的外表世界，屬於攝影語彙的「上相」（photogenic）問題；然而「還原」到攝影技術的下方圖像，不僅僅是去視覺化的真正主題的陳述，更是對於現代主義攝影中影像與真理必然關係的批判，拒絕傳統攝影性的表態。因此，在侯淑姿的影像中，我們看到一種需要觀者參與的「發散」（diffuse）擺置，邀約著進行美學判斷的「冷攝影」：真實的訊息與內容，或是表演物件，是必須越過正常圖像的那條不可見的線。下方影像加了文字及技術的對應之影像敘事，是對於「眼見為憑」攝影真實性的否定，也是一種「不應沈默」發聲的政治立場顯示。

因而，在侯淑姿的作品中，觀者一直在進行美學批判的抉擇。懸掛的高度使畫心離地約一百六十五公分，因此視線平行會落在上方影像的下緣，而圖像的分隔線是在視線之中，尤其在第一個展間，利用較高的懸掛方式，

不僅僅有著如紀念碑的影像裝置，更有平行於視線的分割線，作為本質與現象的辯證。侯淑姿的「冷影像」，透過分隔線的處理，邀請觀眾進入「眷村」人、事、物議題的複雜性，反應在其中「現實政治」（realpolitik）所展開的政治、經濟、社會關係。[7] 在侯淑姿分散的影像中，其所切分的不僅僅是倫理與美學的區分，更是以審美的獨立性進入到藝術／社會／知識／認知等所雜化的世界。

表演物件：田野、研究、游說、社會行動

因此，在「鄉關何處」展覽中，從攝影作品到文件化影像自身，從攝影作品以及從眷村所採集物件等，其如眷村街道擺設座椅、盆栽的方式，都一直強調課題不斷翻譯自身、雜化的過程。作品的樣態是一個不斷的跨越「分隔線」的實踐，作品本身就是參與社會、歷史場景的過程之顯現。在侯淑姿的作品中，這種「跨越」傳統作品形式的限制，成為一種「之外」的「表演物件」。也就是說，將侯淑姿的作品設定為一個「行動者──網絡」之物體系，其終極意義是不可窮盡的，這正是真實物件的品質，也是《鄉關何處》所延伸的複雜問題性，是運作於「背景」的網絡，或者是如海德格所言的「框架」（gestell）。[8]《鄉關何處》作品的跨越界線，是一個典型的開放作品（open work），不但在空間上是一個不斷延續、跨越與延伸的場域，其時間更是延續到現在的進行式：包含侯淑姿從2009年開始的長年研究，具體形成的書寫：「文化景觀鳳山黃埔新村再利用規劃研究計畫」、「高雄市眷村女性生命史紀錄計畫」等研究計畫；對社區的參與、關懷與照料的行動；還有對政府一連串的游說與請願行動。正確而言，侯淑姿的作品擴延至典型影像之外的行動者網絡，聯繫著眷村、生命歷史、都會化、居住正義、中國／臺灣國家性、全球冷戰的軍事、政治部署等等表演物件／網絡。

侯淑姿早期的作品，就一直在進行對典型攝影影像分隔線的跨越，成為需要參與的「冷影像」。從最早的作品《窺》的現場表演，要求現場男生報出「第四圍」的尺寸，反轉「陽具──邏

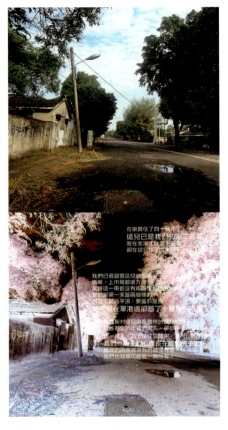

《我們在此相遇》〈鍾文姬與黃克正 03〉／侯淑姿攝／左營／2012

Jhong Wen-ji & Huang Ke-jeng 03 from the *Here Is Where We Meet* series / photo by Hou Lulu Shur-tzy / Zuoying / 2012

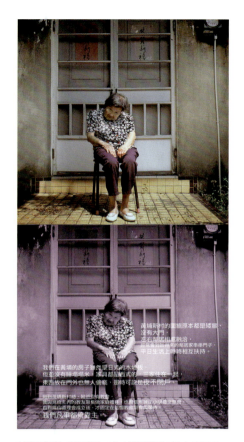

《長日將盡》〈陳景琛 09〉/ 侯淑姿攝 / 鳳山 / 2015
Chen Jing-chen 09 from the Remains of the Day series / photo by Hou Lulu Shur-tzy / Fengshan / 2015

各斯中心主義」（phallogocentrism）。在《青春編織曲》中，女性勞動者的青春歲月建立在臺灣世界工廠的「經濟奇蹟」，在現場請觀眾換取「臺灣製造」（Made in Taiwan）的衣服標籤。於日本駐村發表的《Japan-Eye-Love-You》，在觀眾間傳遞著護士服的充氣娃娃，侯淑姿在黑板上重複書寫「不關我事」（I am not responsible for this），透過表演批判日本情色文化工業，同時也對指責日本政府對教科書關於二次世界大戰歷史事實的竄改。隨著作品的發展，從《猜猜你是誰》、《亞洲新娘之歌》到《鄉關何處》的作品，強調邊緣主體性的陳述，研究、田野、調查與社會行動更成為作品的核心，可以說侯淑姿的影像實踐，是實踐在社會、文化與政治擴展場域之上，是置放在攝影意義上的奧斯丁（J. L. Austin, 1911-1960）所言的「操演行動」（performative act）：從奧斯丁的「言行一致」（saying as doing）到侯作品的「攝影、行動一致」（photographing as doing），而這正是必須跨越到典型攝影框架之外的真正原因，成為影像真實性的社會行動。[9]

《鄉關何處》的「鄉」，當然指的是「家鄉」，「日暮鄉關何處是」正是對1949年後隨國民黨來臺的軍人，在年老的時候，無法歸根大陸、也無法歸在臺灣的雙重「無家」狀態。1945年至1950年，中國大陸約兩百萬軍民遷入臺灣，政府為了解決人口激增所帶來的居住、安頓問題，開始興建房舍及利用日本的軍人宿舍，將住民以軍種、職業、工作特性分別安排在固定的區隔範圍，許多住民當時認為這僅僅是「暫時」的家，尤其在早期「動員戡亂時期」與「臺灣人」有一定的區隔。這個雙重的無家狀態，即是臺灣城市和農村景觀中獨特的「眷村」，為從中國和其他地方撤退的國民黨士兵及其家屬提供的臨時住房。從1990年代中期之後施行的「眷村改建條例」，由於種種關於工程規劃與眷村騰空、搬遷時程產生的實際落差，致老舊眷村土地的處置不如預期，再加上國內房地產市場景氣低迷，更加深改建的困難。在土地開發、建物改建與遷移的種種困難過程中，今天的眷村中有許多已完全被遺棄，或處於高度廢棄狀態，亦或已遭拆除。

經歷拆除與迫遷，不到二十年間，臺灣八百九十七個眷村剩下僅僅不到五十個存留下來，雖然其中有十三個已轉為眷村文化保存區，但其實仍是以「博物館」化的方式進行文化保存，而忽略了文化就是「生活」的方式（ways of living）；二十餘年來，並非所有人都願意離開這個生活了一輩子的「家」，然而同時也忽略了「眷村」一開始就是獨立在整體都市規劃之外，為解決大批「外來」人口的居住問題而興建的社區，換言之，就整體都市計劃而言，這是一種建築在「分離」政策，而非「融合」原則的社區住宅規劃；回應的僅是當時執政者將臺灣視為暫時的「反共抗俄」基地與堡壘，而非永續的家。眷村所具有的特性，是一種「家非家」的失根狀態（rootlessness），與自我和集體的歷史及所棲的脫離。換句話說，眷村消逝與存在的獨特性，標示著發生在臺灣歷史、社會發展史的特異點，我們甚至可以從「眷村」的「不可翻譯性」可見一般。在全臺原有近九百個眷村，至現今，被清拆到可能剩下不到五十個。侯淑姿的《鄉關何處》對應著眷村三個不同的空間消逝狀態以及平行的人的消逝生命，面對時空及人、事、物不可逆的歷史性，侯淑姿懷抱迫切的「革命情感」使命感，以「攝影者」的身分出發書寫眷村不可記憶的歷史，也作為周旋於眷服處、國防部、市政府與立法委員間、眷戶的遊說者，為眷村爭取保存契機，完成「眷村」在臺灣歷史中的文化拼圖：侯淑姿作為創作者保存未來的記憶，保存獨特「眷村」文化，註解在從二次大戰之後關乎臺灣的歷史「錨定點」（anchoring point）。

家／非家的冷顫政治

貫穿在獨特的「眷村性」、「臺灣性」以及「全球次序」的歷史，原初場景當然是1949年轉進到臺灣的國民黨全球軍事部署與強權對峙。美、俄對於資本／共產主義在全球的政治與軍事對峙，「冷戰」的非戰之戰，將「熱戰」的能量封存在對峙雙方的國家，尤其在共產主義前線的「反共復興堡壘」，對峙於共產勢力掌握的東亞地區，此軍事情勢對美國造成莫大威脅。於1950年韓戰爆發，美國與中共皆捲入此戰役，為避免兩岸利用韓戰期間挑起戰事，美國因此給予了臺灣在軍事上的保護，並將臺灣納入民主陣營，改變了臺灣在國際上被孤立

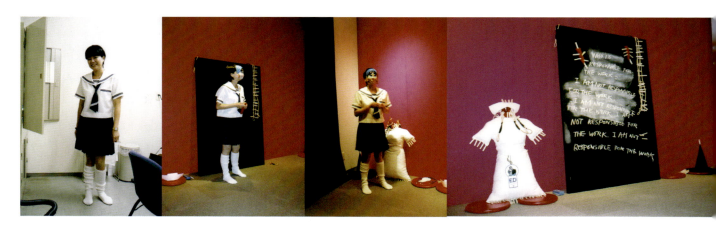

侯淑姿於「Japan-Eye-Love-You」展覽現場行為表演，橫濱美術館畫廊／日本／2000
Performance by Hou Lulu Shur-tzy at the art gallery of Yokohama Museum of Art / Japan / 2000

侯淑姿　HOU Lulu Shur-tzy

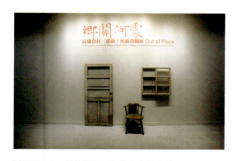

「鄉關何處」展主題牆 / 高雄市立美術館 / 2017
Theme wall of *Out of Place* exhibition / Kaohsiung Museum of Fine Arts / 2017

的處境。在臺灣，冷戰的對峙狀態蓄積了更為強大能量，尤其位在冷戰的前線的臺灣，冷戰邏輯轉換其治管邏輯成為主宰人民之「生命權力」（biopower）愈強，操縱著生存與死亡、法律與教育、居住與遷徙等等生命政治面向。

原子彈在長崎與廣島投下的兩個月後，1945年10月，喬治・奧威爾（George Orwell, 1903-1950）在他的文章《你和原子彈》（You and the Atomic Bomb），思考生活在核戰爭威脅陰影下的非「熱戰」的世界次序，他使用了「冷戰」一詞，推測了後原子彈時代中「大規模毀滅性武器」（mass destructive weapon）出現對地緣政治的影響，對一個既不可征服又與鄰國處於永久「冷戰」狀態的國家、社會與政治的影響。在這篇文章中，奧威爾寫道：

> 縱觀整個世界，並非朝著無政府狀態發展，而是轉向一種新的奴隸制發展……但很少有人考慮過它的意識形態的含義：在一個既不可征服又與鄰國長期處於冷戰狀態的國家中，會形成如何的世界觀、信仰、與社會結構。[10]

冷戰的非戰爭狀態，當然是一種備戰狀態，內化到日常生活之中，塑造了專屬「冷戰」的「世界觀、信仰、與社會結構」。在反共復興基地前線的臺灣，面對著武器部署的熱戰爭，其作用必有如「冰箱」一般冷藏備戰的緊張狀態。[11] 換言之，這牽涉冷戰的軍事部署轉譯到了個人生活的「白色恐怖」陰影下的冷顫。「眷村」，尤其有著臺灣最大眷村社區的高雄，正是庫存著冷戰之「冷」的原始操作地點，讓「家」永遠是「非」（un）「家」（heimlich），不安適、詭異、陌生、詭譎的場所，顯示以「眷村」為「家」的影像所包含的詭譎性（uncanny）。在「鄉關何處」的最後一個展間的二部曲「長日將盡」，其中昏暗的氛圍與懸吊的攝影裝置，影射其拍攝對象鳳山黃埔新村的住民，其中也包含許多經歷孫立人、郭廷亮政治迫害的相關人士。展間中，只剩骨架的房屋架構裡，中間置放餐桌椅，並無入口可進入，指涉的是劉奶奶「家非家」長日將盡的內在狀態。

葛洛伊斯（Boris Groys, 1947-）曾經言及在生命政治的時代，必須以「文件」的方式生產藝術。[12] 透過「冷攝影」所定義的物與人的經驗，即是文件、影像、物件等記憶、遺忘與創傷的辯證關係，一個在「回憶中的遺忘」的疏離主體經驗；換言之，這是「曾是記憶，爾後失憶」的「詭譎」（uncanny）情景。冷影像的技術，從「感知品質」進入到影像的內在關係，探討人主體之外影像所塑造「外置記憶」（exosomatic memory）之客體關係，呈現典型圖像之外的敘事性。在侯的《鄉關何處》的影像裝置，跨越典型攝影的分隔，進入到由表演物件所展開的「行動者網絡」，包含著影像布局、物件、文字資料等等的擺設，其文件的時間性展開是從「此曾在」到「此將在」（this-will-be），作為「未來歷史」的證據、宣告與證言。冷影像書寫將臨的歷史，作為給予未來的備忘錄。正是從位於高雄的眷村在冷戰時期的邊緣性，進行一種朝向未來開放的影像的視覺性；企圖尋找藏匿於黑暗歷史角落糾結的問題性（problematics），是發生在場所／物件／家庭／團體／自然的綱次下遷徙、移民、他鄉、殖民等錯時斷裂的冷戰／冷顫記憶，以見證與證據所持有文件性（documentality）潛能，作為能抗衡「治理性」及「生命權力」抹除記憶、歷史的藝術實踐。侯淑姿的「冷影像」，針對高雄地區眷村在面臨拆遷的「歷史轉向」（historical turn）記憶工程，利用「記憶」作為「物」的概念，呈現臺灣作為冷戰歷史的封存與個人的生命歷史，儘管「眷村」包含了無可窮盡且糾結綜錯的複雜性，但《鄉關何處》逼近了「眷村性」，開展出能認知過去到未來的契機，尋出屬於臺灣──世界未竟的文化拼圖。

1 Sigmund Freud, "The Uncanny," *The Complete Works of Sigmund Freud,* trans., James Stretchey (London, Hogarth Press, 1975), p. 219.
2 Graham Harman, *Art and Objects* (Cambridge: Polity Press, 2019), p. x.
3 Graham Harman, *Prince of Networks: Bruno Latour and Metaphysics,* Anamnesis (Re. Press, 2009), pp. 71-95.
4 引自Alfred Stieglitz攝影展序言，Anderson Gallery，New York，1921。
5 Graham Harman, *Art and Objects*, pp. 20-23。
6 在這裡，特別強調「陳述」與「發聲」的差別，主體位置的聲音是代表了正是主體真實性。Jacques Lacan, *Four Fundamental Concepts of Psychoanalysis*, trans. Alan Sheridan (Norton & Co, 1977), pp. 139-140。
7 現實政治（Realpolitik）強調權利及利益而無政治信仰之政治。Bruno Latour, "From Realpolitik to Dingpolitik–or How to make things public," in *Making Things Public: Atmospheres of Democracy*, eds., Bruno Latour & Peter Weibel (Cambridge, MA.: MIT Press, 2005), pp. 14-41。
8 Martin Heidegger, *The Question concerning Technology and Other Essays*, trans. William Lovitt (New York: Harper Perennial, 1977), p. 20.
9 J. L. Austin, *How to Do Things with Words. The William James Lectures delivered at Harvard University in 1955* (London: Oxford University Press, 1962), p. 7.
10 George Orwell, "You and the Atomic Bomb," *Tribune*, October 19, 1945.
11 李士傑發表在2008臺北雙年展Dictionary of War曾用「冰箱」的概念比喻臺灣的冷戰之冷。網址：http://dictionaryofwar.org/Cold_Coldness_the_War_of_Coldness。
12 Boris Groys, "Art in the Age of Biopolitics: From Artwork to Art Documentation," in *Art Power* (Cambridge, MA.: MIT Press, 2008), pp. 53-66.

Double Gaze, Double Voice:
Hou Lulu Shur-tzy, We Meet in the Name of Women

Author / Wang Ya-lun

Hou Lulu Shur-tzy, who traveled to the U.S. for her graduate studies in art and photography during the late-80s, is one of the few veteran artists in Taiwan who has consistently dedicated efforts to the pursuit of gender equality. Hou systematically promoted feminism through her work, fighting for the rights and equality, as well as the visual politics, that women deserve.

Not Just for Photography: In the Name of a Female Photographer

While completing her university degree, Hou came into contact with photography through university clubs and the photography field at the time. With her previous training in fine arts, Hou traveled to the U.S. in 1989, hoping to fulfill her art dream. In August of the same year, Hou published *The Reflection of Life: Hou Lulu Shur-tzy Photography Collection* and proceeded to the Rochester Institute of Technology to study imaging arts. This collection became a sort of prophecy on Hou's later creative attitude and style: the interplay between texts and images, society and the self.

The artist's almost five years of studies in the West have undoubtedly influenced her work. She mastered photography, sculpture, and action art, artistic presentation, and photography restoration techniques, a topic seldom approached by students who studied abroad at the time. Although the years have taken youth as their price, these topics became subjects that Hou explored after returning to Taiwan, as if the past was preparation for the path ahead. Of course, apart from these subjects, the artist's most profound awakening was what she could do for women and society as a woman herself; it turned out, she was aiming for more than mere photography.

During her years in the U.S., Hou encountered many female artists, and the sense of assurance that was felt while they talked was a propelling force, one that inspired Hou to reflect on the role, identity, and circumstances of women. Hou also encountered feminist artists and feminism while studying in New York. During the second wave of feminism between the 1960s and 1980s, Hou said that she "reflected on my own mental state from the perspective of a feminist, and how, as a woman from the East, I could express my works in a Western setting." This was also the artist's first female awakening. These female artists were often educators as well as artists, and they used photography as a medium of expressing the meaning of self-existence and weren't afraid of confronting politics head on. It wasn't hard to imagine these figures as a spiritual guide for the early works of Hou, and they also served as the key element that prompted Hou to go from the exhibition wall to the masses.

Hannah Wilke was a U.S. painter, sculptor, photographer, video artist, and performing artist. Wilke was also a teacher, who inspired Hou. Judy Dater, who also centers most of her works on her own body, photographs herself as a middle-class housewife as a way of scrutinizing her personal marital struggles,

realistically depicting the lives of women and expressing the banal, trivial, and even oppressed spiritual states of middle-class married women, shattering the image of women in male-centered visual mythologies. Jo Spence sought to overturn male dominance and insisted on representing individuality through a body that was more than a realm for male desire. In contrast to the works and action art of the aforementioned female artists, art critic Chiang Li-hua believes Hou's works integrate photography, performance, and action art as a four-step visual imagination parody of lifting a woman's skirt, accidentally revealing visual imaginations of the phallus, which is a direct hit on Taiwan society's visual inertia of consuming the female body. Art critic Chen Hsaing-chun describes it as "a fluctuating process of dialogue and struggle between the subjectivity of the artist and gender conditioning." The work *Take a Picture, It Lasts Longer* interprets women's inescapable dilemma under male desire and power.

What's worthy of attention is that, in *Take a Picture, It Lasts Longer*, Hou started writing texts on her own body, such as "PEEK A BOO," "WHAT ARE YOU LOOKING AT," and "WITH A FACE LIKE THAT," all of which are satires of how the male gaze objectifies the female body. The discourse of identifying gender based on the "view" of the presence/absence of the phallus is reproved by feminist scholar Hélène Cixous as the "voyeur's theory." She also states that the only practice is alternative writing, and this "writing body" is "women's writing (écriture feminine)." A few short years after *Take a Picture, It Lasts Longer* and after a series of exhibitions in Taiwan and abroad, as well as residency experiences and challenges, *Not Only for Women* attracted attention, as well as criticism, arousing battles between different art critics in Taiwan and internationally. Feminist themes started appearing in Hou's works, and the young artist set off on a path of no return.

After Hou returned to Taiwan in 1994, she immediately devoted her efforts to arranging her solo exhibition and photography preservation. Hou also entered the world of politics, focusing on art policies. Aligning with "political correctness," art thoughts were politicized, which led to ideological criticism in terms of artistic realms and the creative identity of artists. From the public sector to artistic freedom, Hou chose *What Is Happiness*, which was her first attempt at creating a work of public art through deeper interviews with more youths. This approach reemerged in the process of *Guess Who You Are*, which deals with the inner landscape and outer expressions across different ethnicities. This was the first time the photographer presented the thoughts of the interviewees directly on each portrait, which were processed after the photography session took place.

Double Gaze: The Concept and Installation of Texts and Images

Juxtaposing photography with photo-text has always been Hou's signature expression, with the descriptions expressing what the photography subjects stated during the interview. This trait emphasized the image's function of providing core information about objects and incidents and allowed the image and text to serve as the other's proof. These embedded texts create dialogues with the audience once again during its display, and the audience will find a perspective and position that aligns with their own. This interaction enables the audience to form a realm between themselves and the work: Looking at works is no longer unidirectional. This is Hou's establishment of "visual image" since the work *Take a Picture, It Lasts Longer*.

In December 1997, the artist participated in the *Asia Contemporary Female Artist* group exhibition curated by Rita Chang, which marked the starting point of Hou's efforts to enter society, allowing art to

become a form of social critique and expanding its realm of concern, inviting viewers to form dialogues with the works. However, the women in the portraits remained silent at this point. The U.S. art critic, curator, art historian, and feminist artist Abigail Solomon-Godeau's *Photography after Photography; Gender, Genre, History* proposes that as the boundaries that separate photography from other forms of artistic production become increasingly fluid, photography after photography is an inquiry into the circuits of power that shape photographic practice, criticism, and historiography. This viewpoint was revealed and put into practice when Hou traveled to the south of Taiwan to live and teach. In her *Asian Brides* series, Hou obviously wanted art to become a form of social criticism, to expand art's realm of concern and become a way of reminding audiences to direct their attention from gender issues to immigration and recent immigrants, all the while breaking the myth of men looking/women being looked at, and that immigrants are no longer mere objects of the viewer's gaze.

The photographs and video installations presented in pairs feature the multifaceted appearances and voices of immigrant spouses. Through the entwinement and juxtaposition of images and texts, the stories and imagery of each immigrant spouse emerge. Each group (individual person) includes a few single images or two to three sets of photographs that are juxtaposed, while the rigid fonts fragment the scene, leaving behind colorless, monochrome photographs. Through this method, the artist interprets the residues of reality that are left behind by the images into designed scenes. In the exhibition space, the vertically arranged photographs, printed texts, and the gaze of the viewers form a field of gazing and being gazed at that is at the same time filled with certainty and uncertainty, presenting a turn through the visible and the invisible. Here, the viewer experiences a sense of unease through the impenetrable gaze. These photographs are like places of encounter, an encounter between the photographer, immigrant brides, and the viewer.

However, some sociologists have different viewing experiences, believing that although the curation of the *Asian Brides* series deserves praise, it nonetheless points to the fact that it is difficult for the creative concept of Hou's photography to become detached from the social background and historical context of the artist's upbringing. Under the gender awareness of Taiwan's patriarchy and the stigma spread through mainstream media, Hou centered her curation around the imagery of the "home" as a starting point for resisting mainstream stigma discourse. "However, judging from the composition of the image works, most recent immigrant women appear in front of their homes with their children or family members from their hometown at their side, which results in the fact that it is still difficult for the gender undertones within the displayed contents to escape the gender awareness of traditional patriarchal societies, in which women represent the guardians of the private spheres/homes. This is also an aspect of recent immigrants that is most lacking in Taiwanese society."

How does Hou reflect on herself through the different joys and sorrows of the women she encountered in real life? In the name of women? Curator Huang Sun-quan asks: "If encounters are viewed as relational, and through the idea of art as encounter, do we have the opportunity to transform this encounter into reflective works? Completing this unique revelation through 'presenting,' we gain understanding of the other with a sense of calm and through the act of listening." We can take a step further and ask, does a single photograph have the ability to conclude all meanings of the image? Susan Sontag discussed images in *On Photography* and expressed the belief in the persuasive descriptive ability of texts, since they have the authority of documents and are viewed as fragments of "reality." By pairing images and

texts in groups of two, Hou forces us to stay longer in front of the images, pulling viewers closer and inspiring deeper contemplation. This is also the reason why she adopted the method of double gaze images so that viewers or critics would be unable to merely glance over the works without actually seeing their message.

As for the intervention and presentation of issues of the socially disadvantaged, perhaps we can look at a few examples of female the U.S. artists. Martha Rosler is a conceptual artist who works with photography, video, installation, sculpture, and action art. Although Rosler's solo exhibition at Dia Art Foundation centered around revealing the inconspicuousness of the homeless and urban policies that conspire to keep the socially disadvantaged out of view, one of the few critiques of the exhibition was that it did not resolve any problems of homelessness in the U.S.. When asked about the difference between doing activist work as an artist and being an activist, Rosler responded: "To be an activist you probably have to be working intensively with a specific community and a specific issue or set of issues, specific outcomes…activists don't expect intractable problems to be solved by an exhibition or a political campaign and certainly not in six months."

The Visual Politics of the Other: Trans-Positioning and Identity in Participatory Art

Image production tools have displayed their anthropological and sociological functions since their birth, and they have acted as cultural production tools that intervene with reality, document change, and write culture, as well as a form of resistance and tool for the disadvantaged and marginalized when battling inequality and the imbalanced disclosure of information in mainstream media. Engaging in a politics of form or politics of writing may not be an intentional or distinct choice; sometimes, it is something that must be done. However, anthropological interviews or close-up interactions connect the life history of others with the movements of the self in certain places, forming meaningful emotional documentation; over the past three decades, displaying her works as art fields, installation art, and image installations have been methods that Hou has never hesitaed to use. In addition, Hou has written and published a substantial amount of text, with the camera in one hand and the pen in the other, a rare female creative in Taiwan's art world.

In 2002, Hou started participating in the investigation and research on repurposing idle spaces. It was not too late. Either through projects repurposing idle spaces, the establishment of the international artist village, or photography material preservation projects, for over a decade, Hou dedicated her energy and voice to a task that was almost tackling two distinctively different missions that are equally important to the artist. On Easter of 2009, Hou was baptized as a Christian, which was around the time when *Look toward the Other Side–Song of Asian Foreign Brides in Taiwan (III)* was exhibited in several locations and when she went inside the "bamboo fence" as an "outsider (other)." Hou started proposing initiatives such as the preservation of the Zuoying Military Dependents' Village and participated in research and lobbying; she even published the Analytical Research on the Basic Spatial Information and Revitalization of Zuoying Military Dependents' Village Research Project, which continued to be researched and published for several years. The encounter with the military dependents' villages in Kaohsiung planted a seed for preserving and repurposing cultural assets.

Sociologist Tim Cresswell proposes the concept of "home" as: "the model of places where people sense emotional attachment and rootedness. Above all else, a home is a place that is seen as the center of

meaning and field of care." A place is often viewed as "a place of collective memory," a site where identity is constructed and created through the connection among a group of people and memories. By delving deeper into society through photographs, photographers or those editing groups of photographs started using photographs to record or re-present social history. When photographers focus on a topic or social issue and use the lens to conduct large quantities of detailed documentation and descriptions containing historical and political nuances, photographers are making value judgments while documenting reality with their works. In Taiwan, the Regulations for *Selecting Old Quarters for Military Dependents for Preservation and Review Criteria* and *the Cultural Heritage Preservation Act* have both been unsuccessful in overpowering commercial interests; therefore, the sociological issues of ethics or legislation (behavior restrictions) have transformed into an issue of sense of place. When an incident or individual is deemed "out of place," they are seen as a form of "transgression," having transgressed the line that is usually geographical, and one that is social and cultural. As an artist and intellectual, Hou listened and courageously critiqued the injustice of policies. Michel Foucault used space relations to express that the self must sense its own existence through a virtual reflective mirror. The artist uses two images with double visual meanings that are placed vertically, with one a positive film and the other a negative film that mourns scenes that have either disappeared or are about to vanish. The artist showcases the oral histories of her daily life (interviews, keeping company, and other efforts) with the residents through descriptive texts on the photographs, with changes over the years documented by the lens, which are in turn preserved by the artist as archives, transforming her participatory actions and interventions in the form of documents. What's different between these works and previous pieces is that the artist is no longer a silent listener; instead, she emphasizes through the act of trans-positioning and identity to feature her actions and appeals.

A Trilogy on Kaohsiung Military Dependents' Villages: *Here Is Where We Meet*, *Remains of the Day*, and *Out of Place* is about military dependents' villages, but the works are also about the fate of Taiwan and the universalized principle of urban development. "Places" is where people identify with its history and themselves, a place where people create rich meanings. The term "place" refers to a whereabout where a group of people is intimately and stably connected with a location, where time and space merge as one, and where society reconstructs the space, giving it the value of shared memories, as well as historical and symbolic meaning. This extended process reached a more significant breakthrough with the birth of photography. Since the 1990s, most critics and curators agree that participatory art is essentially political art: it encourages viewers to collaborate with artists and inspire new liberating social relationships, such as the relationship between the artist and the military dependents' villages of Kaohsiung.

From "here is where we meet" to "ça a été," perhaps the ruthless passing of time leaves traces in the photographs, but the diminishing of a nation's memory will become eternal in the participatory image justice of Hou, since what photography is concerned of is "ça a été," or "the stubborn."

Conclusion

Although art is seen as useless and photography a 20th-century trend, as an educator, Hou Lulu Shur-tzy continues to believe that images serve the purpose of preserving the last aura for others, a way of voicing justice, either through artworks, with the camera in hand and occasionally through her own actions and performances, or by engaging in one after another field of conversational interactions. The artist uses photography, documents, and sound to record the life histories of the "others" she

encounters, her narratives roaming between multiple times and spaces and using the archival installations of her writings to reconstruct their "homes." The cultural details and knowledge that seep through the images make Hou seem like a historian who repeatedly appeals for the preservation of images while advocating for a "home" for the images with keen and prophet-like determination. Each of Hou's works is original, and she defines her role as an artist as understanding and engaging in dialogue to allow identification and deeper analysis. Just as curator Huang Sun-quan states: "Hou Lulu Shur-tzy treats each person that she as her own home. Hou finds a dwelling place in each encounter, and she seeks the intimate home in the direction of their glances."

Because she has always stood at the margins of the city, asking questions about being out of place in the remains of the day.

侯淑姿於《青春編織曲》作品發表於「盆邊主人・自在自為」展覽的行為演出 / 新莊市文化藝術中心 / 1997
Performance by Hou Lulu Shur-tzy / Xinzhuang Cultural Arts Center / 1997

Cold Photography:
Hou Lulu Shur-tzy's Photography Project as a Performative Object

Author / Lin Hong-john

Out of Place: A Trilogy on Kaohsiung Military Dependents' Villages: Hou Lulu Shur-tzy Solo Exhibition at the Kaohsiung Museum of Fine Arts features Hou Lulu Shur-tzy's images and research on the military dependents' villages in Kaohsiung. The trilogy began in 2009 and was comprehensively exhibited in 2017, creating a total of 76 works in the span of eight years. Upon entering the exhibition space, viewers are greeted with the first of the trilogy, *Here Is Where We Meet*, which showcases images of the last military dependents' villages, Lizhi New Village, Chongshi New Village, Zizhu New Village, and Fuxing New Village, vertically displayed in large square formats. The images at the top are positive films, and those at the bottom are either negatives or copies that have been processed into black-and-white. At the bottom of some of these images are texts that seem to be excerpts from interviews, the "speaking subject" of the interviewees. The exhibition rooms are arranged like a memorial, or similar to the writing of an epitaph, with the edited texts as condensed and concise descriptions of the subject's life story amid the changes of time and space. The viewer then enters the third section of the trilogy: *Out of Place*, which is synonymous with the exhibition, featuring the people, incidents, objects, and scenes of the navy dependents' villages Mingde New Village and Jianye New Village. The images in this section are similar to the previous exhibition space, with square images placed vertically. The works allow viewers to see the chairs and plants at an approximately two-meter-distance; the traces of time are distinct on the objects, alluding to the idea that someone once sat in these chairs, looking after the plants. Hints of human handling, clues of "it-has-been," become an epitome of the appearance and disappearance of objects and images. Finally, in the last section, the dim lighting arrangements and cut lighting effect of the second part of the trilogy *Remains of the Day* accentuate the form of the objects. Within the exhibition space is an empty building frame that simulates ordinary military architecture, with a dining table and some chairs placed within.

The "empty" house and "empty" dining table and chairs create an "unheimlich (uncanny)" atmosphere. Just as the German word suggests, a place that is un-heimlich is a place that feels un-homely. The unheimlich exhibition space gives the uncanny and isolating sense of "feeling unhomely at home." Apart from the three exhibition spaces, there is also a small space like a reading room displaying documents on Kaohsiung's military dependents' villages. Within this room are books that belonged to General Tsao Cheng-kang, models of ROC Navy Battleships, family photographs of the military dependent Liou Wun-mei, as well as Hou's reports on her research on Kaohsiung's military dependents' villages. These documents present the reality framework of history and act as narratives that have "overflown" externally to the images.

This article tackles the "overflown" qualities of Hou's *Out of Place* as a gateway to exploring the aesthetics of contemporary photography. Of course, one important approach is to interpret the aesthetic meaning of the second imaging of Hou's works, which Huang Sun-quan referred to as the "double gaze": two duplicated but different images, a part of which is the dual presentation of visual

and document, which either adds to the density through duplicated images, is the split of the image itself, or denotes the tension and rupture between the two images, and the image aesthetic possibilities that have developed from this quality of being "duplicated and different." This approach interprets Hou's work through the aesthetic concept of "Object-Oriented Ontology (OOO)," as in treating artworks as mobile, performative "real objects" that operate amid the tension between sensory experiences and art; here, artworks are viewed as an approach to "truth" that emerges through disappearance and retreat. This article explores the definition and aesthetic meaning of the "performative object" in OOO through Hou's works and uses Bruno Latour's (1947-2022) "Actor-Network Theory," which leads to the deduction that the context of Hou's works lies in the reality and truth amid the artistic framework and is embodied amid the backdrop of the "Cold War" which manifested in the political economy of Taiwan and the world.

Heating Up "Cold Photography"

The "cold" in "cold photography" does not refer to the approach to form, nor does it point to the atmosphere that the exhibition attempts to create. "Cold photography" references Marshall McLuhan's (1911-1980) method of using thermodynamics as a way of determining the "temperature" of media. McLuhan believed that extent that the receiver intervenes with the media determines its "coolness" and "hotness." Cool media requires the active participation of the receiver, while hot media is often passively received. Therefore, McLuhan viewed the television, which at the time had low resolution and was black-and-white and monoaural, as "cool media." In contrast, films are "hot media." "Cold photography" often requires the participation and intervention of parties that exist "external" to the content of images to heat up the "coolness" of photography. For instance, postmodern photography requires the intervention of viewers to understand its true meaning, which emphasizes photography as an "individualized" practice that exists upon the interdependence between technology and art, and that the "self-awareness" of the photographer shows mediation as technology progresses with time.

This "external," rather than "internal," image that requires the interventive quality of the "beholder" is precisely what Harman meant when he referred to art as the "true quality" of a diminishing "non-presence," an autonomous object theatricality established amid a framework and network. At the same time, the objects within the network translate each other, altering one another's integrity as objects; in other words, the objects within the network coexist and change each other's characteristics. The concept of the "performative object" is similar to Latour's actant, which enters the network and presents its own power as well as its inner relationships, and the operations of the network are the operations of the universe of objects. When human beings make use of these objects, they become the "thing-at-hand," the subject depending on its effects with the object, and existing as its attachment. Just as objects have corporeality, their lives often add to the fear of human beings; the threat of objects is increasingly felt by human subjectivity. In other words, it emphasizes a "non-anthropocentrism" where human beings are no longer placed at the center of the world, an objective turn of various aesthetic subjectivisms.

From Perceiving Quality to Real Objects

The format of the images is approached with the logic of juxtaposition; or, it could be said that the way these images are vertically arranged aligns with the relationship between the external and the internal. The lower image, placed where the vision diminishes, is displayed in a more essential manner, as if the image on top is a mere phenomenological, external world that, in photographic terms, falls in the photogenetic category. However, the lower image, which reverts to photographic technique, not only is a de-visualized display of the real theme but moreover acts as a critique of the necessary relationship between images and truth in Modernism photography, refusing the expression of traditional photography. Therefore, in Hou's images, we see a diffused arrangement that requires the beholder's participation, a "cold photography" that invites aesthetic judgment: true messages and content, or performative objects, can only be accessed once the invisible line of normal images is surpassed. The lower images paired with texts and descriptions of techniques are denials of the truthfulness of "seeing is believing" and a political stance that "one should not be silent."

Therefore, in the works of Hou, the beholder is constantly engaging in choices of aesthetic critique. The images are hung 165cm above the floor, which leads to the result that the vision falls on the lower part of the upper image, with the divide between the two images at the center of vision. This is especially true in the first exhibition space: By suspending the images slightly higher, not only do the works become image installations that resemble monuments, but the separation line parallel to the vision also becomes a dialectic between essence and phenomenon. Through the separation line, Hou's "cold images" invite audiences to enter the complexity of the people, incidents, and objects of military dependents' villages, reflecting the political, economic, and social relationship of the realpolitik within. What separates the dispersed images of Hou is not only the distinction between ethics and aesthetics but entering a world that has become complex due to factors including art/society/knowledge/cognition from the independence of aesthetic judgment.

Performative Objects: Field Investigation, Research, Lobbying, Social Activism

Hou has been traversing the border of typical photographic images and into "cold images" that require participation since her early works. The live performance of her earliest work *Body Bounding* breaks the fourth wall and asks for male body parts among the audience, overturning "phallogocentrism." In *Labors and Labels,* the youth of female laborers becomes synonymous with the "economic miracle" of Taiwan, the factory of the world, and viewers on the site are given clothing tags with "Made in Taiwan" written on them. An inflatable doll is passed around among the audience of *Japan-Eye-Love-You* during a residency in Japan, while Hou repeatedly writes "I am not responsible for this" on the blackboard, using performance as a way of criticizing Japan's porn industry and condemning the Japanese government's tempering of World War Two facts in schoolbooks. As the work developed from *Guess Who You Are*, *Song of Asian Brides in Taiwan*, to *Out of Place*, Hou emphasizes the narratives of marginalized subjects, with research, field, investigation, and social activism lying at the center of the works. One can say that Hou's image practices are applied above the realms of society, culture, and expanded political fields; in the words of J. L. Austin (1911-1960), it is a "performative act" placed above the meaning of photography. The "photographing as doing" in Hou's works is an extension of Austin's "saying as doing," and is precisely the reason to extend beyond the framework of typical photography and become social activism for the truthfulness of images.

The "place" in *Out of Place* obviously refers to the home, and the Chinese title references the poem verse "I gaze afar as the evening descends, where is my home?" which also echoes the sentiments of the military personnel that escaped to Taiwan with the Kuomintang in 1949, and how they are unable to either return to China nor become rooted in Taiwan in their old age, a double "homelessness." Between 1945 and 1950, approximately two million military personnel and civilians fled to Taiwan from China, and as the population skyrocketed, the government was faced with the task of finding places for these people. The government started building houses repurposed old Japanese military accommodations and allocated housing according to their military types, professions, and work characteristics. Many residents thought these were temporary homes, especially since they were separated from the Taiwanese during the "Period of national mobilization for suppression of the Communist rebellion." This double homelessness led to military dependents' villages, temporary housing arrangements for Kuomintang soldiers and their families who retreated to Taiwan from China or other regions, a unique scene seen in the cities and rural areas of Taiwan. Hou's *Out of Place* corresponds to the diminishing states' different spaces and the diminishing lives of people living parallel to the residents. Faced with the historic irreversibility of space, time, people, incidents, and objects, Hou harbors a pressing sense of "comradery" and calling, which prompted her to set out as a photographer and embark on the mission of documenting histories that cannot be remembered. Hou also went back and forth between military dependents' village service stations, the Ministry of National Defense, the city government, legislators, and military dependents' village residents as a lobbyist, dedicating her efforts to preservation so that military dependents' villages can find their place as a piece of the cultural puzzle of Taiwan's history. As an artist, Hou preserved memories of the future, documenting the unique culture of military dependents' villages as a footnote to the anchoring point of Taiwan's history since World War Two.

The Cold Politics of Home/ *Unheimlich*

Strung along the unique history of the nature of military dependents' villages, the nature of Taiwan, and "global order," the original scene would of course be the Kuomintang's global military deployment after they relocated to Taiwan in 1949 and the tension between powers. With the global political and military confrontation between the U.S. and Russia and between Capitalism and Communism, the non-war of the Cold War directs the energy of a hot war toward the opposing nations. In particular, the "anti-communism revival forts, on the front lines of Communism, confronted regions in East Asia that have fallen under the Communist control of communist states, a military situation that posed a great threat to the U.S. Both the U.S. and the Chinese Communist Party were involved in the Korean War, which broke out in 1950, and as a means to prevent conflict between the two sides of the Taiwan Strait amid the turmoil, the U.S. provided military protection toward Taiwan, and the island was grouped into the democratic camp, changing Taiwan's isolated state on the international stage. The tensions of the Cold War accumulated more force, especially in Taiwan, which was at the forefront of the tensions, and the logic of the Cold War impacted governing logic into a forceful governing over the "biopower" of the people, controlling aspects of biopolitics including survival and death, law and education, as well as living and relocation.

Boris Groys (1947-) states that in times of biopolitics, art should be produced as documentation The objects and human experiences as defined by "cold photography" denote the dialectical relationship between the memories, forgetfulness, and trauma of documents, images, and objects, an estranged

subjective experience amid "forgetting in memory." In other words, it is an uncanny state that was once a memory but was later forgotten. The technique of "cold photography" begins with perceiving quality and proceeds to the inner relationship of images, exploring the objective relationship of the exosomatic memory of images outside human subjectivity and presenting narratives that exist beyond typical images. Hou's image installation *Out of Place* transcends the separation of typical photography and enters the "activist network" of performative objects, which includes arrangements of information such as images, objects, and texts. The quality of time in its documents lies amid "it-has-been" and "this-will-be," as evidence, declaration, and witness to "future history." Cold images write histories that are to come, as a memo for the future. The marginality of the military dependents' villages in Kaohsiung during the Cold War allows a visuality of images that faces toward the openness of the future; the problematics hidden in the dark corners of history that it attempts to uncover are fragmented memories of the cold war/cold politics such as relocation, immigration, foreign places, and colonialism that occurred in the frameworks of venues/objects/families/groups/nature as a means to witnessing and as evidence to the potential of documentality. This is an artistic practice that contends with how governance and biopower wipes away memory and history. Hou's "cold images" constitute a memory project that has undergone a historical turn as the military dependents' villages in Kaohsiung face the fate of being demolished; it treats memory as an object and presents Taiwan as the hidden histories of the Cold War and the lives of individuals, despite the fact that military dependents' villages contain intertwined complexities. Nevertheless, *Out of Place* strikes close to the nature of military dependents' villages and develops an opportunity to recognize the past and future, discovering a piece of Taiwan, a piece of the unfinished puzzle of the world.

作品
WORKS

女性與影像再現

影像與裝置、生命信仰與行動、觀念攝影與行為藝術、我是誰／使命與對話
作品內容：1989《生命的倒影》、1992《迷宮之徑》、1998《猜猜你是誰》、2002《快樂是什麼》系列

文 / 王雅倫

綜觀臺灣在步入現代化後的藝術發展，實在一時之間無法找到像侯淑姿這樣的女性藝術家，創作至今約四十年來的作品，不僅如她自己所說的：「把世界當成取鏡與思索的對象，草木樹石皆有情有義」；與她相遇的對象，藝術家更是懷抱自覺與醒悟，她問：「生命是什麼？我／她是誰？」誠如女性主義學者舒拉米特‧賴因哈茲（Shulamit Reinharz）曾指出：女性主義是一種視角（perspective），不是一種方法，是根據其視角發展出創新的方法。是的，侯淑姿的視角總是與人不同，她長時間傾聽、記錄每一個受訪的對象，以一種行動藝術開始，完成以一種影像裝置的觀念藝術；她以藝術介入這個社會，掀開性別迷失，底層生活、社會公義、文化闕如等議題。

如同攝影評論者張蒼松所言，侯淑姿的女性主義思想與影像創作，已然不再只是為了關心女人自身權益而已。或如藝術家姚瑞中所云：「侯淑姿長期耕耘非主流議題已達史詩級厚度」。從1989年出版的攝影專輯《生命的倒影》，到赴美留學後的跨媒材作品《迷宮之徑》，返國後開始進入多元社會與人群的場域下，接觸政治領域，因追尋自我身分認同問題，創作了《猜猜你是誰》，也進一步使用文字與圖像並置的表現手法；隨即侯淑姿赴日本駐村後，回到臺灣正式進入公務體系，在告一段落後，恢復藝術家自由創作身分時，她創作了《快樂是什麼》，都在在顯示出影像在藝術家手中被重構的意義。

以攝影和文字書寫似乎已成侯淑姿的生命印記，這十四年間她除了走入公眾進行的參與式對話，也成為一名關注各種女性議題的影像先鋒者。

Women and Image Representation

Image and Installation, Life Belief and Action, Conceptual Photography and Performance Art, Who Am I/Mission and Dialogue

Includes works from *The Reflection in the Lake of Life* (1989), *The Labyrinthine Path* (1992), *Guess Who You Are* (1998), *What Is Happiness* (2002) series

Author / Wang Ya-lun

A glance at the art development of Taiwan after modernization will lead to the realization that it is hard to find female artists like Hou Lulu Shur-tzy. Throughout the forty-or-so years of her career, Hou not only embodies her own words of "treating the world as a reference and object of reflection, and that each tree and rock is filled with the sentiment," but the artist treats her encounters with a sense of awareness and clarity. Hou asks: "What is life? Who am I/who is she?" As feminist scholar Shulamit Reinharz once stated: Feminism is a perspective, not a method; it is an innovative approach generated from a feminist perspective (1992). Indeed, Hou's perspective has always been unique. The photographer spent ample time listening to and documenting each interviewee, completing image installation conceptual artworks that begin as a form of performance art. Hou uses art as an intervention toward society, unveiling issues such as gender disorientation, the lives of the underprivileged, social justice, and cultural absence.

Just as photography critic Chang Tsang-sang stated, Hou's feminist thoughts and images no longer merely serve the rights of women. Artist Yao Jui-chung also stated: "Hou's long dedication to non-mainstream issues has reached epic depth." From the publication of the photography album *The Reflection in the Lake of Life* in 1989, the intermedia work *The Labyrinthine Path* that the artist created after traveling to the U.S. for her studies. From the time she finished her studies and returned to Taiwan, she entered a diversified society and people, in which she began to explore the political environment. Hou started to gain a clearer perspective on identity, she created another piece of artwork, *Guess Who You Are,* which further inspired her to employ the expression method of pairing text with images. She then went to Japan as a residency artist. Upon returning to Taiwan, she began to work in the public service as an administrator. After *What Is Happiness,* which the photographer created after regaining her freedom as an artist, these works all manifest how the meaning of images is reconstructed in the hands of the artist.

Photography and writing have almost become the artist's documentation of life. Over the past 14 years, not only has Hou engaged in public discourses, she has also become an image pioneer concerned with a variety of feminist issues.

《生命的倒影》 / 1989
The Reflection in the Lake of Life / 1989

《迷宮之徑》/ 侯淑姿 / 1992
The Labyrinthine Path / Hou Lulu Shur-tzy / 1992

1990年的夏天,天使降臨我家

我親眼見到他們的墜落

我目睹他們的翅膀的垂萎

翅膀已不再能承載他們的重量

天使們對我痛苦地微笑

霎那間,我領悟了我的命運

我無法避免墜落一如我無法避免降生

無路可逃出迷宮

The angels came to my house in the summer of 1990.

I witnessed their falling.

I saw how their wings withered.

The wings were not able to bear their weight anymore.

They smiled at me painfully.

All of a sudden, I realized my fate –

I can not avoid falling as I can't avoid from being born.

There is no way out of the Labyrinth.

《迷宮之徑》01〈與天使的相遇〉/ 1992
The Encounter with Angel from *The Labyrinthine Path* series *01* / 1992

《迷宮之徑》02〈男人與女人〉/ 1992
The Beginning: Man and Woman from *The Labyrinthine Path* series *02* / 1992

《迷宮之徑》03〈命運〉/ 1992
Destiny from *The Labyrinthine Path* series *03* / 1992

《迷宮之徑》07〈逐出伊甸園〉/ 1992
The Expulsion from the Garden of Eden from *The Labyrinthine Path* series *07* / 1992

《迷宮之徑》09〈墜落〉/ 1992
Falling from *The Labyrinthine Path* series *09* / 1992

《迷宮之徑》15〈暗黑的襲擊〉/ 1992

The Attack of Darkness from *The Labyrinthine Path* series *15* / 1992

《迷宮之徑》19〈等候飛翔〉/ 1992

Waiting to Soar from *The Labyrinthine Path* series *19* / 1992

《猜猜你是誰》〈萬淑娟〉/ 1998
Wan Shu-jyuan from the *Guess Who You Are* series / 1998

《猜猜你是誰》〈陳正文〉/ 1998
Chen Jheng-wen from the *Guess Who You Are* series / 1998

《猜猜你是誰》/ 侯淑姿 / 1998
Guess Who You Are / Hou Lulu Shur-tzy / 1998

《猜猜你是誰》〈沈吳足〉/ 1998
Shen Wu-zu from the *Guess Who You Are* series / 1998

《猜猜你是誰》〈潘雪雲〉/ 1998
Pan Xue-yun from the *Guess Who You Are* series / 1998

我是誰 / 侯淑姿
Who Am I / Hou Lulu Shur-tzy

猶記得在美國求學、工作時，常被人問起打從哪兒來，我的回答從「我是中國人」，慢慢調整為「我是臺灣人」，但卻因為無法詳細如實回答自己祖先遷臺的過程，而遭譏諷「不知道自己是誰」，當時的羞愧感如今仍然鮮明；來到臺南，探訪的過程解答了部分對自己身分的困惑。

I remember when I was studying and working in the U.S., people often asked me where I was from. At first, I would say, "I am Chinese," but I gradually changed my reply to "I am Taiwanese." Because I could not give a clear account of how my ancestors relocated to Taiwan, people ridiculed me for not knowing who I was. I remember the shame deeply to this day. My visitations in Tainan answered some of my questions about myself.

《猜猜你是誰》〈陳春木〉/ 1998
Chen Chun-mu from the *Guess Who You Are* series / 1998

《猜猜你是誰》〈陳慧蓮〉/ 1998
Chen Huei-lian from the *Guess Who You Are* series / 1998

你是誰 / 侯淑姿
Who Are You / Hou Lulu Shur-tzy

我選擇性地訪問素未謀面的臺南人，包括不同的族群、宗教、年齡、教育背景、性別，透過訪問了解他們的身分認同。訪談中，他們的生命經驗讓我重新看待這塊土地。他們的點滴故事與臺南的歷史緊密相連、具體而微的道出族群與文化的消長，我藉由影像記錄個體的生存樣態或某個時刻的外貌再現，並摘錄部份訪談詮釋其身分認同。

I deliberately chose people from Tainan whom I did not know and who had different groups, religions, ages, genders, and received different education, and interviewed them about their identities. During the interview, the life stories that they shared allowed me to inspect this land again from a deeper perspective. The stories of these people are intimately connected with the history of Tainan and were epitomes of changes in ethnicity and culture. I documented the outer expressions of the lives or moments of the individuals, excerpting parts of the interviews as interpretations of their identities.

他者 / 離散的身體

亞洲女性與社會、影像與裝置、男性的凝視、女性勞動者、外配、視覺政治學

作品內容：1993《不只是為了女人》、1996《窺》、1997《青春編織曲》、2000《Japan-Eye-Love-You》、2005《越界與流動——亞洲新娘之歌 I》、2008《越界與認同——亞洲新娘之歌 II》、2009《望向彼方——亞洲新娘之歌 III》系列

文 / 王雅倫

侯淑姿的兩件重要作品《不只是為了女人》和《窺》，大部分延續了藝術家在國外所受到的藝術洗禮及行動藝術的方法，以自身及友人的身體表演與影像裝置，試圖點燃蘿拉·莫薇（Laura Mulvey）提出：「女性被客體化，並且順從於控制與好奇的凝視之下」，產生出「女人是影像，男人主導視線」的長期觀看的性別不平等，並鬆動臺灣社會的視覺政治學。《窺》與《Japan-Eye-Love-You》也在日本展出引發關注，作品的後續討論超過預期。

然而，1997年的《青春編織曲》卻是藝術家從自身、他者凝視，轉向社會關懷的起點。自此，底層女性的社會問題漸漸成為藝術家關心與創作的主軸。南下高雄的專任教職的田野調查課程更讓她看到城鄉的差異，弱勢女性之身體自主權問題。如何不依賴人道主義、觀看他人的傷痛的視角，侯淑姿以雙眸雙聲的形式，再次以嵌入的文字在展示時與觀眾形成對話。這些照片就像一個相遇之所，是攝影者、外籍新娘與觀者三方之交會。作者的目的為使觀者進入「敘事裡」，並且成為故事反思的一部分，希望藉此能引導觀者進入外配的獨白，試圖跳脫社會對外籍新娘定型標籤化的「他者」的觀點。作品《亞洲新娘之歌 I（2005）、II（2008）、III（2009）》以一種鏡像式的觀看，以一種自我反射，一種迴旋、一種凝視，圖繪了一個集體卻互異的亞洲女性生命歷程。

The Other / Discrete Bodies

Asian Women and Society, Image and Installation, the Male Gaze, Female Labor and Immigrant Spouses, Visual Politics

Includes works from the *Not Only for Women* (1993), *Take a Picture, It Lasts Longer* (1996), *Labors and Labels* (1997), *Japan-Eye-Love-You* (2000), *Border-crossing/Diaspora–Song of Asian Foreign Brides in Taiwan (I)* (2005), *Border-crossing/Cultural Identities–Song of Asian Brides (II)* (2008), *Look toward the Other Side–Song of Asian Foreign Brides in Taiwan (III)* (2009) series

Author / Wang Ya-lun

Hou's two important works *Not Only for Women* and *Take a Picture, It Lasts Longer* largely continue the artist's overseas art training, the methods implied by performance art, the bodily performances of herself and her friends, and image installations. Hou attempts to ignite Laura Mulvey's concept of "the objectified female body and obedience amid the controlling and curious gaze," which leads to the longtime gender inequality in viewing where "women are images while men dominate the perspective"; the work also shook the visual politics of Taiwanese society. *Take a Picture, It Lasts Longer* and *Japan-Eye-Love-You* also attracted the attention of some Japanese curators, leading to a variety of discussions on the works.

However, the artist's 1997 work *Labors and Labels* was inspired by Hou's own experience and the gaze of "the Other." The work also marks the turning point when the artist directed her concern toward social issues. Ever since, social issues regarding underprivileged women have become a central theme in the artist's oeuvre. A teaching trip to Southern Taiwan also exposed her to the differences between urban and rural areas, as well as the issue of the body autonomy of underprivileged women. Hou endeavors to adopt a perspective that does not rely on humanism nor merely regards the pain of others; instead, the photographer uses her eyes and voices double gaze and double voice to engage in dialogues with her audiences, once again through displays that are embedded with text, allowing viewers to enter the narrative and become part of the reflection of the story. These photographs are like places for encounters between the photographer, immigrant brides, and the viewer. The artist's goal is to lead viewers into the narrative and become part of the reflection of the story, in the hopes of guiding viewers into the monologue narration of the immigrant spouse, attempting to break free from the labels of "the other" that we have given foreign brides. Work *Song of Asian Foreign Brides in Taiwan I (2005), II (2008), III (2009)* offers a mirror-like perspective, a reflection of the self, a turn and gaze that showcases the collective but different life journeys of Asian women.

《不只是為了女人》/ 侯淑姿 / 1993
Not Only for Women / Hou Lulu Shur-tzy / 1993

1992年10月,即我在美國讀書的第四年,決意將形似乳房的鋁質物釘上十字架;此舉動意謂著個人深深以為女性在男權宰制的社會,多方受壓抑與被犧牲。之後,我陸續邀約十六位男女就我的觀點,對該物體做回應,他們完全不受任何限制,可對該物體做各種反應,我在訪問過程,除了拍照,也同時記錄探訪他們對女性主義、婦權運動的想法。他們的回應代表個人的觀點與經驗,所有受訪者與我之間便展開多層次的男女對話。該階段的計劃完成於1993年4月,過程中個人深受震撼,身處異質文化,體驗婦權運動的種種效應與影響,對此訪談所引發的反響,及其中問題的複雜難解,至今仍持續發問與尋求解答。

有關十字架本身的多重矛盾複雜意義,引來許多爭議,但在此訪談計畫中,可說是引發對話的觸媒劑,並隱示女性在天主教、基督教改革過程中被有意壓抑的地位。

In October 1992, the fourth year of my studies in the U.S., I decided to nail a pair of aluminum breasts onto a cross as a way of expressing my deep belief in how women are suppressed and sacrificed in patriarchies. I later invited 16 people, men and women included, to respond freely to the work and my concept. Apart from taking photographs, I also documented their thoughts on feminism and feminist movements throughout my interviews. They responded with their personal opinions and experiences, and I engaged in dialogues with these interviewed men and women. The project ended in April 1993, and I was shocked by the impact of feminist movements in a heterogeneous culture. The feedback from the interviews and the complex dilemmas that arose are topics that I am still dealing with today.

The contradictions and complexities of the cross bring controversies, but it acted as a catalyst for conversation in this interview project and alluded to the idea that women are suppressed in Catholicism and the Christian Reformation.

《不只是為了女人》〈丹妮斯 ‧ 普勒特〉/ 1993

Denise Pelletur from the *Not Only for Women* series / 1993

《不只是為了女人》〈布魯斯 · 薩佩奇〉/ 1993
Bruce Sapach from the *Not Only for Women* series / 1993

《不只是為了女人》〈依蒂 · 許若特〉/ 1993
Edie Schrot from the *Not Only for Women* series / 1993

《不只是為了女人》〈德南・楊絲〉/ 1993
Danan Youngs from the *Not Only for Women* series / 1993

《不只是為了女人》〈托比・若斯〉/ 1993
Toby Ross from the *Not Only for Women* series / 1993

《窺》/ 侯淑姿 / 1996

楔子
在美國某處,一位靚女翩然走過大街,街邊某男子目不轉睛地隨著她的移動而左右顧盼。一老嫗在旁見狀,戲言調侃道:「拍張照片吧!照片更可歷久彌新!」(Take a picture, it lasts longer!)。此話的目的在令觀看者感到尷尬,並喝止其視覺冒犯的舉止。

男性觀看與描述女性的方式、角度,自古以來反映著視覺政治學中權力結構的兩極化。在探討女性／自我影像的內在化過程中,我以自己的身體為創作主體,延用男性建立的視覺模式,導引觀者的視覺好奇心,提供觀者未預期的視覺報償,抒發個人的女性主義觀感。《窺》的八組自拍、自導、自演攝影作品意在模糊禮教與社會批判對藝術、女性的設限,並對臺灣當前大眾媒體充斥氾濫女體影像提出批判。

Take a Picture, It Lasts Longer / Hou Lulu Shur-tzy / 1996

Prologue

In the U.S., when women feel someone is looking at them profanely, they will say to the person: "Take a picture, it lasts longer." It is meant to embarrass the viewer, also to snap the activity of visual violation.

The ways in which men look at and depict woman reflect the polarization of the power structure of visual politics since ancient times. In the internalization of exploring the female/self imagery, I have used my own body as a subject, inviting visual curiosity with male-established patterns, in order to deliver unexpected and unwanted visual rewards, expressive of my own feminist thinking. The eight series of "Peek a boo" photographs intend to blur the boundaries of propriety and social strictures imposed on art and on woman as a whole.

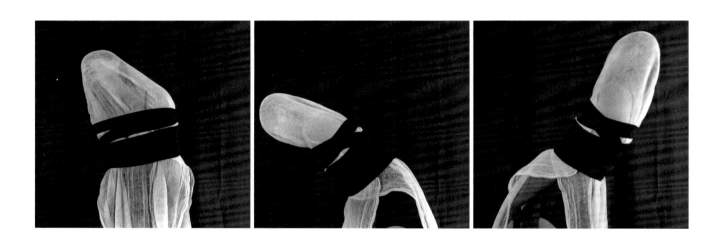

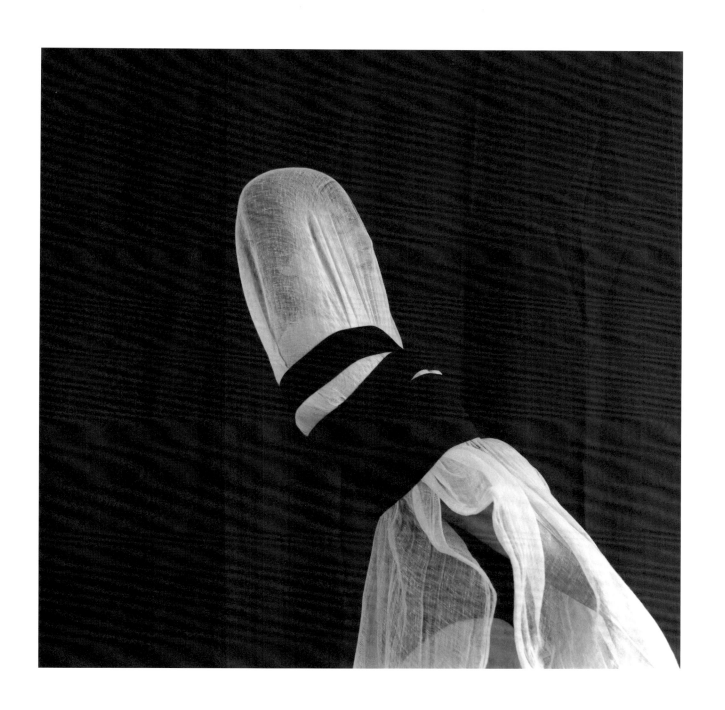

《窺》〈Body Bounding 01-04〉/ 1996
Body Bounding from the *Take a Picture, It Lasts Longer* series *01-04* / 1996

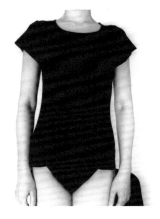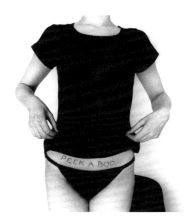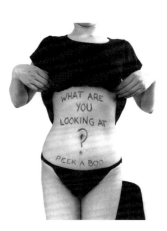

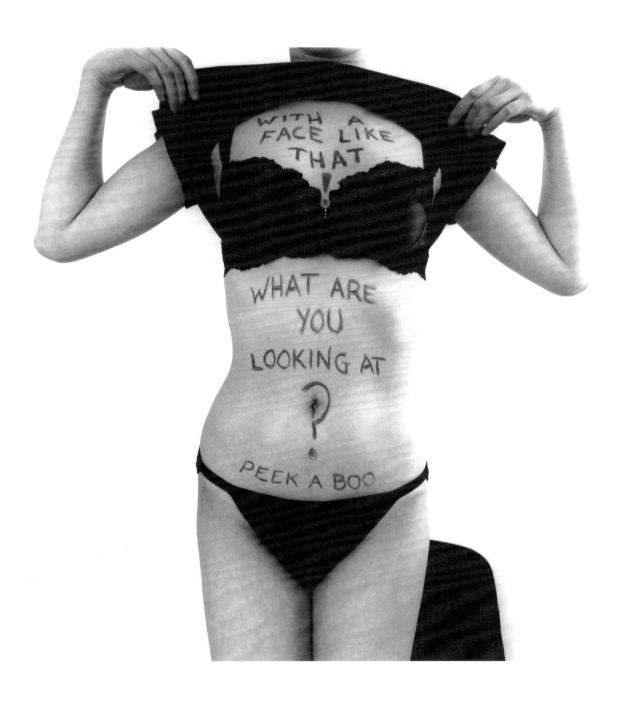

《窺》〈Body Writing 01-04〉/ 1996
Body Writing from the *Take a Picture, It Lasts Longer* series *01-04* / 1996

《青春編織曲》/ 侯淑姿 / 1997

在一段時間的美國流浪之後，對臺灣的陌生與不了解，竟逐漸成為一種愧疚。而來自藝術理論與實踐創作之間的辯證抗爭關係，卻在回到臺灣，走進新莊的剎那，更明顯地緊張昇高起來。與新莊及「盆邊」地區女性勞動力接觸的過程中，臺灣經濟奇蹟背後的女性群像乍隱乍現，我所試圖突顯呈現的是人力與機械的對抗、合作，與基層勞工女性的聲音。她們經年累月地在工廠加班或做家庭代工，汗水與淚水化為繽紛的成品的一部分，過去曾經為國家贏得大量外匯的基層工作者，卻在全球性的紡織工業連鎖環的快速變動下，面臨轉業或失業的困境。在與這些女性接觸的過程中，我去揣摩一種不同的生命存在價值，也在產生共鳴互動之際，辨別自己的存在。也許藝術家在這裡發出的聲音可以印證自己是一個女性藝術工人（female art worker）吧。作品將以兩部分呈現，第一部分影像探討女性勞工的手工操作與機械的關係，以影像裝置稱頌、榮耀臺北「盆邊」女性紡織勞工。第二部分則是由藝術家以自己製作的標籤，與現場觀眾交換他們身上穿的衣服的標籤，並藉交換過程反思外國品牌、本地製造與名牌崇拜的現象。

Labors and Labels / Hou Lulu Shur-tzy / 1997

After living in the U.S. for six years, I came back to Taiwan in 1996. I soon had the opportunity to combine the training and exposure I obtained during my time overseas and the unique circumstances facing Taiwan in many levels of society, especially when I undertook the project "Labors and Labels." The dialectic relationship between art theory and practice became more intense as soon as I encountered the factories in Hsin-Chuang. Through the process of getting in touch with the female textile workers, I could see the image of female workers laid behind the miracle of Taiwan's economy. I attempted to present the conflict and collaboration between human power and machines, including the voice of lower-level female workers. They have worked day and night in the factories; their sweat and tears have become part of the gorgeous textile products. After having won a tremendous amount of income for the country, they were forced to face the fate of joblessness or switching jobs due to the fast changes facing the textile industry globally. During the process of dealing with the female workers, I attempted to imagine a different kind of existence value. When the resonance occurred between me and them, I also tried to identify my own existence. Perhaps the voice of the artist could prove myself as a female worker. The series of work is presented in two parts, one is to show gratitude to the female textile workers living on the rim of the Taipei basin. In the second part, I exchanged the labels made out the images of female workers with the audience to reflect the phenomenon of admiration of famous foreign brand clothing.

《青春編織曲（一）》/ 1997
Labors and Labels (I) / 1997

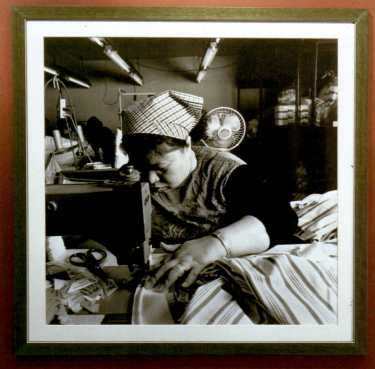

《青春編織曲（三）》 / 1997

Labors and Labels (III) / 1997

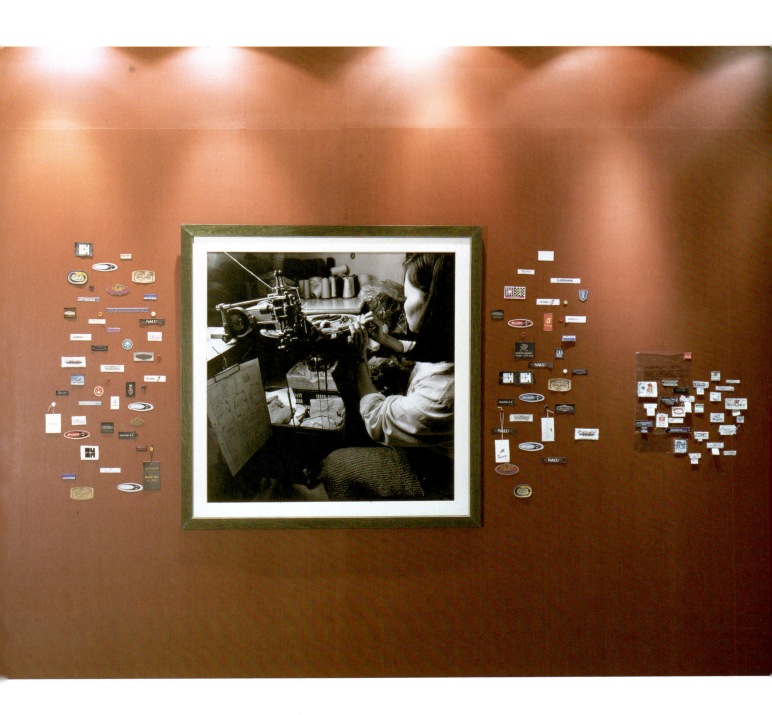

《青春編織曲(四)》/ 1997

Labors and Labels (IV) / 1997

《Japan-Eye-Love-You》 / 侯淑姿 / 2000

本作品係2000年於日本橫濱美術館畫廊個展作品中的一部分，該系列作品包括攝影、錄像、表演三部分，創作源於1998年在東京的Za Moca基金會四個月的駐地創作經驗；做為一個非日本女人在東京，親身目睹日本情色文化的泛濫與變態，是一次極端驚悚的體驗；傳統日本女人的溫文有教養的形象在大量的影像複製品的傳播下受到嚴峻的考驗，純潔無邪、可愛美麗的女性成為男性沙文主義宰制的對象，而其中護士、高中生又為特殊類型化的代表。

Japan-Eye-Love-You / Hou Lulu Shur-tzy / 2000

The series of work were first shown in the exhibition at the gallery of Yokohama Museum of Art in Japan. The media applied included photography, video and performance. These series were inspired and created during the residency at Za Moca Foundation, Tokyo. As a non-Japanese, Asian woman, the depictions of women in Japanese art and commercial imagery had a profound influence on my life and the life of millions of other Asian women. In magazines, newspaper, posters, through videos, television and computers, uncountable depictions of school girls, nurses, stewardesses, office girls, and brides are offered as icons of Japanese womanhood-models to be admired and imitated. The Japanese mastery of imagery technology and the traditions of its graphic concerns provide a mirror of the national character. Recently, while resident in Japan I saw a reflection in that mirror that was horrifying. Something was looking at me through these images of typical innocent, cute, beautiful women.

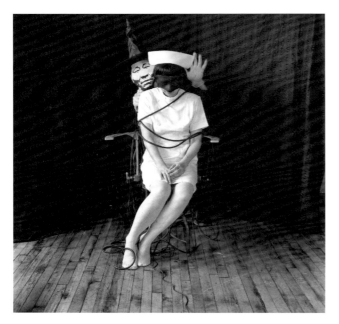 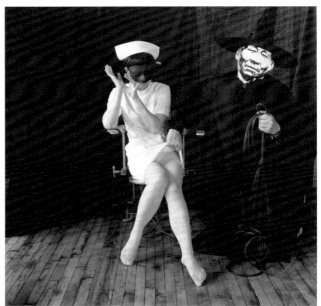

《Japan-Eye-Love-You》〈鈴木先生的醫療介入 01-04〉/ 2000

Mr. Suzuki's Medical Intervention from the *Japan-Eye-Love-You* series *01-04* / 2000

越界 / 流移 / 認同 ──《亞洲新娘之歌》創作論述
侯淑姿 / 2005-2009

楔子

2004年我因工作南下高雄，走進美濃、屏東、高樹、長治等地鄉間時，觸目可及的「越南新娘」的斗大招牌、無處不在的越南小吃店，農田裡常見戴著斗笠幫忙農事、操著濃濃的外國口音的外籍女子，「外籍新娘」的存在便成為隱藏心中亟欲探究的課題。然而如同打開了潘多拉的盒子，這個課題探問著人存在的終極價值，使我有不可承受之輕的喟嘆。她們無奈哀怨的眼神深深地鐫刻在我的腦海中，當我追問愈多，那喟嘆聲彷彿愈漫長不止。

越界與流移 ── 探索臺越婚姻關係的圖像

《越界與流移 ── 亞洲新娘之歌 I》的作品在2005年8月至10月間經由屏東外籍配偶中心及美濃南洋姐妹會的協助，訪問了十位來自越南、柬埔寨、泰國、印尼的亞洲新娘，影像與訪談試圖呈現她們移民臺灣、嫁為臺灣婦的心聲。這些飄洋過海，離鄉背景遠嫁臺灣的亞洲新娘與號稱「新臺灣之子」的外籍新娘的子女究竟面對的是什麼樣的處境？相對於她們來臺灣前所抱持的無限憧憬，往往心酸、無奈、焦慮代替了對美好生活的期待，她們甚至發出對次等待遇的抗議與悲鳴。作品中特意以訪談的文字如實呈現她們的經歷，聽她們娓娓道來。並置的照片所呈現的是她們真實世界的存在與內心的告白。

《越界與認同 ── 亞洲新娘之歌 II》延續2005年的主題，探訪當初受訪的十位外籍配偶的現況，以影像裝置的手法探討臺灣社會對她們的存在的觀感與看法。個人在與她們的對話間，認知到飄洋過海遠嫁臺灣的這件事對她們的生命所帶來的改變與衝擊，在跨越地理的邊界的同時，她們也在不同文化的交疊處流移。大量東南亞外籍配偶的移入，形成了臺灣新一代的多種族色彩，然而外籍配偶的母國文化卻在父權體制與臺灣文化優越論的基調下，隱晦而蒼白；2008年的創作繼續先前的對話，探討這些外籍配偶及其子女隨著時間的推移，對臺灣文化的認同及與母國的連結狀態。外籍配偶由東南亞嫁至臺灣，經歷了一個身分重構的過程，異國的婚姻、不對等的經濟關係往往造成與母國及家鄉的隔離與斷裂，然而，她們卻奮力積極融入臺灣，譜出了一首首動人的生命之歌。

Border-crossing / Diaspora / Cultural Identities–*Song of Asian Foreign Brides in Taiwan*
Hou Lulu Shur-tzy / 2005-2009

Prologue

Since 2004 as I undertook a series of on-site research projects around the countryside of Meinong, Pingtung, Gaoshu and Changjhih for my teaching position at National University of Kaohsiung, I noticed the ubiquitous signboards of "Vietnamese Bride," Vietnamese food stalls and foreign women who wore leaf hats working in farms and speaking with strong accents. "Asian Foreign Bride" became the subject I began to explore. A process like opening a Pandora's Box ensued. It is about the value of human beings' existence, which made me feel "the unbearable unworthiness of being." Their sad and helpless eyes are engraved on my mind. The deeper I pursue it, the more melancholic their expressions seem to be.

Border-crossing/Diaspora–Images of the Taiwanese-Vietnamese Marital Relationship

Border-crossing/Diaspora–Song of Asian Foreign Brides in Taiwan (I) (2005) is a series of work completed with the help of the Pingtung Foreign Spouses Center and the Trans-Asia Sisters Association in Meinong. Ten Asian foreign brides from Vietnam, Cambodia, Thailand and Indonesia were interviewed and photographed.

Border-crossing/Cultural Identities–Song of Asian Brides (II) (2008) is a sequel to *Border-crossing/Diaspora–Song of Asian Brides (I)*. It demonstrates the life and situation of foreign brides in Pingtung and Meinong through images and confessions. From the dialogues with them, I realized the change and impact of marrying a Taiwanese man had on them. While crossing the geographical boundary, they migrated between different cultures. The huge wave of immigration of foreign brides from South-east Asia forms a new multi-racial culture in Taiwan. However, the culture of Asian foreign brides is suppressed under the control of paternity and dominance of Taiwanese culture. They have gone through the process of reflection of their identity when they came from South-east Asia to marry Taiwanese men. Foreign marriage and imbalanced economic relationships cause isolation from their home countries. However, their struggle to fit into Taiwanese society creates a touching song of life.

外籍新娘與「他者」的標籤

對「外籍新娘」這個議題的探討,源於身為女性主義者對弱勢女性的存在的關切,為還原受訪者的主體發聲的位置,文字呈現的是第一人稱的敘述,希望藉此能引導觀者進入她們的獨白,試圖跳脫社會對外籍新娘定型標籤化的「他者」的觀點,也提出在個人反省與外籍配偶對話所引發的思考。身為一個創作者,每一次的創作都是對自身處境的反省,在訪談中我對自己了解東南亞歷史文化的不足感到愧疚,也對部分受訪者的臺灣經驗的直言批評與指控感到抱歉,更對部分南洋姊妹在臺灣的悲慘遭遇一掬同情之淚,此系列作品仍有未盡周延之處,但有感於社會大眾普遍以標籤化的方式相待,她們的聲音隱微不明而處於社會底層的無助與弱勢,她們的存在與生命的價值尊嚴仍有待重視。

原鄉的探訪

緣於亞洲文化協會的獎助,我得以在2008年的夏天探視了過去三年所曾訪問的外配姊妹們的原生家庭,造訪了分布於越南的胡志明市及南部的茶榮省、薄寮省、永隆省,西部的西寧省的七個外配姊妹的父母與家人。延續2005年的《越界與流移——亞洲新娘之歌 I》、2008年的《越界與認同——亞洲新娘之歌 II》,這次的東南亞之行成為構築2009年《望向彼方——亞洲新娘之歌 III》的作品的主軸。

在尚未造訪越南之前,心中充滿種種疑問:越南果真是窮山惡水不養人嗎?而臺灣對這些外籍配偶而言,可真是新天新地的好所在嗎?相對於臺灣大量的對外籍新娘的負面報導,越南媒體又是如何看待「臺灣新郎」呢?由1995年至2008年的十三個年頭,臺越婚姻關係又經歷怎麼樣的變化呢?2005年6月20日《商業週刊》在第917期內容宣稱,有三千名「湄公河畔的臺灣囝仔」流落異鄉,引起社會大眾的關切,2005年5月臺灣伊甸基金會積極在越南成立了華語幼兒園,而今那些臺越兒的下落又是如何呢?在2008年8月的短短三週的越南行期間,除了造訪外配姐妹的父母外,亦透過與學術機構、駐外單位、教會組織的聯繫,一一拼湊臺越婚姻關係的圖像。而親身的造訪,對此一議題的探究,包括臺越婚姻中文化、階級的差異與困境,有了更深層的理解。2009年的《望向遠方——亞洲新娘之歌 III》的作品是延續前兩階段(2005、2008年)的作品,透過影像裝置與錄像裝置的方式呈現此一面向複雜的議題。

Asian Foreign Brides / Labels of "the Other"

As a feminist, I explore the subject to show my care to women of minority. In order to restore interviewees' words, I adopted "first person" depiction. By doing so, I want to guide the audience into their world and eliminate the stereotype of treating the foreign brides as "the Other" from society. I also incorporated my personal reflection and thoughts derived from my dialogues with these foreign brides. As an artist, each piece of work is a reflection of my own situation. During the interview process, I was ashamed of my lack of understanding of Southeast Asian culture. I felt sorry when I heard the direct criticism and accusations some of the interviewees levied on Taiwan. I am also very sympathetic of the experiences that some Asian foreign brides had in Taiwan. I was very much aware that certain areas are yet to be covered, such as that Taiwanese society still tends to label immigrants with certain stereotypes; recent immigrants often move about in less privileged social circles, hence their voices are often ignored; hence the lack of due respect the due respect for their identity and dignity.

Visit to the Motherland of Asian Foreign Brides

With the sponsorship of the Asia Cultural Council, I was able to visit seven families in Ho Chih Ming City, Vinh Long, Bac Lieu and Tay Ninh Province. This trip to Vietnam in 2008 became a major part of the new work *Look toward the Other Side–Song of Asian Foreign Brides in Taiwan (III)*.

Before I visited Vietnam, I had lots of questions in my mind. Is Vietnam really a place unsuitable for people to live? Is Taiwan the promised land for these foreign spouses? Compared with the many negative reports on foreign brides in Taiwan, how do the Vietnamese media feel about Taiwanese grooms? What changes did Taiwanese-Vietnamese marital relationships go through from 1995 to 2008? On June 20, 2005, an article in the 917th edition of Business Weekly stated that there were three thousand "Taiwan children of the Mekong River" (Children born in Taiwan to a family with a foreign spouse, but who were sent back to their native countries due to various reasons), and this article brought society's attention to the plight of these children. In May 2005, the Eden Social Welfare Foundation of Taiwan established a Mandarin kindergarten in Vietnam. One might ask, what is the situation of these children right now? During my three-week visit to Vietnam in August 2008, I visited the parents of these Asian foreign brides, and I pieced together the images of Taiwanese-Vietnamese marital relationships through contacting and talking with academic institutes, foreign offices and church groups. I attempted to present the culture differences, dilemmas and hopes that lie within Taiwanese-Vietnamese marital relationship.

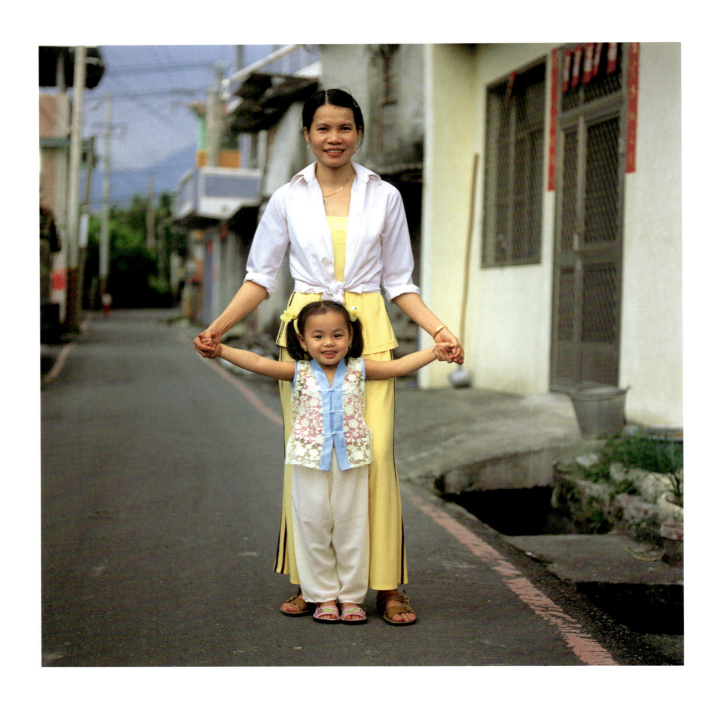

《望向彼方──亞洲新娘之歌 III》〈黃氏戀與女兒 (A)〉/ 越南 / 2009
Huang-shih Nien and Her Daughter (A) from the
Look toward the Other Side–Song of Asian Foreign Brides in Taiwan (III) series / Vietnam / 2009

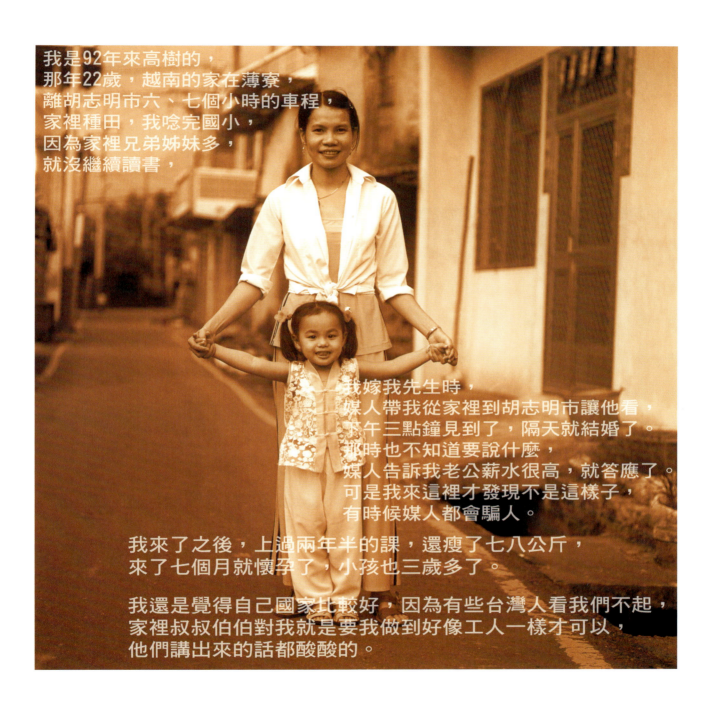

《望向彼方——亞洲新娘之歌 III》〈黃氏戀與女兒 (B)〉／越南／2009
Huang-shih Nien and Her Daughter (B) from the
Look toward the Other Side–Song of Asian Foreign Brides in Taiwan (III) series / Vietnam / 2009

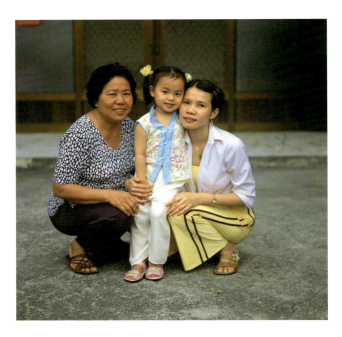

五年中間我回去過兩次，我先生說我在這裡不管去哪哩，
他都希望能陪著我一起，我一個人出去他會不放心，
我想去哪裡他都會帶我去。

有時候我先生對我太好還會被家人罵，
說他太愛老婆了。
以前剛來的時候每天都哭，都好想家，
不過小孩出生以後就很忙了，現在有時候想起來也是會哭。
有時候人家問我先生娶一個老婆多少錢，
他會說沒有什麼多少錢的，
娶老婆只要相愛就好了，不要去說什麼錢的事情。
我只希望小孩子好好長大、有工作、還有可以自己存錢，
過年時可以給爸爸媽媽一點錢啊；
可是我先生怕我工作累，怕我受不了。

《望向彼方──亞洲新娘之歌 III》〈黃氏戀與女兒、鄰居 (A)、(B)〉/ 越南 / 2009
Huang-shih Nien and Her Daughter and Neighbor (A)、(B) from the
Look toward the Other Side–Song of Asian Foreign Brides in Taiwan (III) series / Vietnam / 2009

92

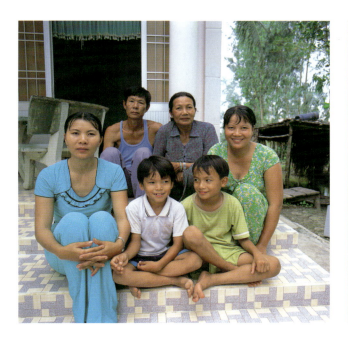

《望向彼方──亞洲新娘之歌 III》〈黃氏戀越南家人 (A)、(B)〉/ 越南 / 2009
Huang-shih Nien's Family in Vietnam (A)、(B) from the
Look toward the Other Side–Song of Asian Foreign Brides in Taiwan (III) series / Vietnam / 2009

阿戀去台灣的時候是自己去的,先生在台灣的機場接她,
她結婚後七個月就懷孕了,第十個月就回來看我們,
女婿沒有跟著回來。有時候我女兒打電話回來,
也會要女婿跟我們講話,雖然語言不通,
可是只要聽到他們的聲音,也感到很高興、很親切。

雖然女兒在越南結婚或是嫁到台灣可能是差不多,
但是嫁到台灣的話,經濟上會好一些,
嫁到台灣的兩個女兒特地寄了九千元美金給我們蓋了這棟房子,
是我們另一個越南女婿設計的,
大部份嫁到台灣的人家裡可都蓋了新房子。

我們對兩個台灣女婿都很滿意。

《望向彼方──亞洲新娘之歌 III》〈黃氏戀越南的家 (A)、(B)〉/ 越南 / 2009
Huang-shih Nien's Home in Vietnam (A)、(B) from the
Look toward the Other Side–Song of Asian Foreign Brides in Taiwan (III) series / Vietnam / 2009

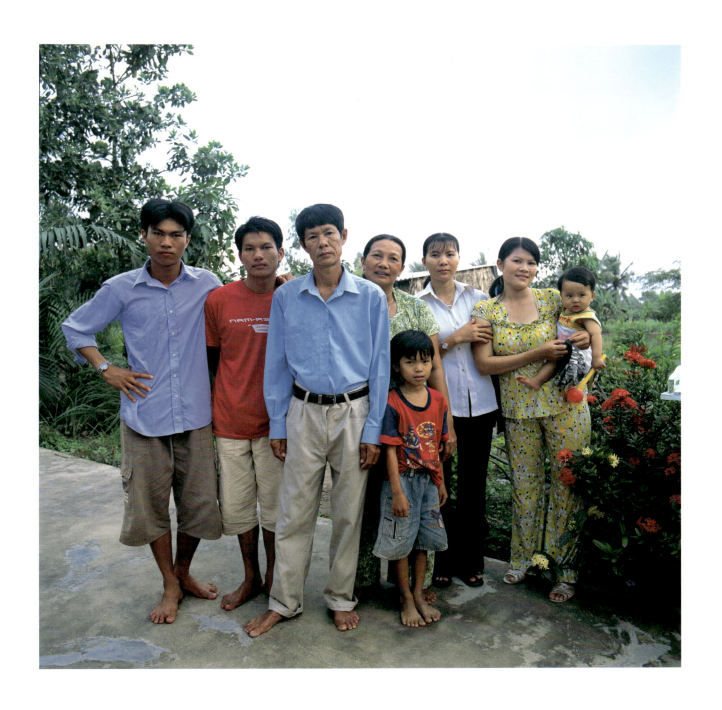

《望向彼方——亞洲新娘之歌 III》〈黃氏戀越南家人〉/ 越南 / 2009
Huang-shih Nien's Family in Vietnam from the
Look toward the Other Side–Song of Asian Foreign Brides in Taiwan (III) series / Vietnam / 2009

《望向彼方──亞洲新娘之歌 III》〈黃氏戀越南的家〉/ 越南 / 2009
Huang-shih Nien's Home in Vietnam from the
Look toward the Other Side–Song of Asian Foreign Brides in Taiwan (III) series / Vietnam / 2009

「攝影能夠幫助人們想像地擁有一個並不真實的過去，它也幫助人們占有他們無法倚靠的空間。」

"Photographs give people an imaginary possession of a past that is unreal; they also help people take possession of spaces in which they are insecure."

<div style="text-align: right;">

蘇珊・桑塔格，《論攝影》
Susan Sontag, *On Photography*

</div>

「越配都來了，來了好多⋯⋯」侯淑姿說著。她們正往美術館會場中，迎向那擬似越南的家／她的家，那是一棟沒有掛湄公河照片的牛奶與蜜調和而成的房子，踏在明晰乾淨的地板，反射著魚貫的人群；這裡沒有水澤，已經跨過海洋。

"The Vietnamese spouses are here, so many of them…" said Hou Lulu Shur-tzy. They proceeded to the art museum, toward the installations that simulated their home in Vietnam/her home. It was a house that did not have photographs of the Mekong River, a house of milk and honey. They stepped on the clean floor, which reflected the crowd. There are no swamps here, and they have crossed the ocean.

<div style="text-align: right;">

《望向彼方──亞洲新娘之歌 III》2010.7高雄美術館開幕前
Look toward the Other Side–Song of Asian Foreign Brides in Taiwan (III)
before the exhibition opening at the Kaohsiung Museum of Fine Arts, 2010.7

</div>

高雄眷村三部曲

影像與再現、影像與裝置、眷村保存的文化行動、攝影作為一種救贖與公義
作品內容：高雄眷村三部曲（2010-2017）：《我們在此相遇》、《長日將盡》、《鄉關何處》

文 / 王雅倫

因在南部持續的田野調查與教學，上帝的感動與帶領，一直倡議文化保存的侯淑姿當然不會錯過眷村保存與拆還的問題。尤其她所使用的媒材「攝影」更是關於記憶、時間與空間這樣的再現問題。藝術家同樣使用圖像跟文字，迫使你停留在作品前更長的時間，拉近並賦予了觀眾更多的思考。當地點轉換成一個場所、一個空間時，它就不只是一個地點、名字，而攝影正是把一個平凡的地點轉換成一個場所、空間很好的媒材。侯淑姿將他人的生命史與自己在那個地方的移動連結起來成為一個有情感的紀錄，她關心女性在此移動遷徙中的生命史，以及面對迫遷的堅強；這樣的舉動跟我們看到的許多行動藝術家與人類學式的調查是非常類似的，但攝影家的工具卻更是永遠的救贖。藝術家將她的作品用序列式展現，現場展示並有存在過當地的一草一木，如她拍攝周邊的樹、房子家具等這些很細膩的東西，我們看到的是一個家族或者是有關聯的文化記憶，更凸顯出主題背後的主人翁處在「不得其所」（Out of Place）的狀況；當不得其所時，就比較容易被污名化。

班雅明（W. Benjamin）說過：「攝影師應力求給自己的照片一個說明。」他提到，這個說明能夠使照片從流行的耗損中搶救出來，並賦予它一種革命性的使用價值，所以他覺得文字跟影像是非常重要的，它不會使照片一直地往審美的路線走。侯淑姿展現的不僅是一個攝影中的地點或蹤跡而已，她也將自己內心的感受及獨白同時呈現在影像上，有別於之前只有一方的內在言語。觀者在觀看時會有兩種不同的感受，這種不同感受可以連結到：為什麼這個地方要被拆除？為何有這樣不合時宜的法令？離散到底要到何時結束？

侯淑姿的《高雄眷村三部曲》（2010-2017）：《我們在此相遇》、《長日將盡》、《鄉關何處》，為期近十年的紀錄、訪談與奔波、協調。時光的無情流逝也許能在照片中短暫閃爍，但一個國族的記憶消失過程將在侯淑姿的參與式影像公義中永存。

A Trilogy on Kaohsiung Military Dependents' Villages

Image and Representation, Image and Installation, Cultural Actions to Preserve Military Dependents' Villages, Photography as Redemption and Justice

Includes works from the *A Trilogy on Kaohsiung Military Dependents' Villages (2010-2017): Here Is Where We Meet, Remains of the Day, Out of Place*

Author / Wang Ya-lun

Due to extended field investigation and teaching in the south as well as the calling and guidance of God, Hou, who has always been an advocate for cultural preservation, would never be absent from issues regarding the preservation and demolition of military dependents' villages. In particular, the photographer's medium of photography is about the representation of memory, time, and space. The artist also uses images and texts that force viewers to stay longer in front of artworks, pulling them closer to the works and encouraging deeper reflection. When the scene changes into another site or space, it is no longer merely a location or a name; instead, the photographer changes an ordinary place into a medium with an excellent venue and space. Hou connects the life stories of others with her own movements in the location, transforming the space into documentation rich with sentiments. Hou is concerned with the life histories of the women amid their movements and migrations, as well as their resilience when forced to relocate. This act is remarkably similar to many performance artists and anthropological investigations, but in truth, the tool of a photographer is a more eternal redemption. The artist displays her works in sequence, while the grass and trees on site correspond to the trees, houses, furniture, and other portrayed details in her works; what is shown before us is the family or related cultural memories. This also accentuates the subject's state of being "out of place"; when a person is out of place, they are easily stigmatized.

Walter Benjamin once stated: "What we should demand from photography is the capacity of giving a print a caption," that this caption "would tear it away from fashionable clichés and give it a revolutionary use value." Therefore, Benjamin believed text and images to be very important, and that texts prevent photographs from continuing down the aesthetic route. What Hou presents is not just a location or trait; this time, Hou presents her feelings and monologue simultaneously with the image, which is different from previous single-sided, inner expressions. Viewers will experience two feelings when viewing the works, feelings that connect with: why is this place being demolished? Why are there such inappropriate laws? When will this dispersion end?

A Trilogy on Kaohsiung Military Dependents' Villages (2010-2017): Here Is Where We Meet, Remains of the Day, and Out of Place include documentation, interviews, travels, and coordination that span almost a decade. The ruthless elapse of time may leave brief shimmers in photographs, but the diminishing of a nation's memory becomes eternal in Hou's participatory image justice.

高雄眷村三部曲之首部曲：《我們在此相遇》
復興新村系列 / 侯淑姿 / 2013

《我們在此相遇》是以個人與末代眷村人及地景的相遇為題，呈現高雄左營區的四個眷村（勵志新村、崇實新村、自助新村與復興新村）在眷村改建條例實施後，末代眷村人的生命圖像及文化地景前後變遷的影像見證。

左營總計曾有二十三個眷村，是為全國最大的海軍眷村區，當年隨著國民政府遷臺的海軍軍眷在此建立了家園。1996年公布的眷村改建條例卻徹底地改變了全臺灣八百九十七個眷村的命運，筆者於2009年2月踏入左營眷村，以此做為與眷戶相遇之地，亦與即將消亡的眷村地景產生連結，透過訪談、影像與文字記錄，與當地居民產生對話，結合個人以行動搶救眷村的田野手記來回應批判眷改政策的不義。

收錄於此書的是第二系列為復興新村系列。該眷村為戰後國民政府克難興建，住戶為士兵與士官長的家眷，拍攝與訪問的對象為殷陳城蘭奶奶，她的生命經驗述說著如何在復興新村落地生根、養兒育女，透過她的話語，觀眾得以了解眷村何以成為逃離家鄉、飽嚐顛沛流離之苦的軍眷得以安居的流奶與蜜之地。復興眷村第二位現身說法的是來自江西的萬海根，我稱之為「國旗爺爺」，仍帶著濃重鄉音的他曾任陸戰隊的士官長。他的院子牆壁上插滿了國旗，也顯示老榮民對國家之愛，他的自述表明了不再對回鄉落葉歸根抱持希望，但對住了五十餘年的眷村家園卻有著難以割捨之情與對這塊生養子孫的土地的認同。

2013年3月復興新村首先被大規模的拆除，接著是自助新村，崇實新村也在2013年8月正式從左營地圖上消失。此系列作品譜寫了荒謬的眷改政策下消失眷村的悼念輓歌，最終是為失落的眷村繫上了一縷紀念的黃絲帶。

A Trilogy on Military Dependents' Villages in Kaohsiung / Episode I: Here Is Where We Meet

Fuxing New Village series / Hou Lulu shur-tzy / 2013

Here Is Where We Meet investigates the theme of an individual in the encounter with the last generation of residents from Military Dependents' Villages and with their living spaces. This project presents four Military Dependents' Villages in the Zuoying District, Kaohsiung, Taiwan (Lizhi New Village, Chongshi New Village, Zizhu New Village, and Fuxing New Village) after an ordinance entitled *Military Dependents' Villages Reconstruction Act* was passed to tear down the villages. The images in this project depict the lives of the last Dependents' generation. They serve as a testimony to the shift in cultural landscape before and after the demolition.

Zuoying once housed 23 Military Dependents' Villages. It was the largest naval community in Taiwan. The serviceman and their families established their new homes in the area when the Nationalist Government of the Republic of China (ROC) relocated to Taiwan. The *Military Dependents' Villages Reconstruction Act* was announced in 1996. It forever changed the fate of 897 Dependents' communities. I first visited the Zuoying Military Dependents' Villages in February, 2009. I met with the Dependents' households and connected with the landscapes in the condemned villages. Through conducting interviews, taking photographs, making text recordings, and generating dialogues with the local residents, I attempt to preserve the cultural, physical, and rhetorical memories of these military communities. The work becomes a critique to the unjust policies behind the destruction of Military Dependents' Villages.

The second series is about Fuxing New Village. The Nationalist Government built this community after the war in an ad hoc fashion for the serviceman and the sergeant major's family. Yin Chen Cheng-lan became one of my main subjects to photograph and interview. Her life experience illustrates how she established roots and started a family in Fuxing New Village. Through her words, the audience is able to understand how this Military Dependents' Village became a shelter for victims of war. Military Dependents that suffered from the trauma of displacement lived comfortably here in the refuge of milk and honey. The second personal testimony from Fuxing New Village was provided by Wan Hai-gen, whom I nicknamed "Flag Grandpa," from the Jiangxi Province in China. The marine sergeant major still had a thick accent from his hometown. The walls in his yard were covered with the ROC national flags, demonstrating the veteran's love for the nation. His recount indicates that he no longer holds hope of returning to his hometown. Having lived in a Military Dependents' Village for 50 years, it is difficult for Flag Grandpa to relinquish the feelings and identity developed for the land that gave birth to his children and grandchildren.

Fuxing New Village was demolished in March, 2013, followed by Zizhu New Village. Chongshi New Village was officially removed from Zuoying's map in August of 2013. The four series of work form a memorial requiem for the vanished military communities under the absurd *Military Dependents' Villages Reconstruction Act.* At last, the lost Military Dependents' Villages are adorned with commemorative yellow ribbons.

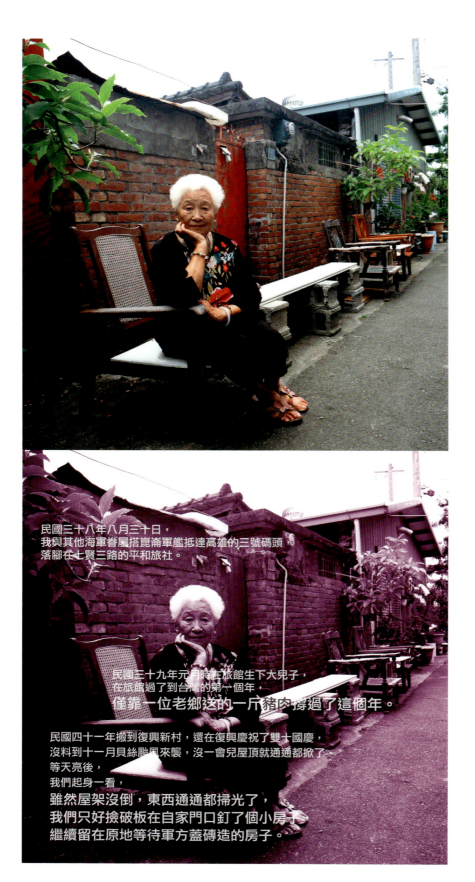

《我們在此相遇》〈殷陳城蘭 01〉／左營／2011
Yin Chen Cheng-lan 01 from the *Here Is Where We Meet* series / Zuoying / 2011

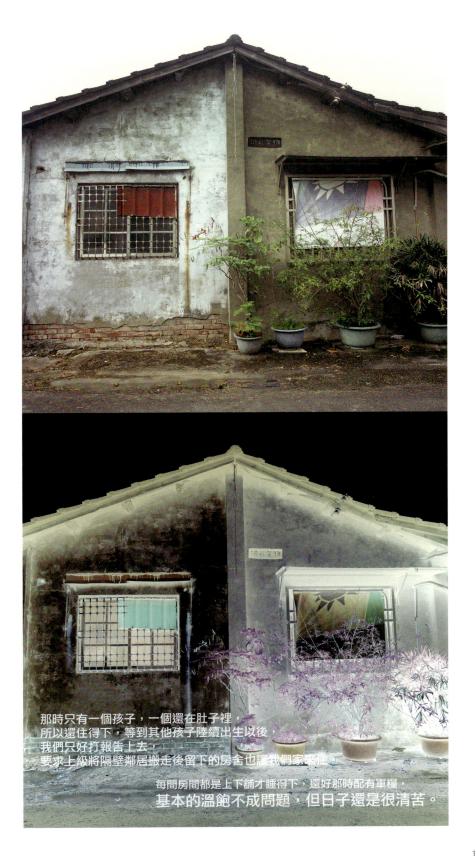

《我們在此相遇》〈殷陳城蘭02〉／左營／
2012
Yin Chen Cheng-lan 02 from the *Here Is Where We Meet* series / Zuoying / 2012

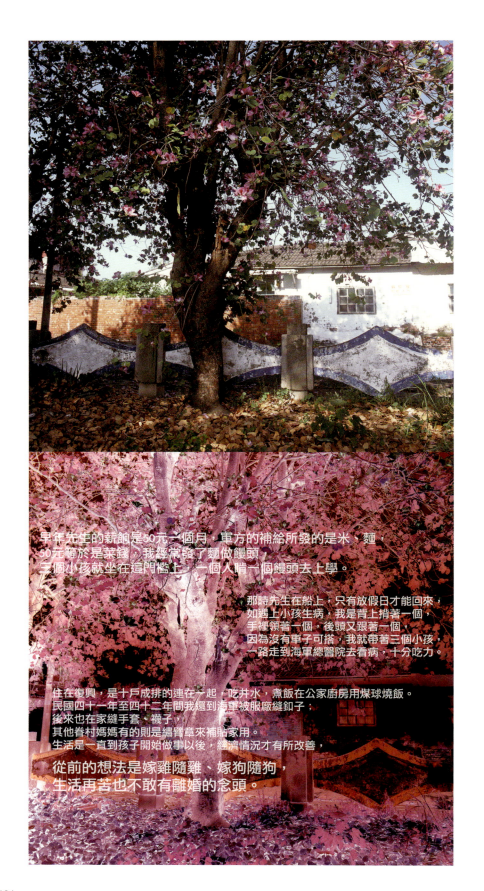

《我們在此相遇》〈殷陳城蘭 03〉/ 左營 / 2013
Yin Chen Cheng-lan 03 from the *Here Is Where We Meet* series / Zuoying / 2013

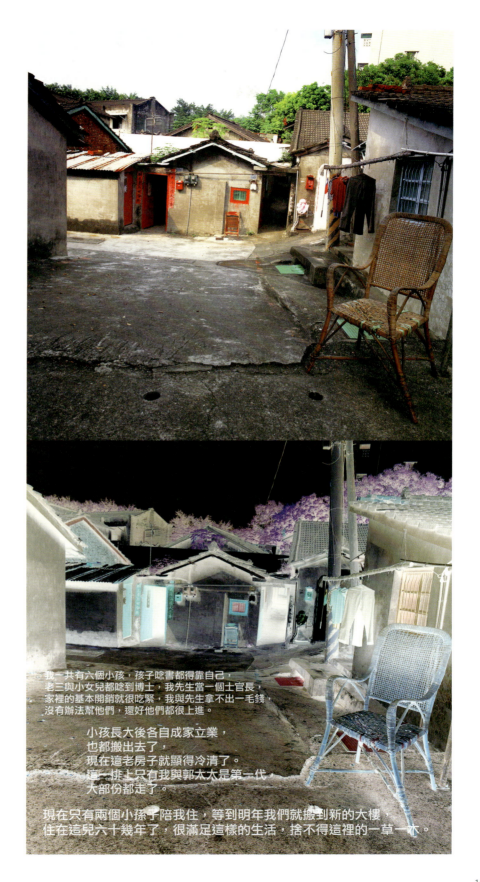

《我們在此相遇》〈殷陳城蘭 04〉/ 左營 / 2012
Yin Chen Cheng-lan 04 from the *Here Is Where We Meet* series / Zuoying / 2012

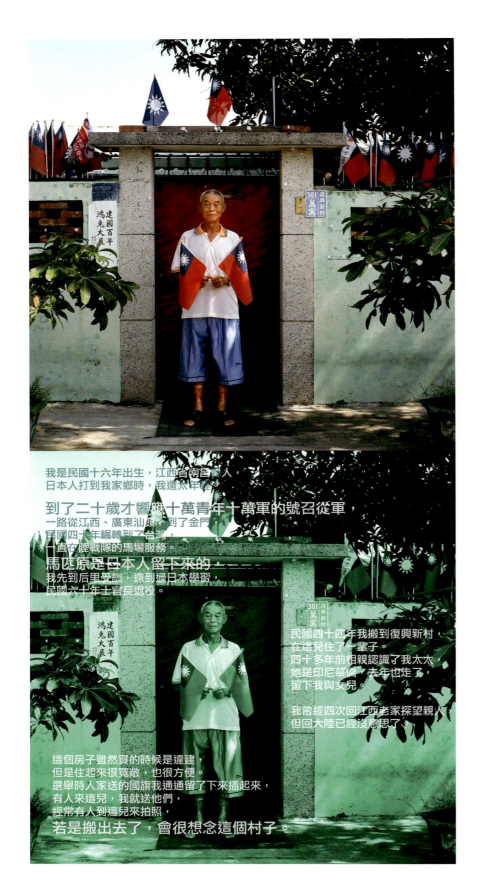

《我們在此相遇》〈萬海根 01〉/ 左營 / 2011
Wan Hai-gen 01 from the *Here Is Where We Meet* series / Zuoying / 2011

《我們在此相遇》〈回響 01〉/ 左營 / 2011
Echo 01 from the *Here Is Where We Meet*
series / Zuoying / 2011

《我們在此相遇》〈回響 02〉/ 左營 / 2012
Echo 02 from the *Here Is Where We Meet* series / Zuoying / 2012

《我們在此相遇》〈回響 03〉/ 左營 / 2011
Echo 03 from the Here Is Where We Meet series / Zuoying / 2011

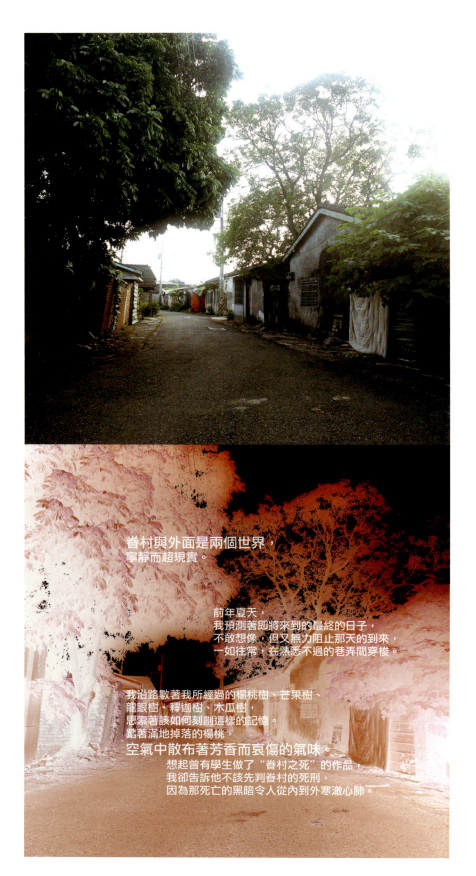

眷村與外面是兩個世界，
寧靜而超現實。

前年夏天，
我預測著即將來到的最終的日子，
不敢想像，但又無力阻止那天的到來，
一如往常，在熟悉不過的巷弄間穿梭。

我沿路數著我所經過的楊桃樹、芒果樹、
龍眼樹、釋迦樹、木瓜樹，
思索著該如何刻劃這樣的記憶。
踏著滿地掉落的楊桃，
空氣中散布著芳香而哀傷的氣味。
想起曾有學生做了"眷村之死"的作品，
我卻告訴他不該先判眷村的死刑，
因為那死亡的黑暗令人從內到外寒澈心肺。

《我們在此相遇》〈回響04〉/ 左營 / 2012
Echo 04 from the *Here Is Where We Meet*
series / Zuoying / 2012

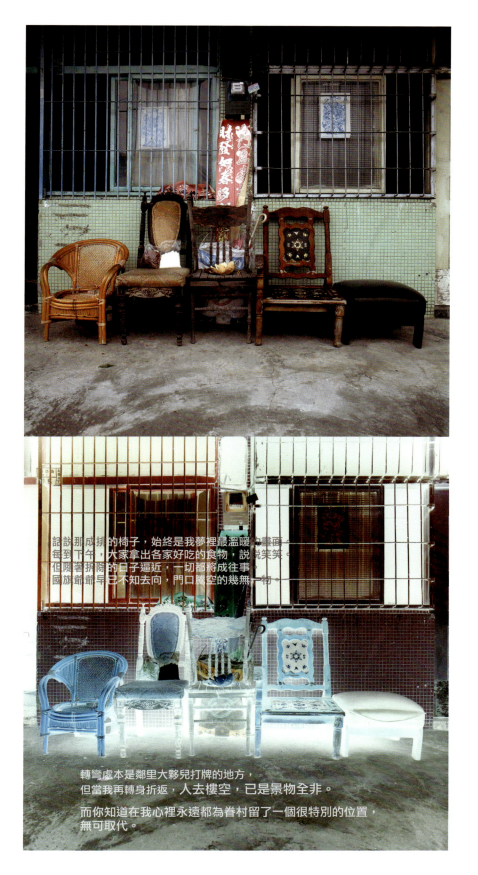

《我們在此相遇》〈回響 05〉/ 左營 / 2013
Echo 05 from the *Here Is Where We Meet* series / Zuoying / 2013

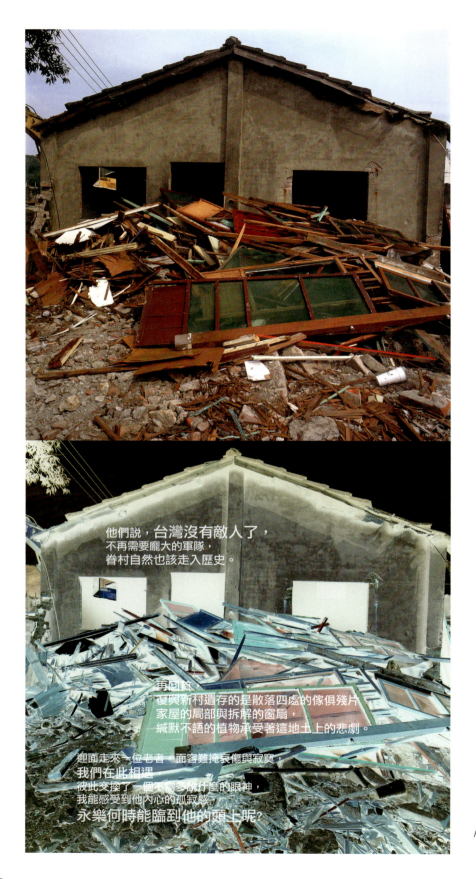

《我們在此相遇》〈殘響 01〉/ 左營 / 2013
Reverberation 01 from the *Here Is Where We Meet* series / Zuoying / 2013

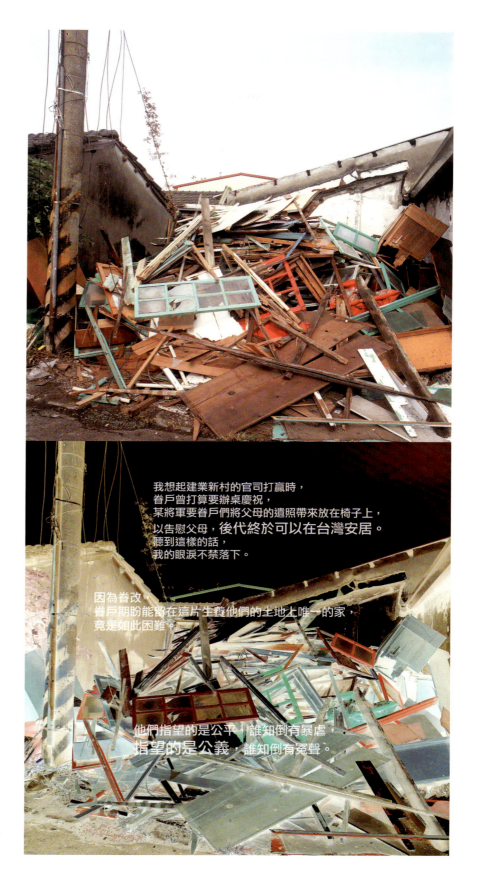

《我們在此相遇》〈殘響 02〉/ 左營 / 2013
Reverberation 02 from the *Here Is Where We Meet* series / Zuoying / 2013

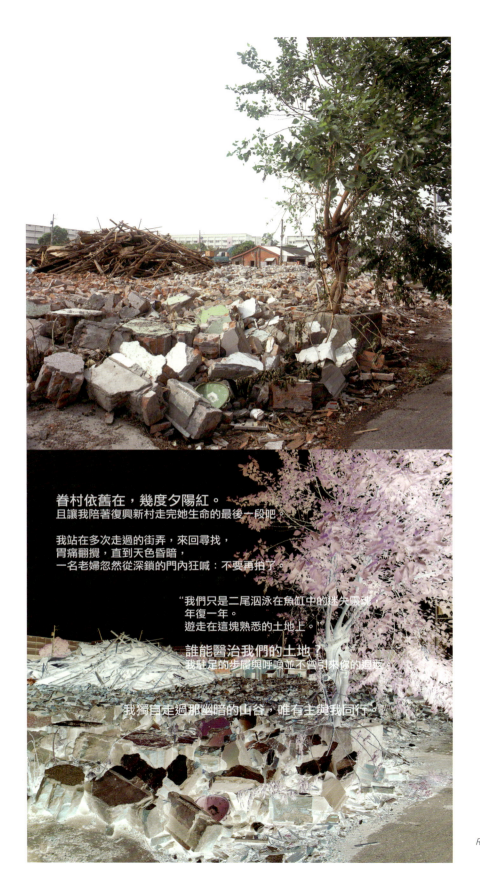

《我們在此相遇》〈殘響 03〉／左營／2013
Reverberation 03 from the *Here Is Where We Meet* series / Zuoying / 2013

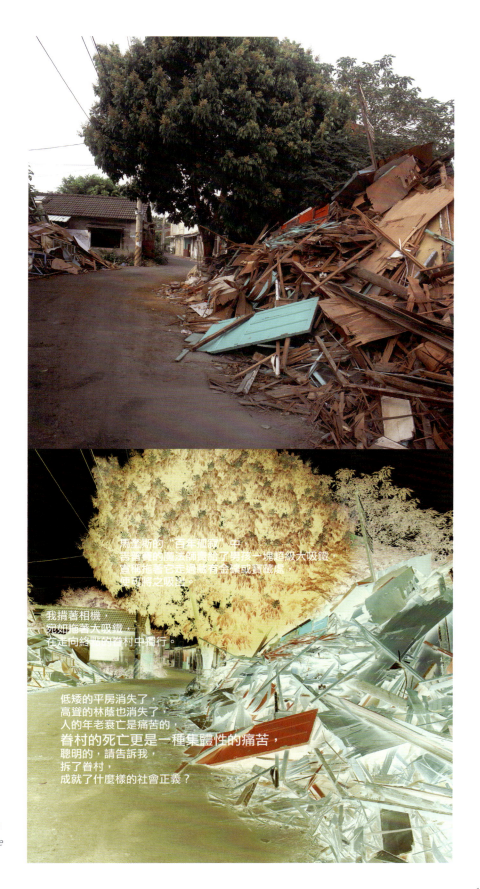

《我們在此相遇》〈殘響 04〉／左營／2013
Reverberation 04 from the *Here Is Where We Meet* series / Zuoying / 2013

高雄眷村三部曲之二部曲：《長日將盡》
黃埔新村系列 / 侯淑姿 / 2015

《長日將盡》探討高雄鳳山黃埔新村的女性眷戶搬離眷村後，回首超過一甲子歲月的歷史記憶的影像跡痕。

眷村改建條例實施以來，鳳山地區的眷村陸續拆除，黃埔新村成為少數幸運獲得保存的眷村。黃埔新村承繼了日治時期在鳳山地區的軍事部署與建設，1947年10月，孫立人將軍選定以臺灣鳳山為新軍訓練基地，並調動百餘名新一軍的部屬來臺，成立了第四軍官訓練班，安置部屬與家眷於誠正新村（後改名為黃埔新村），是為全臺第一個眷村。1955年5月黃埔新村因「郭廷亮匪諜案」、「孫立人事件」而舉國皆知。

本作品的主角劉奶奶（陳景琛）隨著她的未婚夫來到鳳山，在此建立了家園。筆者在2014年7月探訪這個村子時，僅餘存極少的住戶，劉奶奶是其中之一。劉奶奶對她住了六十餘年的房子堅持駐守到斷水斷電的前一刻。她的生命經驗敘述著隨政府來臺的軍人眷屬遠離家鄉而成為異地的圈外人（外省人），臨老再次面對苦心經營的家園的遽變，深切表達對住了六十餘年的眷村家園的難以割捨之情與無處再尋眷村的悵惘。無親戚與家族支撐的外省眷戶因著眷村的集體生活關係而建構起在臺灣的家園，原本以為是臨時的居所，但終了卻取代對岸的老家而成了眷戶心靈與情感上的「原鄉」。

此系列作品探討這群飽受離散之苦的居民（女性）客居他鄉的生活形態、鄰里關係、個人生命與大時代的關聯與消長。

A Trilogy on Military Dependents' Villages in Kaohsiung / Episode II: The Remains of the Day

Huangpu New Village series / Hou Lulu Shur-tzy / 2015

The Remains of the Day is a photographic series dedicated to rekindling the Military Dependents' feelings of displacement and nostalgic memories, allowing the viewers to trace the six-decade historical trajectory of female residents who spent their lifetime in Huangpu New Village.

A number of Military Dependents' Villages in Fengshan Borough have been tearing down successively since the implementation of the *Military Dependents' Villages Reconstruction Act.* Huangpu New Village is a rare survival under this act. It took over the military facilities and infrastructure in Fengshan District established during the Japanese colonial period. In October 1947, General Sun Li-jen chose Fengshan as the military training base for the New 1st Army, redeploying more than one hundred subordinates of the New 1st Army from Mainland China to Taiwan and arranging them in the fourth officer training class. These subordinates and their families settled down in Chengzheng New Village (later renamed as Huangpu New Village) which is the first Militarily Dependents' Village in Taiwan. In May 1955, the village received the whole country's attention for the espionage case of Guo Ting-liang (or the military mutiny case of General Sun Li-jen).

Grandma Liu (Chen Jing-chen), the protagonist of this series, settled down in Fengshan with her fiancé. When the artist visited this village in July 2014, Grandma Liu was one of the few residents who still live there. She refused to leave the house where she spent a lifetime until the authority cut off the water and electricity supply. Her life experience vividly reflects the story of Military Dependents. They were not only forced to migrate to Taiwan with the Nationalist Government and become strangers (i.e. Mainlanders) in a foreign land, but also confronted in old age with dramatic change of their cherished home in Taiwan. The story revolves around Grandma Liu's affection to the village where she has lived in for more than six decades, and her deep reluctance to witness its destruction. The turmoil of war severed their connections with relatives and families in Mainland China. These Military Dependents had no choice but to build new homes in Taiwan and lead their lives by living as collectives. Thus, these village, although they were designated to be temporary stays, turned out to be their spiritual and emotional "hometowns" that replaced their real origins in Mainland China.

This photographic series features the women who have become diasporic in a foreign land, addressing their lifestyle, their relations with neighbors, as well as the vicissitudes of their lives.

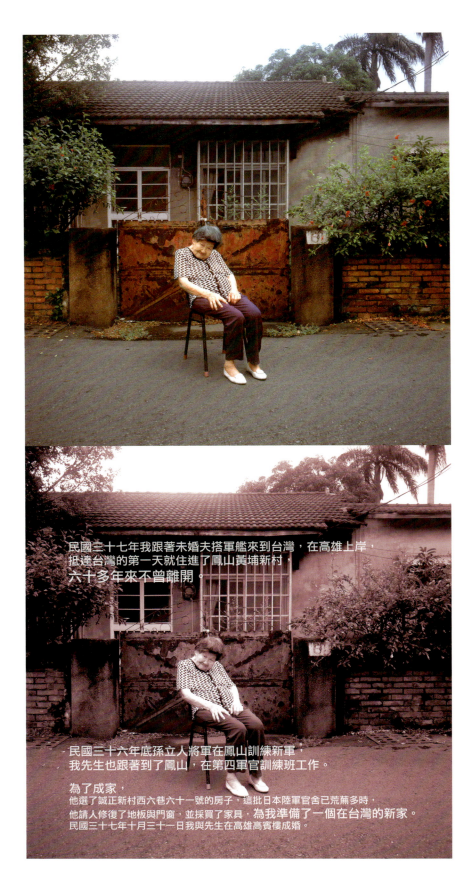

《長日將盡》〈陳景琛 01〉／鳳山／2015
Chen Jing-chen 01 from the *Remains of the Day* series / Fengshan / 2015

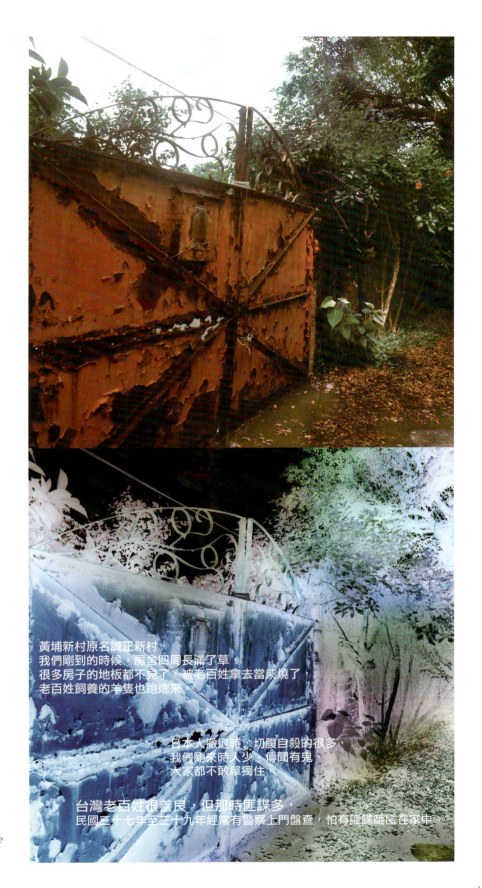

《長日將盡》〈陳景琛02〉／鳳山／2015
Chen Jing-chen 02 from the *Remains of the Day* series / Fengshan / 2015

《長日將盡》〈陳景琛 03〉/ 鳳山 / 2015
Chen Jing-chen 03 from the *Remains of the Day* series / Fengshan / 2015

《長日將盡》〈陳景琛04〉/ 鳳山 / 2015
Chen Jing-chen 04 from the *Remains of the Day* series / Fengshan / 2015

《長日將盡》〈陳景琛 05〉/ 鳳山 / 2015
Chen Jing-chen 05 from the *Remains of the Day* series / Fengshan / 2015

《長日將盡》〈陳景琛 06〉/ 鳳山 / 2015
Chen Jing-chen 06 from the *Remains of the Day* series / Fengshan / 2015

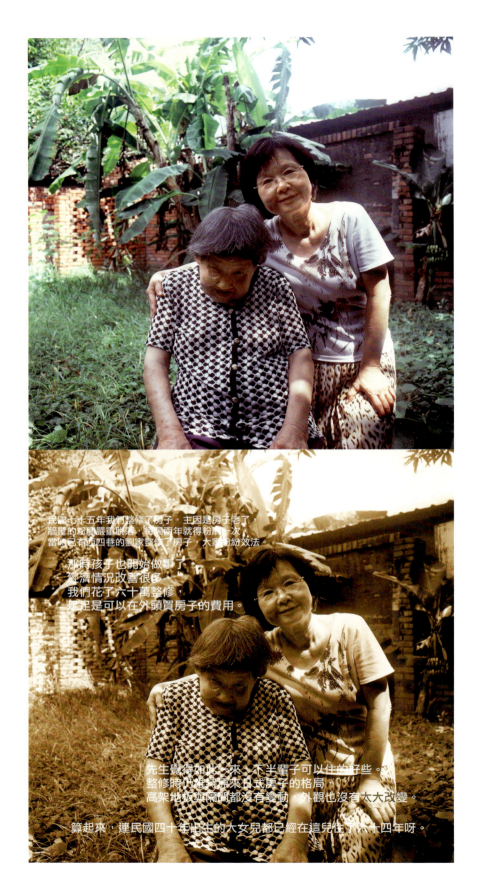

《長日將盡》〈陳景琛 07〉／鳳山／2015
Chen Jing-chen 07 from the *Remains of the Day* series / Fengshan / 2015

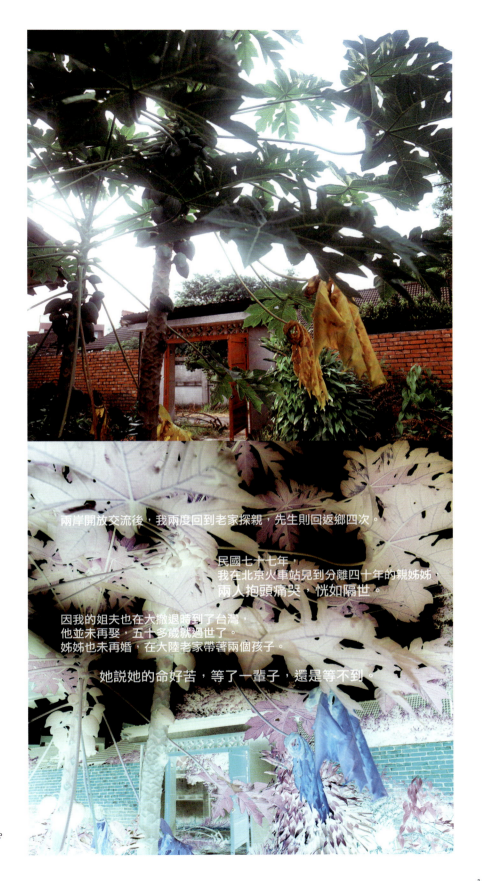

《長日將盡》〈陳景琛 08〉/ 鳳山 / 2015
Chen Jing-chen 08 from the *Remains of the Day* series / Fengshan / 2015

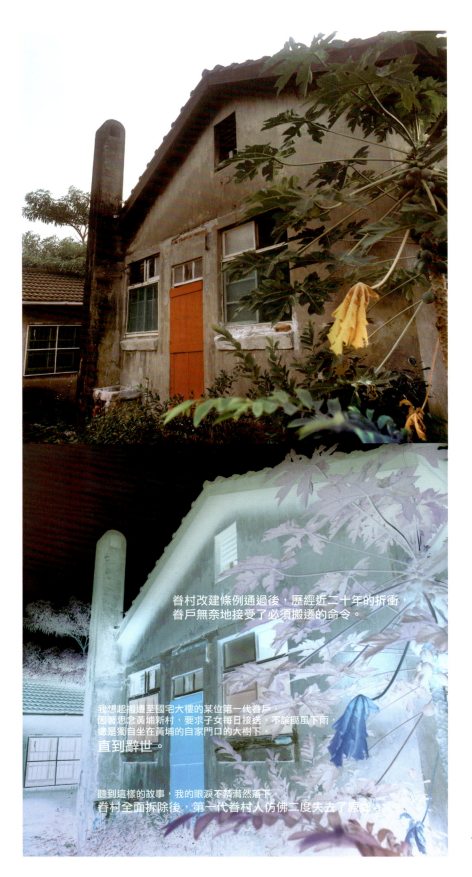

《長日將盡》〈回首 01〉／鳳山／2015
Recollection 01 from the *Remains of the Day* series / Fengshan / 2015

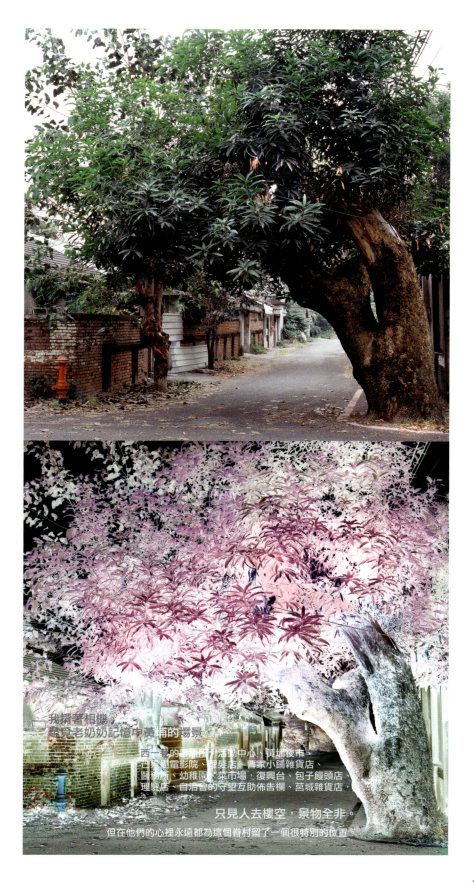

《長日將盡》〈回首 02〉/ 鳳山 / 2015
Recollection 02 from the *Remains of the Day* series / Fengshan / 2015

高雄眷村三部曲之三部曲：《鄉關何處》
明德新村系列、建業新村系列 / 侯淑姿 / 2017

本系列作品映射左營明德新村與建業新村在眷改末期蒼涼哀傷的命與運。

此二村為依傍左營海軍軍港的日遺眷舍，是捍衛國家的海軍軍官眷屬在飽經戰亂後的庇護所。第一代海軍眷村人心念國家，僅能遙望大陸家鄉，最終埋骨臺灣；而稚年來臺的第二代，今已成耄耋長者，一生以眷村為家，在此落地生根，繁衍後代。

此二村與緊鄰的合群新村於2010年因其特殊的歷史價值而為高雄市政府登錄為文化景觀，占地五十九公頃，數量達近一千戶的龐大眷舍得以存留，明德新村更於2013年獲選名列全國十三個眷村文化保存區之一。但因國防部種種不當的迫遷手段，致使明德新村與建業新村的眷戶一一揮別家園，失去了他們在臺灣的原鄉。作品關注此二村的殘餘眷戶在眷改末期持守家園、等待正義到來的真實處境。

作品計有明德新村與建業新村兩個系列，延續首部曲與二部曲以眷村女性為發言主體的基調，她們陳述浮生若夢的過往，與身為軍人眷屬的知足喜樂與哀傷；老將軍在反共復國大業早已灰飛煙滅之際，終其一生守衛臺灣的軍人魂因眷改迫遷手段而傷重累累，本與眷村同命一體的眷村人在此刻失去了他們賴以存活、孕育代代眷村人的子宮（母體），二度失根。臺灣政治板塊的移動與眷村聚落地景的消亡致使眷村人彷若集體失憶，在遺忘與記憶中擺盪，看似不合時宜（out of place）的眷村人漸次失去了他們說話的主體位置與發言權。至此，一幢幢爬滿藤蔓的眷舍空屋以傷逝之姿訴說人去樓空的蒼涼與無奈，眷村改建一頁滄桑將隨著眷村人遷居而告終落幕，謹以此作品書寫與紀念高雄左營與鳳山軍眷族群離散的人生。

A Trilogy on Military Dependents' Villages in Kaohsiung / Episode III: Out of Place

Mingde New Village series, Jianye New Village series / Hou Lulu Shur-tzy / 2017

This series of works portrays the plight of Mingde New Village and Jianye New Village in Zuoying during the late stage of implementation of the *Military Dependents' Villages Reconstruction Act.*

These two villages located near Zuoying naval base contain military dependents' quarters remaining from the Japanese colonial period. In the early days, they served as a refuge in the wake of war and chaos for the families of naval officers protecting the nation. The first-generation residents of Military Dependents' Villages gave their allegiance to the nation, so they could only longing for their homes in mainland China from a far distance, and ultimately were buried in Taiwan. The members of the second generation, who came to Taiwan while very young, are now elderly persons. They have always considered the Military Dependents' Village to be their homes, and put down roots and raised families in the villages.

In 2010, the Kaohsiung City Government designated the two villages and the outlying Hequn New Village, a total area of 59 hectares and including almost 1,000 Military Dependents' homes, as being a Cultural Landscape Preservation area due to the historical value of the three villages. Furthermore, Mingde New Village was included as one of the 13 Military Dependents' Villages cultural preservation areas nationwide in 2013. However, due to the Ministry of National Defense's many underhanded methods of forcing them out, the residents have gradually bid farewell to their homes, and lost their homeland in Taiwan. The works in this series focus on the true situations faced by those residents who still remained in the two villages during the late stages of implementation of the "Act" as they remained to guard their homes and wait for justice.

Here I present a combination of two series of work, the Mingde New Village Series and the Jianye New Village Series. Continuing from episode I and episode II, I have interviewed the women who live in the Military Dependents' Villages, hearing the stories of their pasts that now appear like fleeting dreams, the modest lives they lived as military families, their joys and their sadness. The plans to recapture China from the Communist Party turned to ash many years ago, but the old generals retained their fighting spirit to defend Taiwan. However, having been forced to leave their homes due to the *Military Dependents' Villages Reconstruction Act,* their spirit has suffered numerous shocks and they have become exhausted. The inhabitants of the Military Dependent's Villages who had expected to share their fate with their homes, lost the foundations of their lives, the womb that had given life to generations of its people, and were cast out and became rootless once again. The change of Taiwanese politics and the Military Dependents' loss of the place where they could live together, caused the inhabitants to suffer from a collective amnesia. Lurching between remembrance and forgetfulness and looked upon as obsolescent, the Military Dependents gradually lost their autonomy of speech and rights. The houses in Military Dependent's Villages were gradually overrun by ivy creepers and disappeared, embodying of the loneliness and emptiness after the people had left. The huge changes brought about by the *Military Dependents' Villages Reconstruction Act* came to fruition with the leaving of the people but this work cordially records the lives of Zuoying and Fongshan Military Dependents in diaspora.

《鄉關何處》〈陳金玉與曹正綱 01〉/ 左營 / 2010 & 2017

Chen Chin-yu & Tsao Cheng-kang 01 from the *Out of Place* series / Zuoying / 2010 & 2017

《鄉關何處》〈陳金玉與曹正綱 02〉/ 左營 /
2010 & 2017
Chen Chin-yu & Tsao Cheng-kang 02 from the
Out of Place series / Zuoying / 2010 & 2017

《鄉關何處》〈陳金玉與曹正綱 03〉/ 左營 / 2010 & 2017
Chen Chin-yu & Tsao Cheng-kang 03 from the *Out of Place* series / Zuoying / 2010 & 2017

《鄉關何處》〈陳金玉與曹正綱 04〉/ 左營 / 2010 & 2017
Chen Chin-yu & Tsao Cheng-kang 04 from the *Out of Place* series / Zuoying / 2010 & 2017

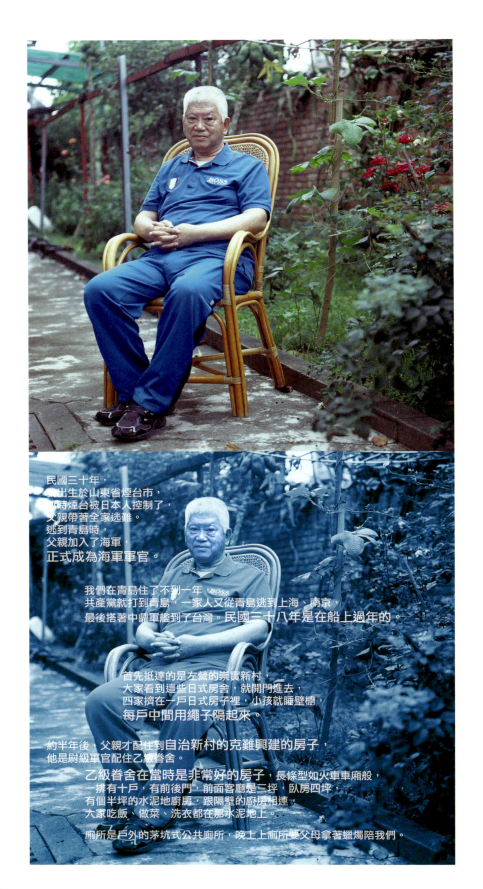

《鄉關何處》〈韓斌 01〉/ 左營 / 2017
Han Pin 01 from the *Out of Place* series /
Zuoying / 2017

《鄉關何處》〈韓斌 02〉/ 左營 / 2017

Han Pin 02 from the *Out of Place* series / Zuoying / 2017

《鄉關何處》〈韓斌 03〉／左營／2017
Han Pin 03 from the *Out of Place* series / Zuoying / 2017

《鄉關何處》〈韓斌 04〉/ 左營 / 2017

Han Pin 04 from the *Out of Place* series / Zuoying / 2017

《鄉關何處》〈林陳壁修 01〉/ 左營 /
2010 & 2017
Lin Chen Pi-hsiu 01 from the *Out of Place*
series / Zuoying / 2010 & 2017

《鄉關何處》〈林陳壁修 02〉/ 左營 / 2010 & 2017
Lin Chen Pi-hsiu 02 from the *Out of Place* series / Zuoying / 2010 & 2017

《鄉關何處》〈林陳壁修 03〉/ 左營 /
2010 & 2017
Lin Chen Pi-hsiu 03 from the *Out of Place*
series / Zuoying / 2010 & 2017

《鄉關何處》〈默禱01〉/ 左營 / 2017
Pray in Silence 01 from the *Out of Place* series
Zuoying / 2017

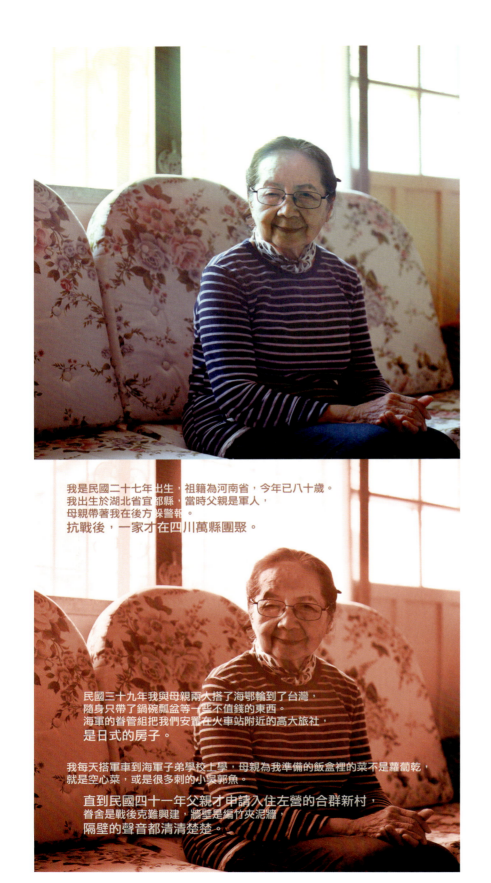

我是民國二十七年出生，祖籍為河南省，今年已八十歲。
我出生於湖北省宜都縣，當時父親是軍人，
母親帶著我在後方躲警報。
抗戰後，一家才在四川萬縣團聚。

民國三十九年我與母親兩人搭了海鄂輪到了台灣，
隨身只帶了鍋碗瓢盆等一些不值錢的東西。
海軍的眷管組把我們安置在火車站附近的高大旅社，
是日式的房子。

我每天搭軍車到海軍子弟學校上學，母親為我準備的飯盒裡的菜不是蘿蔔乾，
就是空心菜，或是很多刺的小吳郭魚。

直到民國四十一年父親才申請入住左營的合群新村，
眷舍是戰後克難興建，牆壁是編竹夾泥牆，
隔壁的聲音都清清楚楚。

《鄉關何處》〈賈劍琴 01〉/ 左營 / 2017
Chia Chien-chin 01 from the *Out of Place*
series / Zuoying / 2017

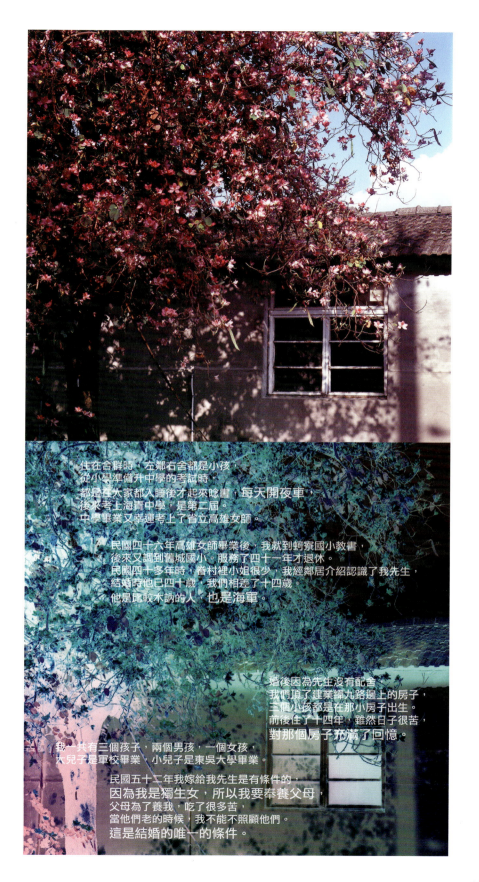

《鄉關何處》〈賈劍琴 02〉／左營／2017
Chia Chien-chin 02 from the *Out of Place*
series / Zuoying / 2017

住在合群時，左鄰右舍都是小孩，
從小學準備升中學的考試時，
都是在大家都入睡後才起來唸書，每天開夜車，
後來考上海青中學，是第二屆。
中學畢業又幸運考上了省立高雄女師。

民國四十六年高雄女師畢業後，我就到蚵寮國小教書，
後來又調到舊城國小。服務了四十一年才退休。
民國四十多年時，眷村裡小姐很少，我經鄰居介紹認識了我先生，
結婚時他已四十歲，我們相差了十四歲。
他是比較木訥的人，也是海軍。

婚後因為先生沒有配舍，
我們頂了建業繼九路邊上的房子，
三個小孩都是在那小房子出生。
前後住了十四年，雖然日子很苦，
對那個房子充滿了回憶。

我一共有三個孩子，兩個男孩，一個女孩，
大兒子是軍校畢業，小兒子是東吳大學畢業。

民國五十二年我嫁給我先生是有條件的，
因為我是獨生女，所以我要奉養父母，
父母為了養我，吃了很多苦，
當他們老的時候，我不能不照顧他們。
這是結婚的唯一的條件。

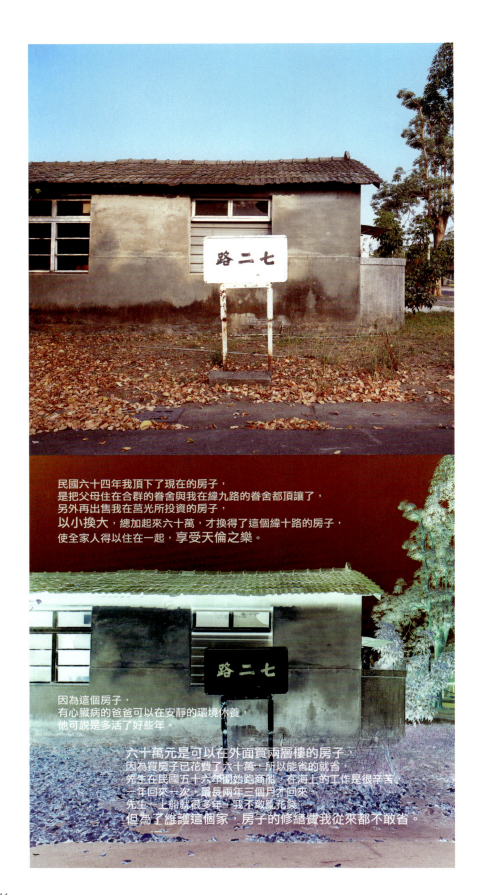

《鄉關何處》〈賈劍琴 03〉／左營 / 2017
Chia Chien-chin 03 from the *Out of Place* series / Zuoying / 2017

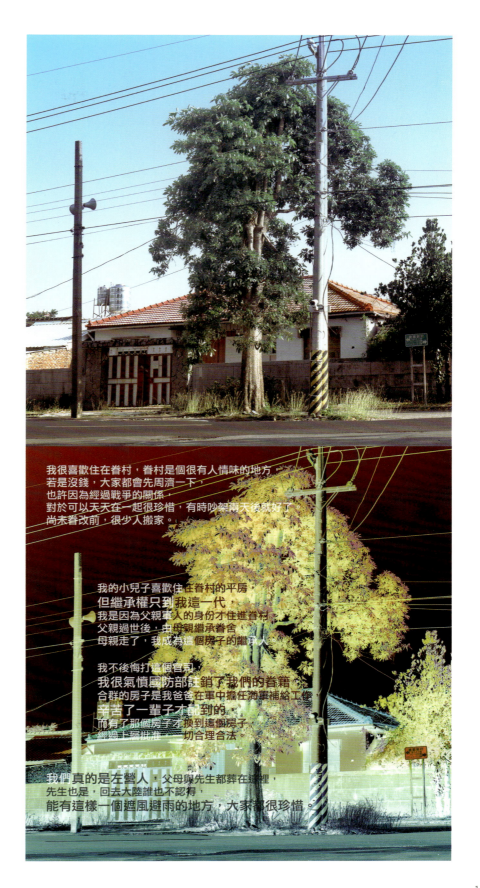

《鄉關何處》〈賈劍琴 04〉／左營 / 2017
Chia Chien-chin 04 from the *Out of Place* series / Zuoying / 2017

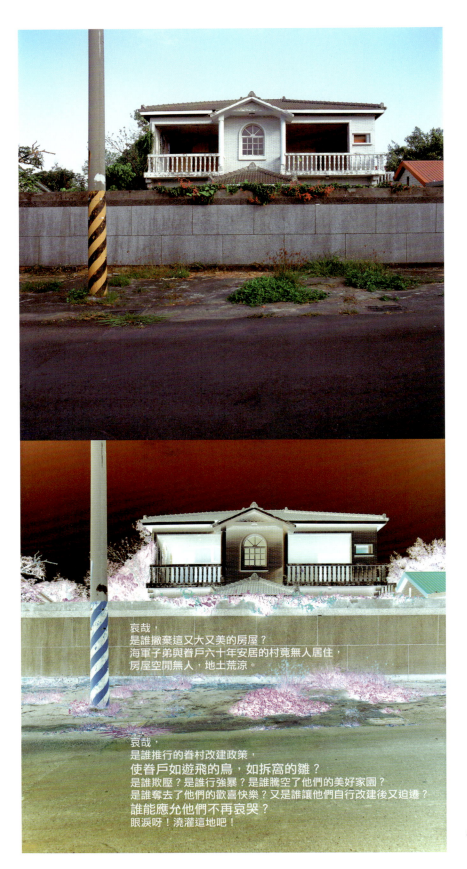

《鄉關何處》〈默禱 02〉/ 左營 / 2017
Pray in Silence 02 from the *Out of Place* series / Zuoying / 2017

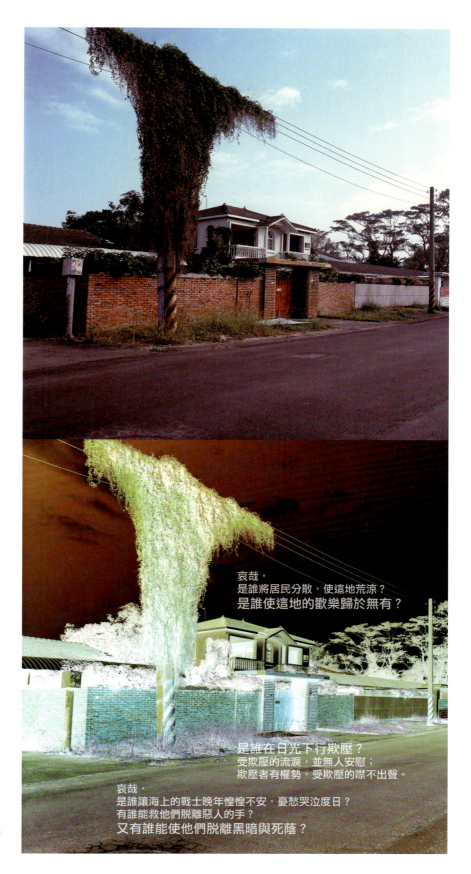

《鄉關何處》〈默禱 03〉/ 左營 / 2017
Pray in Silence 03 from the Out of Place series
/ Zuoying / 2017

口述訪談
INTERVIEWS

侯淑姿訪談紀錄

一、創作心路歷程

王雅倫（以下簡稱王）：請問您何時開始接觸攝影？您在大學研讀的是哲學，是在怎樣的契機下從哲學轉入攝影領域？家人如何看待您的藝術之路？而您到了美國留學學習藝術，可以談談在創作過程中，您對材質的敏感度及掌握是否對往後的創作有一定影響？

侯淑姿（以下簡稱侯）：我是在高中的時候決定要考美術系，只是當時並沒有考好，所以誤打誤撞進入臺大哲學系。那時母親去日本觀光，回臺後送我一台Nikon FE2相機作為考上大學的禮物，所以我開始在課餘的時候，加入攝影社去學習攝影，比方沖底片、印照片、策劃展覽等等。當時就發現自己對攝影是充滿熱忱的，於大四時舉辦過雙個展，也跟臺大攝影社在社教館舉辦聯展。當然以我當時的年代而言，拍照大部分是拍攝風景，屬於「直接攝影」（Straight Photography），比較少暗房加工、比較少拍攝人物，是偏向心象攝影的方式，主要是受到美國攝影家麥諾·懷特（Minor White）的影響。我在大學畢業後，曾在阮義忠的暗房工作室短期學習過，後來也跟蔣載榮學習區域曝光理論（Zone System）。不管我是去拍攝龍洞、九份、平溪（那時候去很多北部比較少人去的地方拍攝），努力尋找自己心中的意象。我的第一本作品集《生命的倒影》寓意著「回望生命，乍成倒影」，此作品集集結了我二十至二十七歲攝影作品。當我向家人表示我一定要出國讀攝影時，母親一開始不理解，但後來也支持了我的決定，直到現在，我的哥哥、姊姊仍是我生活中很大的精神支持力量。在我出國前（1989）曾向李光裕老師學習過素描一年，還畫人體模特兒。其他媒材經驗比較少，直到我申請上羅徹斯特理工學院（Rochester Institute of Technology，簡稱 RIT）影像藝術碩士，後來又去阿爾弗雷德大學（Alfred University）念雕塑，這個過程接觸了版畫、陶藝、金工、木工、錄像。在美國的學習過程中，發現裝置藝術當道，行為藝術、公共藝術方興未艾，體悟自己需要跨領域、跨媒材的學習，很慶幸自己在當時的學習環境當中做了很多嘗試，對往後的創作有相當大的影響。

〈重門裡外的謎語〉/ 侯淑姿攝 / 1987
Riddle of the Gate / photo by Hou Lulu Shur-tzy / 1987

〈光影的畫〉/ 侯淑姿攝 / 1988
Painting with Light / photo by Hou Lulu Shur-tzy / 1988

王： 您特別提到在美國羅徹斯特理工學院攻讀影像藝術碩士時，受到當時美國藝術圈興起跨媒材、行為藝術很強的文化衝擊。這成為您開始思考女性的角色、身分與處境的起點，這個連結可以請您再談一下？您早期作品似乎跟在紐約留學時期接觸的女性主義藝術家或女性主義思潮相呼應，請問這對您的創作主軸有何具體影響？

侯： RIT的訓練過程非常強調「非照片」（Non-photo），雖然是在攝影學院就讀，但已經從攝影轉向影像藝術，認為跨媒材、跨領域是很重要的，也強調成為藝術家的要件之一是從事行為藝術，必須要身體實踐。我的碩士題目探討「愛與慾」（Love and Desire）的關係，但這個題目存在著巨大的文化差異。我也發現周圍的老師或學生對女性主義都是有很強烈的支持態度，即使是男老師也會很直接表明他是一位女性主義者的立場。當時處於一個很大的文化衝擊，也不是很適應每十個禮拜就要評圖的巨大壓力，必須要很熟悉藝術思潮的發展，也要很熟悉同時代的藝術家的作品，在那種狀況之下，我檢視自我內在的心理處境，有如是以女性主義者的角度自我檢視。我作為一位東方女性，在西方的環境下要如何表達出我的作品，而能被理解與接受，也

察覺我一定要轉換我的創作語言,所以我嘗試過很多種創作模式,從自拍、行為藝術、公共藝術、各類的媒材,到最後的碩士論文是運用陶偶做出裝置拍攝的「編導式攝影」(Staged Photography)。

一直到後來去阿爾弗雷德大學學習雕塑,我創作了《不只是為了女人》,是美國留學期間的兩套作品之一:第一套作品是《迷宮之徑》(The Labyrinthine Path),探討愛與慾之間的關係;第二套作品即是《不只是為了女人》。當時接觸的女性藝術家對我的藝術創作很有影響。特別值得一提的是,有一位德國女性藝術家—費莉・艾斯波(Valie Export)—前來擔任客座教授,她看了我的作品,就說我的作品很有力道,我在此校接觸到很多活躍的藝術家(working artist),可以說前一所學校比較注重理論與研究,後一所學校比較注重藝術家之間的交流互動。

王: 您於1996年創作《窺》這個充滿女性主體意識的作品時,試圖以極為直接、強烈的影像,解構父權文化。關於這個作品,您是如何發想與創作的?以及您是如何詮釋這個作品?是否能談談您再度到了美國駐村時與謝德慶在紐約相遇的機緣嗎?您當時如何理解行為藝術,又如何將攝影以一種觀念呈現出來?在學習的過程中就接觸到很多行為藝術,也因為學習的課程與環境有一定的影響,種種加起來的因素是如何加乘在《窺》這個作品之中?

《不只是為了女人》/ 侯淑姿攝 / 1995
Not Only for Women / photo by Hou Lulu Shur-tzy / 1995

侯： 創作《窺》這個作品的時間點是1994年回到臺灣時,在伊通公園畫廊舉辦了「不只是為了女人」的個展。在展出的過程中得到兩極的反應,有許多男性藝術家對此作品的評價是不太友善的。此作品是以乳房狀的金屬物放置於十字架上,邀請參與者來回應我提出的概念:「女性是社會的犧牲者」。我記得在伊通展覽時就有藝術家説要「撒一泡尿在這十字架上」,就是非常不禮貌、羞辱性的反應,剛好又因為這個展覽的作品被一位商業攝影師整體拍攝進該雜誌的報導中,我一怒之下,對這位攝影師與雜誌社提出侵權的告訴。這個過程中讓我發現我的創作自由是十分受限、受約制的,臺灣普遍對於這種女性主義的議題不是那麼正面的接受。所以我申請進駐謝德慶提供的藝術家工作室,這是在1995至1996年的十個月駐村,該工作室是位於曼哈頓南邊威廉斯堡(Williamsburg)的大地藝術家工作室(The Earth)。謝德慶非常鼓勵我做行為藝術,我自認我的強項並不是在這方面,思考過後,決定把我在臺灣的經驗運用於此處,將主軸放在於男性是如何看待女性、觀看女性,而女性又是如何回應這種觀看,所以創作出《窺》。這個作品引用了一個俚語(slang):「Take a picture, it lasts longer」, 這是美國紐約客慣用的俚語:「你如果想一直窺看,不如拍張照片來的日久彌新。」以此概念去反諷男性觀看女性的一種霸權,而女人是如何以嘲諷、黑色幽默的態度去應對社會的制約。這些攝影作品為連續性的影像,連續動作的分解與定格的過程,在這個過程中我比較著重於這是一種概念的呈現媒材,而不是去記錄什麼——你必須先要有強烈的意圖與創作目的去創造(create)——所以我們才説影像創作者(image maker)而不是影像拍攝者(image taker)。《窺》這個作品並不是一開始就套用理論,而是在比較後端的時候把約翰・伯格(John Berger)所提出的男人觀看、女人被看的狀態表現出來,或是女性扮裝(masquerade)這部分都是實驗後,凝聚成為每一個系列呈現出來的。

王： 您在出版作品集這件事上似乎特別的用心,在很年輕的時候就有這樣的出版意識,《生命的倒影》是您最早出版的作品集,雖然現在回頭看的時候,那是一道年輕的生命印記,但意義很不一樣。在後來幾年您陸續的展出,還出版了幾本質感和成果都是很優質的作品集;而日本的東京都寫真美術館也展示您的作品與作品集,書寫和評論應該也已是您創作的一部分了,想請您多談談這方面的細節。

侯：《生命的倒影》就是二十至二十七歲的九十八幅黑白攝影作品收集而成，當時我在東華書局擔任一部中文辭典的執行總編，那時的主編何秀煌教授非常鼓勵與支持我勇敢地將自己的作品整理出來，整理出三個主題，第一個主題主要是拍攝自然、生態、生活中的即景；第二個單元是由6×6的相機拍攝的，龍洞的風景、九份廢棄的小屋、中山北路的飯店或咖啡廳火燒的場景，都是在表達出時間的流逝、記憶的痕跡，當時對這些靜物的美感非常著迷；第三個部分就是拍攝臺大、動物園等都市景觀，現在看起來還是會覺得很有趣的場景，那是黑白的底片時代，所有的照片都是自己沖放、印製，陶醉在自己的創作當中，也就決定將它整理出版。我在2012年出版了《女性影像書寫：侯淑姿影像創作集（1989-2009）》、2014年《老時光，好時光：左營眷村影像書》，都是在整個展覽結束告一段落後，我花很多時間來編輯的，當然如高雄市立美術館也配合展覽出版過我的兩本專輯。

《老時光‧好時光──左營眷村影像書》（主編：侯淑姿）／李俊諺攝／2014
Old Times, Good Times: Military Dependents' Villages Image Book (Editor-in-chief: Hou Lulu Shur-tzy) / photo by Lee Chun-yen / 2014

由於我曾在日本駐村過，也曾在美術館參加過幾次展覽，東京都寫真美術館前總策展人笠原美智子的策展論述「關於愛，我略知一二：論亞洲當代攝影」（I Know Something About Love, asian contemporary photography），強調展出的作品與愛的關係。另外是娜塔莉・塞茲（Natalie Seitz）的文章比較著重在談論我受到文化的衝擊之下，對作品之影響與改變。至於笠原美智子的文章則對曾經抗戰剿匪的軍人住在日遺眷舍的歷史變遷深有所感，也對我作品中上下兩幅的、左右兩幅的概念覺得非常新穎。此外還有日本評論家飯澤耕太郎也書寫過關於我的作品的評論。已逝的臺灣藝評家陳香君對於我早期的作品也有相當深入的探討。由於張元茜的推薦，美國的華敏臻女士（Michelle Vosper）所著的十六位華人女性藝術家的專書《創作無界：中國、香港、澳門和臺灣的女藝術家》（Creating across Cultures: Women in the Arts from China, Hong Kong, Macau, Taiwan）中，有一專章介紹我，這本書比較著墨在女性藝術家與作品之間的關聯性，對成長歷程、生命經驗談得比較多。

王：**我們知道其實您有幾年時間一直在做攝影影像修復、預防性保存工作，乃至於撰寫相關研究成果，開辦工作營訓練、培育相關人才等；等到國家攝影文化中心成立後，您依然扮演這樣一個先鋒導師的角色，能否談談您回國後除了專注在創作和教學外，如何開始這一類像是搶救文化資產的工作及角色，您又有哪些值得與我們分享的案例？**

侯：碩士期間我先在喬治・伊士曼博物館（George Eastman Museum）實習了一年，也修了一些攝影材質保存與修復相關的課程，而後在阿爾弗雷德大學（Alfred University）當了一年特別學生，在康寧社區大學（Corning Community College）教了半年的書，之後才又繼續修習修復相關課程，也取得了證書。喬治・伊士曼博物館很重視十九世紀的攝影製作方式的辨識（Process Identification）與保存修復方法，我自己則專注於蛋白紙劣化與保存修復的研究。回到臺灣後，我做了張清言的玻璃版與李梅樹的玻璃版的保存計畫。2004年我受檔案管理局的委託，進行了「攝影類檔案保存修護方法之研究」。

2004年8月我到了高雄大學教書，第一年的田野調查課程是以美濃紙傘為主題，帶領學生實地到美濃調查，並聘請匠師授課，讓全班的學

生於美濃實地向匠師學習紙傘的製作，前後六週的時間。我在2005至2006年，也在臺南的文資中心舉辦攝影材質保存的工作坊。

其後文化部籌設國家攝影文化中心，我擔任了五年的諮詢委員與典藏委員，特別著力於臺灣攝影的美學與歷史價值體系的建立，尤其是早期十九世紀臺灣攝影的重要性，得到莊靈、張蒼松等委員的認同，促成了十九世紀照片的購藏。

二、攝影語彙的形成

王： 談談您的作品，1995年在伊通公園的展出《不只是為了女人》算是您回臺灣後首次個展，也是第一個強調女性自覺意識的作品，可以談談它跟您在美國的畢業作品《迷宮之徑》有什麼樣的呼應嗎？在這個展示作品中出現圖片和文字之間的搭配關係，能否詳述影像與文字之間在您後來的作品中的演變和意義嗎？

侯： 1992年創作《迷宮之徑》時，我並不了解女性主義，直至1993年的《不只是為了女人》，我才萌發了探討女性被制約的課題的想法，《迷宮之徑》是在一種封閉的系統與自我對話，《不只是為了女人》則是與外部的對象對話，將展場變成是一種對話的場域，與觀者互動產生反應。到1998年的《猜猜你是誰》就被拆成兩部分，每位受訪者闡述自己身分認同的經驗，而我也對這位受訪者提出我對他（她）的論點。這些嵌入的文字在展示時會再次與觀眾形成對話，觀眾會在其中找到與自己較為相符合的觀點與立場。沿用此手法，2005至2009年的《亞洲新娘之歌》的作品也嵌入了受訪者的自述，也試圖與觀眾產生對話。當然，也會因此而激發出其他的觀點與看法。

王： 您幾乎後來大多數作品《不只是為了女人》直到《亞洲新娘之歌》和《高雄眷村三部曲》系列，也都以「攝影裝置」、「攝影雕塑」來操作並呈現，而且您也會後製處理您拍攝的影像，有時加入單色的色彩，能說明攝影與裝置之間的考量和整個展示空間的計畫策略嗎？

侯： 是的，從我最早的創作開始，曾多次使用「裝置」手法來呈現我的作品。《亞洲新娘之歌》第一次展出是2005年10月在清華大學藝術中心的

《不只是為了女人》／侯淑姿攝／1995
Not Only for Women / photo by Hou Lulu Shur-tzy / 1995

10000 cutting a day

500 ironing a day

200 dozens of polo shirts a month

2000 label-sewing a day

500 edge-wing a day

《青春編織曲（三）》/ 侯淑姿攝 / 1997
Labors and Labels (III) / photo by Hou Lulu Shur-tzy / 1997

邀請展，當時我便決定了「兩兩並置」呈現的這個形式，而最完整的展覽是在高美館展出的「高雄眷村三部曲」。可確定的是，我的展出計畫往往都不只是展出作品而已，從雙眸（策展人黃孫權用語）的呈現、色彩的設定、到空間裝置，都是這個系列一開始展出時我就已經策劃完成了，三個系列的差別只是在於採訪對象的增補，以及我後來去了這些外配的原生家庭一趟而增加的；當然我還用了Video動態影像。

王：您在1997年創作《青春編織曲》企圖呈現生活於都會衛星城市的產業婦女的生命史。您意圖透過呈現臺灣經濟奇蹟背後的紡織女工身影，凸顯亞洲女性紡織工在全球經濟鏈下的勞動生命。關於這個作品，您是如何參與這個聯展的？以及您是如何詮釋這個作品？而這個作品是否可以說您從《不只是為了女人》作品中，自己走向面對群體女性問題的開始，甚至到《青春編織曲》關注的是勞動婦女的存在價值，能談談從自身身為一個藝術家（一個女性藝術工人）轉向社會關懷的《青春編織曲》這條路的心路歷程嗎？

侯：1997年我第二度返回臺灣，在立法院擔任國會助理，那時新莊的藝文中心邀請張元茜策劃「盆邊主人」的展覽，邀請了美國的茱迪．芝加哥（Judy Chicago）與韓國、日本的女藝術家，臺灣則是邀請了林純如、徐洵蔚、吳瑪悧與我，共同來關切女性的議題，臺灣的這幾位藝術家主要是關注新莊的紡織女工。那時我實地到了新莊的紡織城，去找可拍攝的對象。正值紡織廠出走，關廠事件頻傳，勞資雙方的關係非常緊張，所以，勞資雙方都不願意接受拍照，所幸協同策展人張小苑介紹她家紡織廠過去的員工讓我到家裡做訪問，透過各種連結，將裁布的、車邊的、織毛衣的，紡織業代工的中下游工廠，一一親自拍攝，當時做了很多功課，在這個過程當中非常震撼。無論工廠環境條件的嚴苛、女工辛勤工作的模樣、她們臉上滿佈的歲月皺紋，都讓我感觸很深。策展人張元茜曾詢問女工：「你覺得新莊如何？」女工回答（閩南語）：「我的青春都落在這裡了。」因此，我將作品命名為《青春編織曲》。此次創作屬觀念攝影，我也做了行為表演，以我所拍攝的女工圖像製成洗標，與參觀的觀眾交換他們身上所穿的衣服的標籤。雖然我不是女工，但我也是靠自己的勞力去做創作，所以自稱為「一個女性藝術工人」，我可以同理他們的狀態。很感謝這樣的

契機,從探討自我去處理身分認同的問題,女性勞工跟臺灣在全球經濟產業鏈之中所產生的位置問題,這樣的轉向對我之後作品的影響也很大。

王: 從《不只是為了女人》、《窺》到《猜猜你是誰》的創作展出,大概有五年的時間,您從關心女性身體的自主性到解構男性凝視,您似乎一直在思考「我是誰」,這個「我思故我在」的問題;乃至於到《猜猜你是誰》,您開始擴大關注「身分認同」這個主體性的問題,尤其是不同背景、甚至是較為邊緣的族群,想請教您,當時的臺灣社會背景對於您以影像提出的問題有些什麼回應嗎?

侯: 因為《青春編織曲》是在《猜猜你是誰》之前,1989年是我出國的時間,1994年回國一次,展出《不只是為了女人》後,又再到紐約駐村,1997年在帝門藝術教育基金會展出《窺》,1989年展出《青春編織曲》,皆是談論女性身分的處境與議題,到《青春編織曲》擴大到女性勞工,臺灣紡織業的處境,《猜猜你是誰》則回應了臺灣當時在探討國族認同的議題,對於國族認同的議題已有明顯的改變。1997年我在國會擔任林濁水委員的助理,他的臺獨與國族論述對我有相當的影響。也使我對臺灣人的身份認同的議題有不同的體悟。《猜猜你是誰》作品中所拍攝的人之中,對於我自己當時思考「我是哪裡人」有

《青春編織曲》展出於「盆邊主人・自在自為:亞洲當代女性藝術家」展 / 1997
Labors and Labels exhibited in *Lord of the Rim, in Herself /for Herself- Asian Contemporary Female Artists Exhibition* / 1997

很直接的影響,包括努力為平埔族正名的萬正雄、萬淑娟父女、研究平埔族文化的陳春木、受日本教育的臺灣女性沈吳足、外省女性吳達云、外籍的天主教神父紀寒竹、美麗島事件受難家屬潘雪雲等,這個題目很明顯政治性比較高,在臺南展出時也得到許多回應,當時談論政治議題的作品相當少,這個作品直球對決的方式在當時是非常前衛的。

王:又似乎在《窺》這件作品系列發表後得到各方不同的評價,究竟《窺》系列裡的女性身體是否又再次陷入眾人窺/虧看的攝影陷阱?是否可以談談為何《窺》作品中不露出頭部?請問您自己怎麼看待這件事件?一些討論和評論是否偏離了《窺》作品的核心理念,它是否影響您之後的創作及表現?

侯:《窺》的作品有很多的報導,有平面的、電子媒體的,女性電影節的影響,受到非常多的關注,那時候帝門藝術教育基金會請傅嘉琿寫評論,但她的文章評論我的身體不夠性感、作品很沙龍。我對此很吃驚,因為她完全不了解沙龍攝影,身體的閹割與自我的閹割的評價對我是一種污辱與誤解,誤解的原因是因為沒有露出頭部,我認為露出頭部就是只談這個人而非討論普遍的女性,所關注的點才會是身體的下半部。而且作品不是要談論自我。這位評論者很像是要打倒藝術家一樣,一一給予負面評論,所以我拒絕了畫冊的出版,以至於她的文章要放在《南方》雜誌上刊登時,我不願意提供作品照片。但李長俊老師公開支持我的立場,王雅倫也在《誠品閱讀》雜誌寫了一篇〈以女人之名:談女體攝影與觀眾〉聲援我,陳泰松也從這個公案出發,寫了一篇藝評家要如何書寫藝評的文章(〈影像的閹割事件——從傅嘉琿評侯淑姿的攝影作品談起〉)。具有專業的女性藝評家在臺灣是非常少的,傅姓評論家雖為女性,但她是以男性觀點書寫女性主義的藝術創作。

王:您於2002年為臺北市建成國中創作《快樂是什麼》,透過實際進駐與訪談該校師生,完成以影像和文字呈現您與師生對於那些人生問題的看法。關於這個作品,您是如何發想與創作的?以及您是如何詮釋這個作品,而這件作品似乎也與建成國中的學校的歷史和地點有一定的關聯?想請問您,這時的創作是否與您自1997年開始參與一些文

化及公共政策有關？您回國後是如何涉入了文化政策與文化行政？而一直到後來離開公部門的工作回歸當一個藝術家，創作了《快樂是什麼》，能談談這方面對您往後作品的影響嗎？事實上除了藝術創作、國際駐村、作品展示，您很快的又回到社會，帶著一雙更透析社會的眼睛，更深入人心的心靈，只不過出現在更荒涼的角落，《快樂是什麼》這件作品似乎道出了您內在對於快樂的定義。

侯：我學成回國以後，第一個工作是在國會擔任林濁水委員的助理，因為他需要制定有關藝術的相關法案。我在這一年的工作當中，撰寫了文建會五個附屬機構的民間版藝術村的報告，另外開過十二場的公聽會，修過三個法案，其中最重要的是一個就是「聘任人員聘任條例」，是人事法，與文化機構如何去聘用文化專業人才有關，這個經驗也引導了我在1999年到臺北市政府籌備臺北市文化局。這是一個從零開始的任務，從三月開始對臺北市議會的五十二位議員進行遊說、撰寫說帖，也與公共電視合辦了六場座談會，得到公眾輿論支持來設立臺北市文化局。文化局成立之後，擔任研究員的職務，編寫預算跟做業務的詳細規劃，包括駐市藝術家計畫的推動與臺北國際藝術村的規劃等，以及諸多研究案的督導、籌備臺北當代藝術館等工作。

我在臺北市政府工作時，是馬英九第一任市長任期內，當時有很多事件發生，比方說：二二八紀念館的爭議、北美館館長林曼麗與文化局局長龍應台的爭議，包括二美館轉型為當代館要如何處理等等，我與這些事有很直接的關聯性，後來又被派去籌備臺北當代藝術館的開館，但又因為臺北當代藝術館要委外而不得不離開市政府，因為我本來是希望能夠在當代館工作的，所以被要求先離開，再到私部門工作，這個過程相當地複雜，由於委外政策的不穩定，所以我離開了臺北市政府，沒有再回頭。不久，我發現自己陷入了一個很憂鬱、很不快樂的狀態，所以當我受邀參與臺北市建成國中的新建工程設置公共藝術的邀請比件時，我提出來的作品就是邀請五十位師生一起去探討「快樂是什麼？」在我拋出這個問題時，我也問自己同樣的問題，就是「快樂是什麼？」每一個人對於快樂的定義的答案也都不盡相同，我從他們的回答當中總結出了一些共通性的看法，再總結性地呈現在作品裡面，所以這個作品是對自己生命處境的反思，也希望這些國中

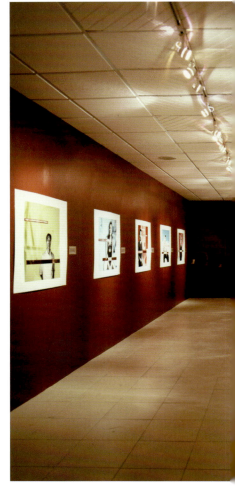

「猜猜你是誰」展場 / 高雄市立美術館 / 2000
Guess Who You Are exhibition / Kaohsiung Museum of Fine Arts / 2000

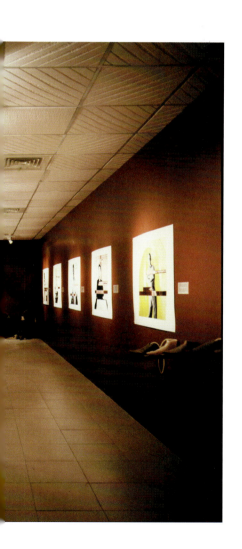

學生的人生有一些正面的影響。其中有幾位目前仍跟我保持聯絡,他們已經從研究所畢業、就業,都是很不錯的學生,在當時就已經可以看到他們的未來。我想這個作品的確對我有很不一樣的意義,當我注意到有相對多數的師生是憂鬱症患者,比如諮商室的主任就是不快樂的人,訪談時臉色最沉重的就是諮商室的主任;或是有一些資優的學生長期被霸凌、受到不好的對待等等;也發現很多學生的家庭有很多問題,然而還必須偽裝成很快樂的狀態,因此在過程中請學校找生命線來做輔導。我也以這本書透過他們家長會去義賣,然後成立了一個基金作為後續的藝術教育的經費,該校當年也得到了公共藝術獎。《快樂是什麼》延續了我過往的訪談式方法,同時用影像記錄下師生的快樂或是不快樂的樣貌,這個過程是很不錯的,因為我很仔細地去整理這個訪談,然後把它編成書,將成果回饋給學校,然後讓校方可以以這本書當成學生輔導的材料,包括我在輔導大一學生時,常以這件作品來做開場,讓學生去檢視他們自己內心的狀態。因為有時候你陷入憂鬱,或是陷入一種比較低沉的狀態,自己其實是沒有察覺的。這件帶領我認識上帝,知曉了這位真神的存在,對我來說是一個非常重要的轉捩點。

三、以女性之名溫和揭露社會現象

王:從早期的《不只是為了女人》、《猜猜你是誰》、《快樂是什麼》,到後來的《亞洲新娘之歌》系列、《高雄眷村三部曲》系列,您都花費很大的功夫在前置的口訪調查上,這樣的深入田調過程,對於您的創作有何影響?訪問是否曾改變您對這個主題的設想?它與文字介入影像的呈現是否有一定的創作思考?

侯:《不只是為了女人》的訪談是以錄音的方式呈現,另外,每位受訪者也寫了簡短的自述,並沒有文字介入影像。從《猜猜你是誰》開始,則有受訪者的一句話的自述與我的表述,鑲嵌到影像中。這些文字的作用我在前面已提及。到《快樂是什麼》因為有出書的計畫,所以當時做了訪談,還做了問卷,以確認受訪者對「快樂是什麼」的定義,也因為需要確定定義,所以做得非常仔細。《亞洲新娘之歌》的三系

列作品則是因為這個議題相對複雜，每一個外配來臺灣的原因與原生家庭的狀態，如何來到臺灣的過程與到臺灣的適應狀態，口訪的時間較長，一定會做逐字稿；到越南的時候還有翻譯人員隨行，因為在越南語言溝通比較困難，也做了錄影，避免翻譯有一些出入，回到臺灣後再逐一做逐字稿。我的學校的東亞語言學系的越南籍老師認為我的作品反映了臺越婚姻真實的狀態，他們認為我的田調是真實可靠的。但在越南的時候，有些當地的人則認為我的作品太過溫和，並沒有反映出越南外配的極端處境，例如有些人是失婚後染上精神疾病，後來回到越南，落入一種人球的情況，這些情況都是我在越南很直接接觸到的。當時在越南拜訪了很多不同的單位，直接面對陷於困頓處境的外配，深度體驗了文化震撼，是一場特別艱難的旅程。田調是非常必要的，若是只著重在影像的捕捉，其實往往會對人、事、時、地、物無法深入了解。我舉一個例子，當時去伊甸基金會，該會拜託我去訪問一位越南女子，她嫁來臺灣，沒有拿到臺灣身分證，像人球一樣被踢回越南，然而卻兩次懷孕，都生女孩，孩子不幸生病。我記得我在訪問的時候，這個外配是在一家臺商公司工作，她的臺商老闆就問我說：「這都什麼時候了，你還有心情做藝術，做藝術要幹什麼呢？能夠幫助他們嗎？」此外，比如拜訪小翠的父母時，小翠已經過世了，而他們的處境也是非常令人心酸的，小翠的父母對我說：「如果你的作品可以幫助我們，我們就讓你拍攝！」我回到臺灣後也找過各種的途徑要幫忙小翠父母，還小翠一個公道，但真的是非常的難。所有的訪談，或長或短，有些時間拉得非常長，眷村的作品也是，前後耗時很久才慢慢了解人物的生命故事；尤其是眷村的部分，主要是因為眷戶遭遇到迫遷，是非常複雜的問題與過程，若沒有文字的表述，純粹影像是有相當難度，文字的介入有其必要性。

王： 我們觀察到在《亞洲新娘之歌》系列與《高雄眷村三部曲》系列您都透過相類似的手法，同時呈現受訪者的外表及內心獨白，這樣的安排在創作表現上是否有其特殊的意義？尤其在影像上您通常是安排人物肖像比較正面的以一種直面面對觀者，而文字上也選擇相對比較易讀的印刷體，這樣的表現手法一則讓觀者沉浸在一種質樸簡約的情境中，但卻又挑起視覺神經的知覺，不讓心靈麻痺的方法，是否可以請您談談當時的創作理念與您是否面對展示後觀眾的挑戰？

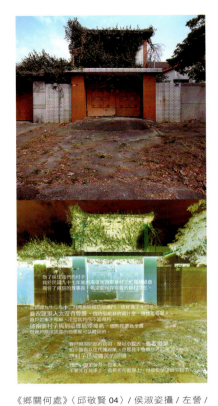

《鄉關何處》〈邱敬賢 04〉／侯淑姿攝／左營／2017
Chiu Ching-hsien 04 from the *Out of Place* series / photo by Hou Lulu Shur-tzy / Zuoying / 2017

侯：《亞洲新娘之歌》第一次是在清大展出，清大提供了兩片壓克力，可以夾裱懸吊的方式展示，幫藝術家省去裝裱費用。當時一開始是希望人物的肖像呈現是直面面對觀眾，觀者在閱讀時也可以非常輕鬆的狀態，因為它的尺度、用字遣詞是小學四年級就可以閱讀的文字，這樣子觀眾便可以讀到一方的獨白，了解到受訪者內心的想法。到眷村作品時就不是兩兩並置的方式，改為上下合併的方式，變成長條形的作品。一方面是2013年我在大趨勢畫廊展覽的時候，展場非常的大，挑高也很高，經過很縝密地測量，就決定用上下的方式來做這個作品，所以這個文字在眷村的部分就如同黃孫權老師提到的「雙眸」的概念；「雙眸」這個概念是指有一部分是紀錄式的、然後文字的部分是文件型的形式來呈現，那兩者在影像上可能以單色或是負片的形式來呈現。所以它一方面因為重複所以會加強對影像的認知，二來是在作品的呈現上文字，是延續性的，一個人的故事通常是兩則、或是四則、六則。在眷村的作品中有比較多我主觀立場上的表述，但在外配的作品時，就比較沒有這方面的表述，主要是因為在眷村作品創作過程中，我的確有太多話想說，對於這樣的議題無法再沉默了，所以在文字上有相當多的表達。不少人對文字出現在圖像上有不同的看法。最不同的看法就是說，圖像如果夠強是不需要文字來說明的，但是就如同我前面所說，這些議題本身太複雜了，單張照片是無法自己獨立將事情交代清楚，除非它是一部紀錄片，其實在紀錄片當中，文字與語言也是非常核心的，所以我認為並沒有必要迴避文字，特別是在觀念藝術之後，文字已經獨立成為一種藝術形式，只是我是把文字與影像變成一種影像敘事，但是這種影像敘事是一種加上文字的影像敘事，因此在色彩配置上，我也會選用比較單純單一的顏色，避免觀者太被干擾，也讓影像整個看起來比較可親近的顏色感，但是又可以吸引他們注意這些文字。

王：在《亞洲新娘之歌》系列中，您通過從北部到南部工作及生活的觀察後，深入外籍配偶的生活圈，訪談、追蹤，了解到她們來臺前後的內心的心理差異，但在作品呈現上，卻刻意地將影像上的操作痕跡減至最低，您是否有意以一種更溫和的方式，呈現這個複雜的社會問題？而我們知道這個主題您持續追蹤很多年，並發表三個系列，甚至您還到了這些外配的原生家鄉，並使用了攝影和錄影雙重的紀錄，您可以

談談您在這個過程中遇到的困難以及突破？想知道您的方法與想法，這麼複雜的問題如何用簡單易懂的方式讓大眾了解？在《高雄眷村三部曲》的拍攝過程當中也有遇到一些公權力的挑戰？您如何用一位女性的角度且不激烈的方式去面對這些挑戰？

侯： 在跟外配的互動過程中，她們的國語不是特別好，她們的生活圈是小的——她的田、家庭，偶爾會出去玩一下。她們的社會接觸面不是很多，相對也就對於我作為老師、藝術家的身分對她們來說也是非常好奇，要先建立信任感與縮小差距，讓她們感覺我不是一位不能理解她們的人，訪談時應該給予她們支持與溫暖；或許我無法直接幫她們什麼，但至少可以讓她們吐露心聲與訴說遭遇到的困難。但是我在作品呈現的時候需要保護她們，在《越界與流移——亞洲新娘之歌 I》，也就是第一系列的時候，我訪問了柬埔寨的外配，她們是非常直言不諱的，對臺灣政府的措施有相當多的批評，例如只要求外配節育，而不要求臺灣人節育等。印尼、泰國的狀況也都很不一樣，我曾經考慮過前往柬埔寨，但家人反對，覺得太危險了。印尼當時狀況也非常不好，所以後來專注於越南的部分。我所挑選的相對應的色彩，來自受訪者給予我的感受，是我主觀對這位女性的詮釋。我知道她們講述的內容是複雜與令人心酸的，但在圖像上我不會刻意去凸顯，多數的情況，也未拍攝她們的丈夫，是避免她們跟丈夫站在一起的時候，丈夫相對看起來是「老殘窮」的，當然也有例外的狀況，夫妻的合影是和諧可親的。我所謂的保護她們，就是當她們很嚴厲的批評時，我會刻意刪除過激的文字。她們不知道這些內容公開後可能帶來的殺傷力，作品表面看起來是非常溫和，沒有很多的波瀾，這些控訴不是大聲抗議，因為她們大多的狀態就是這樣，默默地承受很多事情。

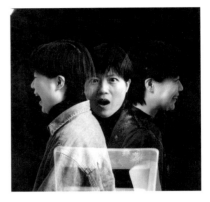

〈自我探索 A-2〉／侯淑姿攝／1996
Self-searching A-2 / photo by Hou Lulu Shur-tzy / 1996

在2009年擔任高雄縣地方文化館輔導團的訪視委員，第一次在醒村看到殘破不堪的房舍，當天晚上就無法入眠，覺得那些房子在向自己呼救。想起更早舊城文史協會理事長曾光正曾向我提及有關左營眷村保存的事，並前往探查，第一次看到面積與數量龐大的眷村宿舍，覺得這麼有歷史價值的房舍必須保存下來。恰好當時國防部研擬北、中、南、東、離島共要保存十個眷村，作為眷村文化保存區，因此透過議員拜會李永得副市長高雄市政府委託高雄大學來進行前置的研究計

畫，因此自己也擔任高雄市文化局委託的「左營眷村空間基礎資料與活化再利用屬性分析研究計畫」的協同計畫主持人，開始進行眷戶的口述訪問及眷村踏查活動。我後來又與國防部協商與遊說，過程十分艱辛，但是我終於走過來了。

王：從《亞洲新娘之歌》系列到《高雄眷村三部曲》系列，可以感受到您進行了一種參與式創作，走進了被拍攝者的日常，這是目前在臺灣比較少藝術家這麼做的，尤其鎖定在眷村拆遷與保存方面的議題，您幾乎以一種檔案式的「保存與修復」概念來面對一個極少人願意碰觸的議題。選擇一個稀有的，但卻有文化價值的主題似乎能讓您義無反顧地向前走，最後您總會讓被攝者參與在一個公共的空間（通常是美術館）間進行討論和回應，這種非常當代的藝術介入社會的作法，是否也與您一直保持與世界藝術走在同一方向有關？可否請您談談在《高雄眷村三部曲》系列中，您如何取得對方的信任，成為藝術作品中的一分子，並在最後成為出版物的共同敘述者？

侯：我之所以涉入眷村的這個議題全是來自上帝的呼召。2009年，我參與了高雄縣地方文化館的輔導團的訪視，看到已經被拆得非常慘烈的岡山醒村，而喚起了我對眷村保存的使命感。十多年來我的角色從一個研究者去寫眷村的報告，再到一個遊說者，去跟國防部眷服處、高雄市政府、立法委員進行協商與保存，並同步進行創作。在這當中，我是扮演著多重角色，因為我迫切地意識到這個消失中的眷村，它是臺灣近代史中很大的一塊拼圖。而這塊拼圖，在很短暫的時間，就是不到二十年的時間裡，八百九十七個眷村被清拆到剩下不到五十個；那些具有文資身分的，很多已經不是眷村，就是一個軍事地景而已，這當中有十三個眷村是國防部評選出的眷村文化保存區。我在《高雄眷村三部曲》作品當中，呈現了眷村的不同狀態：消失的、回不去的，以及奮力存活的三種狀態。我想跟我在美國學過照片修復這樣的經歷有很大的關係，因為我知道「影像等於是記憶」。影像是可以對抗遺忘的，老照片的保存有它的重要意義，但是能夠掌握當下正在消失中的也是重要的，不管是地景，不管是家屋，不管是人。我知道那種急迫感跟那種你一回頭，它就消失不見的遺憾。所以我的確是義無反顧，雖然我不知道最終的答案，這對我是一個責任，也是一個巨大

的挑戰。當眷村這個作品呈現在高美館的時候，它是一個非常全面性的揭露這個議題，就有點像炸開這樣子。我記得當時有很多的觀眾，來跟我說他們在高雄住了一輩子，包括我的同學，他也是高雄人，他說他完全不知道這些眷村的存在，他從未聽聞或造訪過。所以我意識到一件事情，就是上帝給我的這個任務真的很特別，我不是一個眷村人，也非外省人、非高雄人，祂讓我有一個不同的眼光與不同的角度去看待眷村。

如同面對外配一樣。我對待眷村的爺爺、奶奶、大哥、大姊，對他們產生了很強烈的一種革命情感，因為最主要是這中間有幾個眷村經歷了迫遷，經歷過他們與國防部的訴訟，以及在這樣一個漫長的掙扎過程中，你看到眷村人一個一個被迫含淚離開，然後看到那些房子，一間一間慢慢地清空，最終成為廢墟。這個過程很不容易，包括我自己去寫了這些報告，做了這些政策研究，也提出了眷舍再利用的方案等等，可以說我把我很多的夢想，包括對眷村未來發展的夢想都投注在這裡。我也很希望有這樣一個契機讓眷村的議題，可以回到一個比較正面的對待，而不是因為政治的操作，讓外省眷村背負著既得利益者、只是屬於國民黨的偏見。希望今年出版的三部曲的論述集與作品集的套數（四冊），可以對上帝有一個交代，也是我對已在天上的眷村老人家的感念。我認為是國家對不起這些軍眷族群，他們的晚年並不是平靜、祥和的，而是要去面對「鄉關何處？家在哪裡？」的困境。也因為這場漫長的戰役，我與這些軍眷族群有了所謂的「革命情感」，感謝上帝的愛，使我在當中成為和平的使者。

四、深入探討作品意涵

王： 您在《窺》系列中以結合攝影及行為表演藝術進行創作，是否意圖透過以女性身體／形象介入藝術創作直接挑戰社會實踐的曖昧性和危險性？《窺》作為一個女性／主義藝術家的藝術實踐，是否必然建立了女性凝視的女性美學系統，《窺》系列在刺激眾人思索、改變臺灣男性凝視認知體系的同時，是否也如您所願的延燒出許多後續的期待和效應，您的創作是否有意透過女體與攝影再現、建立女性凝視（female

gaze），以及藝術評論與藝術創作之間關係？您2000年在日本的創作《Japan- Eye-Love-You》，是否開啟了您對亞洲女性關懷的起點？

侯： 好，應該是說在作品《窺》，它有一部分挑動了社會的敏感神經，就是對於身體的裸露，對於這種視覺政治學的底線的挑戰。也就是說在哪一條線上，是大家可以接受。以現在的角度看《窺》，當然也不是那麼驚世駭俗。但在1997年發表的時刻，其實是承受著滿大的壓力。這個壓力來自很多的責難，質疑女性藝術家有必要如此去談女性的處境嗎？是否一定要聚焦在所謂的「男性觀看」（male gaze）？但我想說的是，「反男性觀看」應當從怎樣的角度開始呢？去挑戰既有體制之後，才有可能建立所謂的「女性觀看」。當然這個作品發表距今已經有二十五年的時間了，如今大家普遍認為談女性主義已經過時，或是談物化女性，已經不是絕對必要的。但是比方說美國的#MeToo運動，或是韓國的演藝界對女性的不平等對待的事件、臺灣的房思琪事件等等。女性藝術家要呈現的「真我」如何被關照，因為這個部分牽涉到很多環節，包括我們之前提到藝術評論的角色，藝術評論是否了解這個創作的脈絡跟解讀，我覺得在這方面有滿大的努力空間。

2000年在日本橫濱美術館畫廊的個展《Japan-Eye-Love-You》是因為我在1998年到日本Za Moca基金會駐村，注意到日本情色影像的氾濫。比方你走進7-11，輕易就可買到一些奇怪的雜誌，其中會有男性直接問年輕的女生，「請問你今天穿的底褲是什麼顏色？」這不是太奇怪了嗎？怎麼會有這種對話？但這種色情雜誌就直接出現在便利商店，而且是相當氾濫的一種狀況。談到一般我們認知的日本女性是溫婉典雅跟持家的形象，與情色影片裡滿足男性幻想的護士、學生的角色的極端對比，所以我就以自拍的方式去嘲諷日本的物化女性的現象。另有一部錄像是直接從A片去製作的。2017年由北美館余思穎所策劃的展覽「微光闇影」中，這是我首次在臺灣發表這系列的作品。

王： 您為了回應在國外時，不斷被問及自己是誰，以及無法清楚回答的窘境，因此在回到臺南故鄉的尋根溯源之旅後，嘗試從差異性別、族群、種族、宗教和階級的臺南人出發，剖析和呈現他們如何看待主流臺灣集體認同論述體系，以及如何打造自身的主體認同經驗，從而創作了《猜猜你是誰》。您是否有意以微觀的個別主體體驗，扭轉主流

的二元對立認同論述體系？您常用很微小的一個人的力量，去做了一個面對這個主流的面對，毫不懼怕，而我們知道您在最近幾年有了基督教信仰，由上帝帶領產生的信心，似乎看到您對生命的相遇產生更多公義之心，可否談談這方面的改變對您的創作有無影響？尤其是對女性勞工、外籍配偶、眷村文化等議題深入研究與深切情感。

侯：我想這題對我來說是滿重要的。因為，我雖然在2002年在做《快樂是什麼》的時候，就決志要成為基督徒，但那個時候並沒有到教會。2004年到了高雄，適應環境花了滿多時間，一直到2008年，我去越南，在旅程體會神保守的恩典，使我一路上都沒有生病，毫髮無損，除了曬傷外，安然歸來。雖然經歷很多的驚險場面，但是一路都非常平安，因此我在2009年的復活節受洗。受洗沒多久之後，神就感召我去做眷村保存的工作。這一路以來，我覺得不管在外配的議題上，或在眷村的議題上，可說是一個信仰之旅，見證神的恩典的旅程。特別在眷村保存的這件事情上。明德、建業、合群三個眷村能夠被保存下來，成為文化景觀，我認為就是一個神蹟，神使用了我在這當中做一個和平的使者，讓本來無法對話的不同團體、族群還有公部門產生對話，產生一種可以協商的機制。神呼召我是為了替這一群被壓迫、受迫遷的眷戶發聲，儘管最後他們並未能如願地留在眷村，但是我自始至終都相信神的公義是要被彰顯。我認為神有祂的美意在當中，比方說，我跟眷村的人傳福音，雖然也遭遇很多困難，但是到最後例如韓斌將軍，他願意禱告、他願意相信有這位神。

最後一位離開的是韓斌將軍，再幾天就要搬離眷村，因為他的官司輸了。（本書出版時他已不得不搬離，但仍有眷戶堅持住在那裏）這個過程並不容易，因為我相信如果說我不是有神的支持，我也不可能支撐到現在，尤其又經歷了癌症。我覺得這一路是上帝讓我知道，我是祂的女兒，而且我在做一件很重要的事情，也許別人不是這麼認為，認為我是一個傻子、一個笨蛋，都有各樣的說法，或是說我就是固執。但是我知道正是因為我是基督徒，所以在眷村與很多人的相遇，其實是神的帶領。我想我是揭露了一般臺灣人或高雄人不曾碰觸過的議題，感觸良多。

侯淑姿　HOU Lulu Shur-tzy

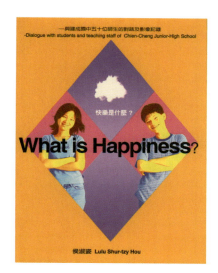

《快樂是什麼》封面 / 侯淑姿攝 / 2002
The front cover of *What Is Happiness* / 2002

王： 您為了創作《快樂是什麼》而實際進駐建成國中，走訪該校師生，並以影像和文字呈現該校師生對於人生問題的看法。在計畫執行和腦力激盪過程，及其最後藝術家與建成國中師生在書中以及在學校成果展中所呈現之共同記憶，您是否試圖從細微之處，逐漸解構臺灣當代公共藝術創作的主流想像，從而逐漸瓦解眾人與藝術之間的巨大藩籬，以及改變藝術、社會以及教育結構和內涵的質變潛能、衝擊和影響力，想請問您這種想法是否與您當時從國外返臺，又有一份與公共事務有關的工作有關，只不過所使用的表現手法，在當時的確是屬於很前衛的方法，您是否對未來的藝術創作者也有所期勉？

侯： 臺灣當代的公共藝術面臨了一些困境，這種困境當然跟法令與執行面有關。還有就是藝術家要進入公共藝術製作的時候，經常會無法適應這整套的作業系統，他們也許可能就是循著那個過去的模式。我當初在提《快樂是什麼》這作品的時候，當然很幸運，執行小組成員或是審議的一些委員，他們容許了這樣的一個開放性，因為在這個案子當中，有百分之二十的經費是要投注在教育，就是實際去跟學生上課，帶領他們做創作，還有就是我的訪談的人數相對地也非常多，五十個人的數量其實是一個海量，一般的訪問很少有做到這樣的人數。如此逐一的訪談跟拍攝、問卷的過程，讓我得以深入地探討這個議題。我想應該這樣講，就是說公共藝術從過去一直強調它是一個物件，至今變成可以是計畫型作品，比如影片拍攝或是一些其他不同的戲劇、表演方式，我想大家對公共藝術的想像開始有了一些不同的改變，我也很期待有更多的影像工作者來做公共藝術，當然也牽涉到攝影這個媒材的特性有關，材質轉換的永久保存、耐候性等條件，但是我還是很期待這種對話式的創作，一種互為主體性的創作，特別是在學校的公共藝術，這個部分可以有比較多的討論跟可能性。

王： 在漫長的五年《亞洲新娘之歌》系列作品中，您刻意讓跨國婚姻中的臺灣新郎缺席，是否認為跨國婚姻中的不公平，並非僅緣於個別的臺灣社經地位弱勢的男性，這是臺灣在全球化過程中臺灣農村所要面對的挑戰與壓力。因此您希望藉由作品記錄外籍配偶，替外籍配偶發聲，希冀雙方能有「互為主體」的可能性，此系列作品對於您可以說是一個女性影像書寫創作的最高峰，它應該不僅是創造一個讓臺灣民

眾看見底層他者的機會，同時也顯現出您對生命的尊敬與價值信仰，但對於一位持相機的攝影者而言，您是否自己曾自問這樣真的就夠了嗎？尤其當攝影主題與社會關懷掛上鉤時，您是否曾經有過心有餘而力不足的困境？

《越界與流動——亞洲新娘之歌 I》〈貴孝與小孩 (A)、(B)〉/ 侯淑姿攝 / 越南 / 2005
Kuei-hsiao and Her Child (A)、(B) from the Border-crossing/Diaspora–Song of Asian Foreign Brides in Taiwan (I) series / photo by Hou Lulu Shur-tzy / Vietnam / 2005

侯：我到越南之後，發現在越南的媒體當中，對臺灣新郎這樣的角色描述是非常負面的，比方說會演出八十歲的臺灣老公公，娶了一個二十歲的越南老婆，然後把它演成一齣鬧劇，眾人哄笑一番。我親眼看過電視上演的這些戲劇，心裡五味雜陳。這種婚姻的不對等，包括老少配或是經濟條件的不對等、社會地位的不對等。但是這些我們過去普遍認為條件較弱的男性，他們在我的作品當中的缺席，其實是刻意的，他們缺席讓不是那麼相稱的相貌、外表、年紀的一個狀態不會被刻意地凸顯，這是一個善意的動機。我企圖透過作品，呈現隨著時間的推移，外配她們的生命的歷程與變化，包括她們的孩子的成長。我曾經希望可以繼續拍攝這個主題，因為又過了十年，現在高美館又正在展出〈貴孝〉的系列。但這些受訪者的境遇已是物是人非，很多當年期待是永恆不變的愛情或者婚姻，已經產生了嚴重的分歧或者離婚，此時繼續去關注他們、呈現這樣的變化，他們不見得願意。也需要有更多的溝通才能延續此主題，包括我自己才能坦然地面對這種生命的改變。眷村的作品，依然是替女性發聲，是眷村女性影像書寫，我並沒有因此而退卻下來。

王：一樣是社會關懷，您在《亞洲新娘系列》之後，同樣是地緣關係，您走進了七個眷村之多，《高雄眷村三部曲》系列，執行了難度頗高的高雄市眷村女性生命史紀錄計畫。可否請您談談這個相遇看似一個「他者」的身分反轉，如何介入另一個他者的「鄉愁」？對於一種離散身體是否在您的系列作品中反覆被提出來，從「我是誰」到「女性的主體性」的問題喚醒，就像建立了一種視覺政治學，能否談談作品的「雙眸」（雙向、並置）設計，是否欲留給了觀眾一個怎樣的想像？以及他自己面對這樣的影像，內心所產生的責任？

侯：有關於眷村的研究，我做過三個計畫，第一個2009年的「左營眷村空間基礎資料與活化再利用屬性分析研究計畫」，我擔任協同計畫主持人，負責眷村的空間再利用的部分、還有政策跟策略，2010年做

侯淑姿　HOU Lulu Shur-tzy

了「高雄市眷村女性生命史紀錄計畫」，擔任計畫主持人，執行了一年，訪問了十五位女性，訪問的期程比較長、也比較深入。這個計畫的難度在於外省女性跟外配一樣被視為「他者」，我覺得外省的女性來到臺灣的時候，她們就知道自己是圈外人，因為她們不會講臺語，她們的風土民情都是來自另外一個地方，她們對於大陸是懷有濃重的鄉愁的。這些訪問會勾起她們比較悲傷的記憶。比方說她們的父母離世的時候，她們都不在身邊，回到大陸就只能是去祭拜父母或是親人的墳，多位受訪者都提到這個部分，甚至找不到墳的就只能在一個空地上，對大約的方向上祭拜，然後每年過年的時候，也沒有祖先牌位，就是寫了一張紅紙來祭拜歷代的祖先等等。這些作為外省人在臺灣的鄉愁跟離散的經驗，令我感觸良多。所以在這樣的一個歷程當中，我也一直希望能夠透過作品去感受她們的生命歷程，所以有這樣一個雙眸作品的產生。回到所謂的第一人稱，互為主體的這樣一個概念。這個第一人稱的敘事，是非常重要的：當觀眾面對這個影像，然後看到第一人稱的敘事，了解這個說話者的立場跟位置。相對地如果在一個風景、一個巷弄的場景或是一棵樹，很可能是我作為一個主述者，陳述我看到的眷村的變化或者是眷改的情景。這個敘事者的變換跟轉移，會讓觀眾因為說話語氣不一樣，而體會到這當中的立場的差異跟說話者身分的轉變。這樣的方式，在外配的作品裡頭是沒有的，因為在外配作品裡頭，我並沒有做這種主觀的陳述。在眷村的作品，有更深刻跟更沉痛的話要說。2014年擔任「文化景觀鳳山黃埔新村再利用規劃研究計劃」的計畫主持人，訪談了多位經歷孫立人、郭廷亮匪諜案的相關人士，也使我對此歷史事件體悟甚深，在二部曲《長日將盡》中表述出來。

王：所以您有預留給觀眾一個想像的空間，以及觀眾他自己面對這樣的影像，內心所產生的一種責任。

侯：展覽過程中，我與觀眾的互動不少，得知滿多觀眾都去過兩、三次，他們就是在那裡徘徊，他們在展場裡找他們記憶中的眷村，消失的眷村。所以我想這個作品創造出一種語境，這種語境讓不曾進過眷村的人，跟曾經住過眷村的人，各自擁有自己對眷村的想像跟回應的空間。其實我自己現在再看這個作品，對比拆除後的現況，變化通常非

常大,比方說整個都拆掉改蓋成大樓,蓋到滿出來的境地,沿著道路邊都蓋到失控的境地。當我們從影像去看的時候,我們就知道這個地方城市的地景變化是急遽的,而背後當然就透露出這個城市的土地商品化,美其名為都市更新,其實本質就是國土賤賣的結果;幸運的是,明德、建業、合群三個眷村,是2010年因為我們的報告通過才被保存下來的。

王: 能否談談《我們在此相遇》、《長日將盡》、《鄉關何處》系列作品中眷村人及其女性,對於宿命中的持守、等待、回不去的鄉愁情懷?是否如同您作為一個女性同時是一位藝術家,面對創作的堅持與離散的生命史的衝突,當持相機的手徘徊在一群「移民」失落的地景中,您也同時尋找著自己的主體性的「所在」,義無反顧,在此系列中您如何凸顯出眷村女性的生命經驗與記憶?對社會、政治等弱勢議題的關注,形塑您創作的主要內容和想法,又您如何讓藝術與社會貼合成為內在自省力?您如何認定以攝影影像作為一種介質,是比其他媒材更容易完成?或者更容易擔負的一種視覺政治學的責任?

建業新村王姜宜鳳與孫女自宅前 / 侯淑姿攝 / 左營 / 2017.7.4
Wang Chiang Yi-feng and her granddaughter in front of their house. Jianye New Village / photo by Hou Lulu Shur-tzy / Zuoying / 2017.7.4

侯: 這是一條漫長而艱苦的道路,大部分的時候,包括眷戶,他們只知道我就是做眷村研究的學者,他們對於我作為一個藝術家的身分,是不了解的。從2009年一直到2017年,直到在高美館展出,眷戶才看到這個作品,所以很長很長的時間中,他們完全不知道我是個藝術家,也就是說在這樣的一個過程當中,我是以一個研究者跟幫助者的角色出現,是一個倡議要保存眷村文化的人。但是對於他們來講,這件事情非常簡單,就是「我要住下去,這是我的家」,至於談到眷村文化保存,那他們對這個課題可就非常冷淡了,因為他們本來是主體,他們身上就是帶著這種生活方式跟這種文化,可是當你跟他講這個文化被保存的時候,他們就傻了,因為他們不知道到底這件事情是要做什麼?這個可能有點離題,但這就是問題的核心,一直處於繞圈子的狀態。在文化人來說,我們認為做文化保存是最核心的,但是對於這些生活在眷村的人來說,他不清楚你到底要保存什麼?那以至於當他們都離開之後,你說你希望看老照片、做訪談,希望有紀錄片或口述歷史的呈現,他們的態度就非常的消極跟負面,因為他們覺得所有的東西就是過去了,沒有了就是沒有了,再回頭只剩難過與傷心、無奈。現在「以住代護」進去的人,多半是沒有住過眷村的人。

因為我所受的專業訓練就是在攝影，也曾在美國伊士曼攝影博物館曾學習保存照片的相關專業訓練一年，對於美國的文化資產（cultural heritage）的保存制度很是感動；因此義無反顧地投身眷村文化的保存，我認為藝術是能夠改變的，特別是影像可以召喚記憶、對抗遺忘，我還是這樣的堅信。就是說影像跟文字、繪畫、雕塑、其他的媒材，的確有一個本質上的不同，因為影像所拍下的就是一個真實的經歷，是在我的「主觀」的角度下，我所看到的眷村，這與眷戶記憶中的眷村不會是一樣的；因為每個人對於眷村的記憶，個人主觀的成分還是很高，但因為我提出了這些影像，他們也重新看待了眷村的美好，也許我也讓他們看到在攝影當中眷村的不同樣貌。其實好像大家都覺得眷村人是既得利益者，可是在整個眷改與迫遷這件事情上，事實上他們是非常無助跟弱勢的一群人，從媒體、民意代表到公部門就是不管你，不願意去正視或是不願意去談迫遷這件事情，所以它的難度跟爭議性很高。若以聯合國教科文組織將「南北離散家族重聚」的活動列入「世界記憶」的檔案為例，兩岸的離散家庭，以倫理與公義的立場，或以戰後新移民聚落的集體記憶保存的角度而言，都仍有許多可努力之處。而攝影，在這當中亦仍有甚多可縫補記憶的空間。

「鄉關何處」展場 / 侯淑姿攝 / 高雄市立美術館 / 2017
Out of Place exhibition / photo by Hou Lulu Shur-tzy / Kaohsiung Museum of Fine Arts / 2017

Interviews of Hou Lulu Shur-tzy

My Creative Journey

Q (Wang Ya-lun): When was the first time you encountered photography? How did your family react to your art career? Did your sensitivity and grasp of materials while studying fine arts in the U.S. impact your later works?

A (Hou Lulu Shur-tzy): I decided to major in the fine arts department at university while I was in senior high school. However, my exam results weren't so good, and I ended up in the philosophy department. After I entered the philosophy department, I received a Nikon FE2 from my mother, who had visited Japan, as a present for being admitted into a university, which encouraged me to join the photography club after classes. I realized my passion for photography and held a double solo exhibition during my senior year and a group exhibition with NTU Photo at the Taipei Cultural Center. Most of my works at the time were landscapes, as in "straight photography" and more like the mindscape photography approach, which was inspired by the U.S. photographer Minor White. After graduating from university, I learned photography at Juan I-jong's darkroom studio for a brief period and the Zone System from Chiang Tsai-jung. I think I was always searching for the imagery in my own mind, like the title of my portfolio *The Reflection in the Lake of Life: The Photography Works of Hou Lulu Shur-tzy*. This portfolio includes the photography works I created between the ages of 20 and 27. When I expressed to my family that I must study photography abroad, my mother did not understand my decision at first, but she later supported my wish. I gained entrance to study for an MFA in imaging arts at the Rochester Institute of Technology (RIT) and later went to Alfred University to study sculpture. During this process, I also learned printmaking, pottery, metalwork, woodwork, and video. When I arrived in the U.S., I discovered that installation art was the main trend while performance art and public art were mainstream genres. This made me realize that I had to learn different fields and mediums in my studies. I was fortunate to have expanded my learning and experimented with different approaches during my studies, which proved to be impactful to my later work.

Q: You particularly mentioned the culture shock regarding the inter-medium and performance art tendencies in the U.S. art world you experienced while studying for an MFA in imaging arts at the RIT. Your early works seem to reflect feminist artists or thoughts you encountered while studying in New York. Please tell us about their impact on the theme of your work.

A: The training at RIT stressed "non-photo." Although I studied at the School of Photographic Arts and Sciences, I shifted from photography to imaging arts and believed it was important to integrate different mediums and art genres. The culture shock that I experienced at the time was intense, and I was not used to the pressure of the evaluation every ten weeks. I had to be familiar with the trends of artistic thoughts and the works of contemporary artists. I reflected on my own mental state from the perspective of a feminist, and how, as a woman from the East, I could express my works in a Western setting and make them understood and accepted. I also realized that I had to shift my method of

〈昨日的夢〉/ 侯淑姿攝 / 1989
Dream of Yesterday / photo by Hou Lulu Shur-tzy / 1989

artistic expression and experience different creative methods, from self-portrait photography to performance art, public art, and various mediums. In the end, my master's dissertation was "Staged Photography" with an installation made with pottery figures.

Later, when I went to Alfred University, I created *Not Only for Women*, one of the two series that I created during my studies in the U.S.; the first was The *Labyrinthine Path*, which explores the relationship between love and desire, and the second was *Not Only for Women*. The women artists I encountered during that time deeply impacted my work.

Q: **When you created the profoundly feminist work *Take a Picture, It Lasts Longer* in 1996, you resorted to images that were especially direct and intense to deconstruct patriarchal culture. During your studies, you encountered performance art, and you were also influenced by the courses and the overall setting. How did these factors materialize in the work *Take a Picture, It Lasts Longer*?**

A: I created *Take a Picture, It Lasts Longer* when I returned to Taiwan in 1994 and held the *Not Only for Women* solo exhibition at the IT Park. The exhibition was met with distinct reactions. Many male artists reacted negatively toward the work because placed in the work was a cross with a pair of metal breasts on top. I invited viewers to respond to the concept I was presenting: "Women are the sacrifices of society." The entire work was photographed by a commercial photographer and included in a magazine; I filed an infringement lawsuit against this photographer and magazine. This process allowed me to discover that my creative freedom was limited and that, overall, feminist subject matters were not positively received in Taiwan. I applied to Tehching Hsieh's art studio, a ten-month residency that spanned 1995 and 1996; the studio was "The Earth." Hsieh was very supportive of my performance art, but I thought performance art was not where my strength lay. After some thinking, I decided to apply my experience in Taiwan and put how men perceived and looked at women, and how women responded to this view, under the spotlight; this led to *Take a Picture, It Lasts Longer*. The photography work is a continuous series that shows the moving frames of movements. What I stressed in this process was the medium that presented the concept; my aim was not to document.

Q: **You seem to have put a lot of effort into publishing portfolios. The first one you published is *The Reflection in the Lake of Life: The Photography Works of Hou Lulu Shur-tzy*, and over the years, you went on to publish others that feature your exhibitions. Your works and portfolio were also presented at the Tokyo Photographic Art Museum in Japan. It seems that writing and critique have become a part of your work. Please tell us more about this topic.**

A: *The Reflection in the Lake of Life: The Photography Works of Hou Lulu Shur-tzy* includes a collection of 98 black-and-white photographic works created between the ages of 20 and 27. I was a managing editor-in-chief of a Chinese dictionary at Tung Hua Books, and Professor He Siou-huang, the editor-in-chief at the time, encouraged me to arrange my works into a system. I sorted the works into

three categories. The first feature nature, ecology, and scenes of everyday life; the second includes images that were taken with 6×6 cameras and feature the passing of time and traces of memory; the third is urbanscapes, such as scenes of the National Taiwan University or the zoo, scenes that remain interesting to this day. It was the age of black-and-white photography, and I developed and printed my works myself, indulging in my creations. I decided to publish my works, which led to *Female Image Writing Lulu Shur-tzy Hou's Photography Work* (1989-2009) in 2012 and *Old Times, Good Times: Military Dependents' Villages Image Book* in 2014. I spent an extensive amount of time editing the portfolios after the exhibitions ended; of course, the Kaohsiung Museum of Fine Arts also published a catalog of my work along with the exhibition.

Because I had participated in a residency in Japan and a few exhibitions in art museums, Kasahara Michiko, the former chief curator of the Tokyo Photographic Art Museum, titled the series on the topic of "love" in her curatorial statement. Natalie Seitz's article talked about how culture shock impacted and changed my work. Kasahara Michiko's article mentioned the issues of Chinese in Taiwan; she was very insightful in her handling of the changes in history and felt my concept of placing images in pairs either vertically or horizontally to be innovative. Others who liked my work include Japanese critic Iizawa Kotaro, who also wrote about my work. Michelle Vosper from the U.S. devoted a chapter introducing my work in her book *Creating across Cultures: Women in the Arts from China, Hong Kong, Macau and Taiwan*.

Q: **You spent a few years restoring photographic images and preventive conservation work, and you maintained this role as a pathfinder when the National Center of Photography and Images was established. Tell us about your role and how you started dedicating efforts to rescuing cultural assets apart from your identities as an artist and teacher after returning to Taiwan.**

A: During my master's studies, I was an intern at George Eastman Museum for one year and took courses on photography conservation and restoration. Later, I gained the status of a special student at Alfred University for one year and taught at Corning Community College for six months. After that, I continued to take classes on repair and obtained a diploma. I focused on the conservation and restoration of deteriorated albumen prints. In 2004, I was commissioned by the National Archives Administration to conduct the Research on Methodology of Photographic Conservation project and organized workshops on the preservation of photography materials at the Tainan Municipal Administration of Cultural Heritage in Tainan in 2005 and 2006. When the Ministry of Culture made plans to establish the National Center of Photography and Images, I served as a member of the consultation and collections group for five years. I focused on the establishment of the aesthetic and historic value system of Taiwanese photography, especially the importance of 19th-century photography, and helped with the acquisition of 19th-century photographs.

Tenderly Revealing Social Phenomena as a Woman

Q: Most of your later works, from *Not Only for Women* to *Song of Asian Foreign Brides in Taiwan* and the *Military Dependents' Village* series, were presented as "photography installations" and "photography sculptures." Was this a display strategy that put the traits of photography, installation, and exhibition space into consideration?

A: Yes. I have presented my works as "installations" since my earliest works. *Song of Asian Foreign Brides in Taiwan* was first presented at an exhibition I was invited to hold at the National Tsing Hua University Arts Center in October 2005. At the time, I decided to present the images in pairs. The most comprehensive display was at the Kaohsiung Museum of Fine Arts, which was also where *A Trilogy on Kaohsiung Military Dependents' Villages* was most comprehensively exhibited. More often than not, my exhibitions were not merely the display of works; instead, the "double gaze" presentation (to quote the saying of curator Huang Sun-quan), color setting, and spatial installation methods were all decided at the very beginning. The difference between the three series was the number and people who were interviewed, and the people who were included after I visited the family of the foreign spouses. I also added moving video images.

Q: We sense that you've engaged in participatory work, entering the lives of the photographed subjects with a focus on the demolishing, relocation, and preservation of military dependents' villages, approaching the subject matter that few are willing to tackle with an almost "archival" approach of "conservation and restoration." This way of intervening with society involves traits that are distinctively contemporary art. How did you gain the trust of your subjects for them to become a part of the artwork?

A: I delved into the subject matter of military dependents' villages purely because of God's calling. In 2009, I participated in a guidance group visitation to the Gangshan Cultural Center, and when I set eyes on the predicament of Sing Village, which already been demolished, I immediately felt a sense of obligation toward the preservation of military dependents' villages. Over the past decade or so, my role has been to write reports on military dependents' villages from the perspective of a researcher, and later a lobbyist, discussing the issue of preservation with military dependents' village service stations, the Ministry of National Defense, the city government, and legislators. Of course, in the end, I approached the subject matter as an artist. This is because I am deeply and urgently aware that these disappearing military dependents' villages are a missing piece to the puzzle of the modern history of Taiwan, where in a very short segment of time (less than 20 years), possibly less than 50 military dependents' villages would be left from the original number of 897. In my Trilogy, I feature military dependents' villages in varying states, those that have disappeared, those that cannot be restared, and those that are struggling for survival. I think my efforts are related to my experience of learning photography restoration in the U.S., because I am aware that image equals memory. Images are resistance against forgetfulness; the sense of urgency is that it might no

longer be there when you turn back to look. For me, this was a responsibility and an enormous challenge.

It's like my encounters with foreign spouses. After spending some time with the elderly and seniors of the military dependents' villages, we bonded over a strong sense of comradery, mostly because I saw how they were forced to relocate, their litigations with the Ministry of National Defense, as well as their long-time struggles. One by one, you see the residents being forced to leave with tears in their eyes, and the houses becoming empty, left to become ruins. This was a difficult process and I hope that my work can let the issue of military dependents' villages be treated in a more positive setting without political undertones, and that the military dependents' villages can be free from the prejudice of vested interest groups and the Kuomintang. I believe our country has failed to treat the military personnel and their dependents with fairness; they were forced to deal with being "out of place," asking "where is home?" in their old age, which was supposed to be filled with peace and tranquility.

Q: **After the *Song of Asian Foreign Brides in Taiwan* series, you once again resorted to geographic relations and commenced on *A Trilogy on Kaohsiung Military Dependents' Villages*, which also expresses social concerns and delves into the difficult task of documenting the life histories of women in the military dependents' villages of Kaohsiung. The topic of the diaspora of the body seems to appear repeatedly in your works, and your query reawakens questionings from "who am I" to "the subjectivity of women," which seems to construct visual politics. Can you tell us about the "double gaze" (two-way, juxtapositioned) design in your works?**

A: In my research on military dependents' villages, I conducted three projects; the first was the *Basic Information on Zuoying Military Dependents' Village and Repurposing Attribute Analysis Research Project* in 2009, which oversaw repurposing the spaces of military dependent villages, as well as related policies and strategies. The difficulty of this project lies in the fact that, like foreign spouses, women from China were treated as "others." I think when the women arrived in Taiwan from mainland China, they were aware that they were outsiders because they didn't speak Taiwanese, and their cultural background was from another land; therefore, they had a deep sense of yearning for China. I think the interviews unearthed some sad memories. For instance, they were not there when their parents passed away, and when they finally returned to the mainland, it was to pay respects at their parents' or family members' burial sites. The experiences of melancholy and diaspora among Chinese in Taiwan are also felt by myself, which was why I wanted to empathize with their experiences through my works, which led to the "double gaze" in the works. As for the first-person perspective and the idea of intersubjectivity, on the one hand, viewers see the images and the narrative from the first-person point of view and understand their position; on the other hand, a scene, an alley, or the view of a tree may be changes or reconstructions that have occurred in the military dependents' villages viewed from my perspective. This shift and change in the narrator make

viewers realize the difference in positioning and identity of the speaker based on the tone of speech. This approach did not appear in the work on foreign spouses, because I did not engage in this subjective narration. In the work on military dependents' villages, the message was much more profound and heavy.

Q: **You were also searching for your own "place" when wandering in the lost landscape among a group of "immigrants" with a camera in your hand. How did you accentuate the life experiences and memories of the women of military dependents' villages in this series? How did you determine photography as a more suitable medium than others or a medium that could more easily shoulder the responsibility of visual politics?**

A: This is a long and challenging path. Most of the time, they viewed me as merely an academic researching the military dependents' villages, the village residents included. They did not understand my identity as an artist. From 2009 to 2017, the residents of the military dependents' villages finally saw my work when it was exhibited at the Kaohsiung Museum of Fine Arts, which meant that, for a very long time, they did not know that I am an artist. But, for them, it was as simple as "I want to stay here; this is my home." They were the subjects and carried the lifestyle and culture with them. For intellectuals, we believe cultural preservation to be at the center of our efforts, but the people living in the military dependents' villages don't know what it is you are trying to preserve, so when you express the wish to see old photographs and conduct interviews or make documentaries or oral history after they had left, they responded with an attitude that was passive and negative, since glancing back at the past brought nothing but heartbreak and helplessness; the people who are moving into the area now do not come from military dependents' villages.

Since my professional training was in photography, I was inclined toward the preservation policies of cultural heritages, and I believe that art can benefit the projects and efforts in coordinating the preservation of military dependents' villages; in particular, images could summon memories and act as resistance toward forgetfulness. I still believe this deeply because the military dependents' villages that I see will be different from the ones in the memories of their residents, since the memories of individuals are affected by subjective experience. However, by showing these images, they reinspected the beauty of the military dependents' villages. The truth is that these people are very vulnerable and neglected by the media, people's representatives, and the public sector; society is unwilling to deal with the issue of forced relocation properly. Therefore, the difficulty and controversy of the issue lie in the fact that the people of Taiwan are unwilling to treat the rediscovered archives as international-grade archives like how North and South Korea are treating their materials. The complicated relationship between Taiwan and mainland China is very similar to North and South Korea. From the perspective of morality or justice, these blood-related people were forced to be separated or categorized; I think there are many things that photography can do in this issue.

傳記式年表
BIOGRAPHICAL TIMELINE

1962	｜出生於省立嘉義醫院｜
	當時父親為華南銀行的行員，一家居住於銀行日式宿舍（明園）。父母均為嘉義縣六腳鄉人。祖父務農之外，也編竹製器具貼補家用，農閒時自製椰殼絃及歌唱自娛。外曾祖父辛勤耕作，擁有許多田產。外公曾擔任嘉義縣六腳鄉竹本村村長與鄉民代表。父親侯清杉與母親侯陳金箱於1957年結婚。婚後育有二男二女。侯淑姿排行第三，上有哥哥志欽、姊姊淑芬，下有弟弟凱文。
1966	三歲半隨父母搬遷至臺北。因父親換分行的緣故，曾四度搬家。先後住過迪化街、涼州街、南京東路、八德路。直到搬遷至八德路的華南銀行宿舍後，生活逐漸安頓。
1968	就讀臺北市立長安國小。因出生於10月，入讀時不足歲，寄讀了一年，次年才算正式就讀。父母對於子女的教育極為重視，管教嚴格。因房客謝叔叔的啟發，小學階段即對繪畫產生濃厚的興趣。
1975	長安國小畢業，榮獲市長獎畢業。就讀長安女中，成績優異。
1978	考上臺北市第一女子高級中學。高一被選入游泳隊，專攻仰式，並擔任隊長。高二上場比賽，個人雖未得獎牌，但因每日上午不間斷的訓練，培養出強健的體能與毅力。課餘時間從建中美術老師學習水彩畫、國畫，並立志考美術系。另向臺灣師範大學陳景容教授學習素描達兩年的時間。
1981	｜北一女畢業｜
	北一女畢業。意外未考上美術系，考上臺大哲學系。母親贈送Nikon FE2相機，開啟了對攝影的興趣，並加入攝影社學習暗房的技巧。從李光裕老師學習素描。
1983	與友人參與一趟古蹟之旅，此行開啟對文化資產保存的興趣。

七個月 / 1962
Seven months old / 1962

三歲半全家合照（前排左二為侯淑姿）/ 1965
Family photo at three-and-a-half years old (second from left: Hou Lulu Shur-tzy) / 1965

侯淑姿　HOU Lulu Shur-tzy

六歲全家合影於臺北新公園 / 1968
Family photo at six years old in Taipei New Park / 1968

約小學三年級 / 1972
Approximately the third grade of elementary school / 1972

小學六年級（最左為侯淑姿）/ 1975
The sixth grade of elementary school (far left: Hou Lulu Shur-tzy) / 1975

1962 | **Hou is born in Chiayi Provincial Hospital**

Hou's father is a bank teller at Hua Nan Bank, and the family lives in the bank's Japanese-styled accommodation. Both of Hou's parents are from Liujiao Township, Chiayi County. Hou's paternal grandfather is a farmer, and her maternal grandfather is village chief and township representative of Zhuben Village, Liujiao Township. Hou's parents were married in 1957 and had two sons and two daughters. Hou is the third child.

1966 Hou moves to Taipei with her parents at three-and-a-half years old.

1968 Hou enrolls at Taipei Municipal Changan Elementary School. Hou's parents pay a great deal of attention to their children's education and are very strict about their upbringing. Hou is inspired by Uncle Sie, their tenant, and has shown a deep interest in painting since elementary school.

1975 Hou graduates from Changan Elementary School with the mayor award.

1978 Hou passes the entrance exam to Taipei First Girls High School. Hou learns watercolor and Chinese painting from an art teacher from Jianguo High School's art class and becomes determined to study fine art at university. Hou also learns sketchwork from National Taiwan Normal University's Professor Chen Ching-jung for two years.

1981 | **Graduates from Taipei First Girls High School**

Hou graduates from Taipei First Girls High School. Hou is not admitted into a fine arts program but instead receives an offer to the Department of Philosophy which she accepted. Hou receives a Nikon FE2 camera as a gift from her mother, which inspires her interest in photography, and Hou joins a photography club to learn darkroom techniques. Hou learns sketchwork from Lee Kuang-yu.

1983 Hou visitts ancient monuments on a trip with friends, which sparks her interest in the preservation of cultural property.

1985　|臺大哲學系畢業|

5月舉辦「文學院素描」雙人聯展「歷歷來時路」，於臺灣大學學生活動中心。

7月參加「臺大攝影社聯展」，於臺北社教館展出。

7月至1986年2月畢業後任職於年代影視公司的CF部門，負責廣告片的文案書寫。

1986　3月至1989年6月受聘於東華書局的中文辭典編輯部，擔任該辭典的總執行編輯，負責管理十人的編輯部。工作之餘，投注於攝影。

1989　|出版第一本個人攝影作品集《生命的倒影——侯淑姿攝影集》|

8月，出版《生命的倒影——侯淑姿攝影集》。同年赴美羅徹斯特理工學院（Rochester Institute of Technology）攻讀影像藝術（Imaging Arts）碩士。於伊士曼攝影博物館（Eastman Museum）實習一年。

1991　2月參加美國羅徹斯特理工學院攝影藝廊舉辦的 SPAS Show。

7月至1992年1月，攻讀碩士之外，於伊士曼攝影博物館研讀攝影材質保存與永久保存檔案實習證書班（Certificate Program in Photographic Preservation and Archival Practice）。

1992　|完成美國影像藝術碩士學位，畢業同年續攻雕塑|

完成三年九十學分的課程，4月於美國羅徹斯特理工學院攝影藝廊舉辦MFA畢業個展「迷宮之徑」（The Labyrinthine Path）。取得影像藝術碩士（MFA）學位。同年獲阿爾弗雷德大學（Alfred University）的特別學生（special student）的資格，免學費選修一年的雕塑課程，該校並提供了工作室。

1993　9月至12月於阿爾弗雷德大學學生藝廊舉辦「不只是為了女人」（Not Only for Women）個展；同年受聘於康寧社區學院（Corning Community College），擔任攝影課程講師。

與父母、姊姊合影於中正紀念堂 / 1984
Hou with her parents and sister at Chiang Kai-shek Memorial Hall / 1984

赴美前留影 / 1989
Hou takes a photo before going to the USA / 1989

侯淑姿　HOU Lulu Shur-tzy

1985 | **Graduates from National Taiwan University Department of Philosophy** |

Hou holds joint exhibition, *Sketch of the College of Liberal Arts -- The Path Here*, at the National Taiwan University Student Activity Center in May.

Hou participates in the *NTU Photo Group Exhibition* at the Taipei Cultural Center in July.

Hou works at the CF department at Era Production after graduation, writing advertising copy between July 1985 and February 1986.

1986 Hou joins the Chinese dictionary editorial department at Tung Hua Books between March 1986 and June 1989 as managing editor. Hou devotes her free time to photography.

1989 | **Publishes first personal photography collection *The Reflection in the Lake of Life: The Photography Works of Hou Lulu Shur-tzy*** |

Hou publishes *The Reflection in the Lake of Life: The Photography Works of Hou Lulu Shur-tzy* in August. She travels to Rochester Institute of Technology to study for a master's degree in Imaging Arts. Hou then becomes an intern at the Eastman Museum for one year.

1991 Hou participates in the "SPAS Show" at Rochester Institute of Technology's photography gallery in February.

Apart from her master's studies, Hou joins the Certificate Program in Photographic Preservation and Archival Practice at the Eastman Museum between July 1991 and January 1992.

1992 | **Completes a master's degree in imaging arts in the U.S. and continues to study sculpture the same year of her graduation** |

Hou holds solo exhibition *The Labyrinthine Path* at the Rochester Institute of Technology art gallery in April as MFA graduation exhibition. She obtains an MFA degree in imaging arts. She then gains special student status at Alfred University and is sponsored a year of sculpture lessons and is provided with a free studio.

RIT 碩士畢業留影 / 1992
Hou RIT master's degree graduation photo / 1992

1993 Hou holds solo exhibition *Not Only for Women* at the Alfred University student gallery between September and December and is appointed as the photography lecturer at Corning Community College.

傳記式年表　BIOGRAPHICAL TIMELINE

1994 ｜於伊士曼攝影博物館「攝影類材質保存與檔案管理證書班」結業，返臺｜

1月至6月於伊士曼攝影博物館修習照片修復保存實驗室（IMP, Conservation Lab.），獲結業證書。同年返回臺灣。

7月臺北攝影節，策劃「影像史探源」展覽，於誠品書店敦南店展出。

9月至1995年6月於世新傳播學院印刷攝影系兼課。

1995 ｜再度赴美、駐村｜

1月，執行「李梅樹家族玻璃底片保存計畫」。

2月，於伊通公園畫廊展出《不只是為了女人》。因作品被侵權，訴訟官司，此展亦於3月高雄鹽埕阿普畫廊展出，皆引起各方討論，女性主義議題浮現。

3月，執行「張清言底片複製計畫」。

10月，通過謝德慶所提供的「大地藝術家工作室」（The Earth）的申請，再度赴美。10月至1996年5月，於紐約市布魯克林區大地藝術家工作室（Earth Artist in Residency）駐村。

1996 ｜《窺》作品首度發表於美紐約市同步空間畫廊｜

8月，策劃「邊際四人展」（Perimeter 4），於美國紐約市456畫廊展出。

9月，舉辦「Take a Picture, It Lasts Longer」個展，於美國紐約市同步空間畫廊（Synchronicity Space）。

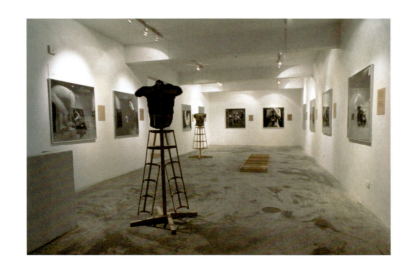

《不只是為了女人》展出於臺北伊通公園畫廊 / 侯淑姿攝 / 1995
Not Only for Women exhibition at the IT Park gallery / photo by Hou Lulu Shur-tzy / 1995

侯淑姿　HOU Lulu Shur-tzy

1994

| **Returns to Taiwan upon completing the Certificate Program in Photographic Preservation and Archival Practice at the Eastman Museum** |

Hou receives certificate of completion in photography preservation from the Conservation Lab at the Eastman Museum (IMP) between January and June and returns to Taiwan the same year.

Hou organizes *The Origins of Photography* exhibition at the Eslite Bookstore Dunnan Store in July during Taipei Photography Festival.

Hou joins the adjunct teaching staff at the Shih Hsin University College of Journalism and Communications Department of Printing and Photography between September 1994 and June 1995.

1995

| **Visits the U.S. once more for a residency** |

Hou executes glass negative preservation project for the family of Li Mei-shu in January.

She holds the exhibit *Not Only for Women* at an IT Park in February. Hou files a lawsuit due to infringement of her work. The exhibition is also presented at the A-pu Gallery in Yancheng, Kaohsiung, in March, provoking discussions on Feminism.

Hou executes a glass negative preservation project for Zhang Qing-yan in March.

Hou visits the U.S. once more in October by applying to Tehching Hsieh's studio "The Earth." She then participates in the *Earth Artist in Residency* in Brooklyn, New York, between October 1995 and May 1996.

1996

| ***Take a Picture, It Lasts Longer* is shown for the first time at the Synchronicity Space in New York City** |

Hou organizes joint exhibition *Perimeter 4*, which is presented at New York City's Gallery 456 in August.

Solo exhibition *Take a Picture, It Lasts Longer* is presented at Synchronicity Space in New York City in September.

傳記式年表　BIOGRAPHICAL TIMELINE

1997

|「窺」個展於臺北帝門藝術空間展出,再度引起社會各界關注。開始立法院國會助理的工作。父親於年初過世|

4月,於臺北帝門藝術教育基金會舉辦「窺」個展。4月22日,演講「女性影像書寫」,於在地實驗ETAT。

6月,完成「藝術村民間版規劃報告」,由林濁水國會辦公室進行發表。

8月,擔任林濁水國會辦公室助理,期間負責辦理十二場公聽會,草擬三項法案。其中最重要的法案為共同草擬的「聘任人員聘任條例」。

9月至12月,兼任世新傳播學院視傳系講師。

11月19、20日,參與「中小型博物館營運管理研習會——紙材與攝影質材保存修復研習營」。

12月,參與由張元茜策展「盆邊主人・自在自為:亞洲當代女性藝術家」於臺北縣新莊市文化藝術中心展出。

1998

|第一次赴日駐村、展出|

1月至6月,兼任世新傳播學院平傳系講師。

4月,參加「意象與美學——女性藝術展」,於臺北市立美術館。

10月至1999年3月,於東京Za Moca基金會藝術家工作室駐村四個月。

10月,「窺」個展,於Za Moca基金會畫廊。

12月12日,1998年中華攝影教育學會國際專題學術研討會,Grant Romer演講〈論攝影材質保存之發展現況〉(現場口譯)。12月16日,Grant Romer演講〈數位時代的攝影質材保存〉(現場口譯),於臺灣省立美術館。

- 白麥琪,〈《窺》:攝影家侯淑姿以前衛影像挑戰偏見〉,《亞洲藝術新聞雜誌》,第8卷第2期,1998年1-2月號,頁45-51。
- 白麥琪,〈使可見成為不可見〉,《亞洲藝術新聞雜誌》,第8卷第2期,1998年3-4月號,頁60-66。
- 臺北市立美術館典藏《青春編織曲(三)》。

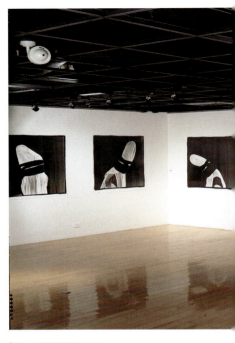

「窺」展覽於帝門 / 1997
Take a Picture, It Lasts Longer solo exhibition is presented at Dimension Endowment of Art gallery / 1997

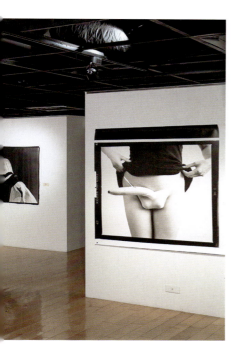

1997 | *Take a Picture, It Lasts Longer* solo exhibition is presented at Dimension Endowment of Art gallery, once again provoking discussions among the public. Begins position as a legislative assistant at the Legislative Yuan. Hou's father passes away at the beginning of the year |

Hou holds solo exhibition *Take a Picture, It Lasts Longer* at the Dimension Endowment of Art gallery in April. She gives the talk "Female Image Writing" at Dimension Endowment of Art on April 22.

Hou becomes the legislative assistant of Lin Cho-shui in August, organizing 12 public hearings and drafting Regulations for Recruitment.

She becomes an adjunct lecturer at the Shih Hsin University College of Journalism's Department of Visual Communications between September and December.

In December, she participates in the *Asia Contemporary Female Artist* group exhibition curated by Rita Chang, at the Taipei County Xinzhuang Cultural Arts Center.

1998 | Travels to Japan for a residency and exhibition for the first time |

Hou becomes an adjunct lecturer at the Shih Hsin University College of Journalism and Communications Department of Graphic Communications between January and June.

She participates in the *Mind and Spirit: Women's Art in Taiwan* at the Taipei Fine Arts Museum in April.

Hou then travels to Tokyo for a four-month residency at the Za Moca Foundation artist studio between October 1998 and March 1999.

Solo exhibition Hou holds the *Take a Picture, It Lasts Longer* is presented at Za Moca Foundation Gallery in October.

Hou acts as interpreter for Grant Romer's talk *On the Development of Preserving Photography Materials* at The Chinese Society of Photographic Educations International Academic Symposium on December 12. She does so again at Romer's talk *Preserving Photography Materials in the Digital Age* at the Taiwan Museum of Art on December 16.

- Maggie Pai, A Picture Lasts Longer: Photographer Hou Lulu Shur-tzy Fights Prejudices through Her Daring Images, *Asian Art News 8.2* (Jan/Feb, 1998): 45-51.
- Maggie Pai, Making Visible the Invisible, *Asian Art News 8.2* (Mar/Apr, 1998): 60-66.
- *Labors and Labels (III)* enters the collection of the Taipei Fine Arts Museum.

1999

| 擔任臺北市政府文化局籌備處研究員，負責籌設文化局 |

3月至6月，兼任世新大學平面傳播科技系講師，教授「視覺傳播理論」。

4月至隔年12月，擔任臺北市政府文化局籌備處、文化局聘用研究員，負責文化局籌備、文化政策之擬定、駐市藝術家交換、臺北國際藝術村的規劃、臺北當代藝術館開館籌備與策展。

5月，日本橫濱美術館學藝員長天野太郎訪問之評論報導〈女性藝術家的日常就是戰鬥的連續〉刊登在飯澤耕太郎主編之《déjà-vu bis》，第18期，文長三千七百字，為首次國際訪問評論文。

9月至2000年6月兼任世新大學平面傳播科技系職訓班講師，教授「色彩學」。

10月，「黑・圓・性感」攝影展，於SOGO敦南館展出。參與「複數元的視野」聯展，於中國北京美術館展出。

2000

| 首次發表《Japan-Eye-Love-You》作品，於日本橫濱美術館畫廊 |

3月，參與「How to Use Women's Body, Transfiguration of Sex, Gender, Nationality」，於東京 Ota Fine Art 展出。

6月，參加「全國第五屆婦女國是會議在北縣」於板橋新站。

7月，參與「近距觀照——台灣藝術家聯展」（Close-Up），於加拿大溫哥華University Gallery of Emily Carr Institute of Art and Design展出。

9月，舉辦「Japan-Eye-Love-You」個展，於日本橫濱美術館畫廊。「窺」個展，於橫濱市 Portside Gallery 展出（同時於橫濱市推出兩個個展）。9月，參與「粉樂町」展，於香港藝術中心。

9月起，擔任輔仁大學影像傳播系兼任講師，教授「攝影實務」課程。

11月25日，參與中華民國攝影教育學會國際專題學術研討會，專家座談：「女人的社會形象」。

12月，參與「心靈再現——臺灣女性當代藝術展」，於高雄市立美術館。

年底結束臺北市文化局的工作。

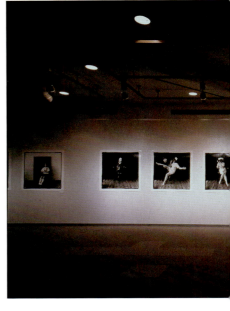

「Japan-Eye-Love-You」展場 / 2000
Japan-Eye-Love-You exhibition hall / 2000

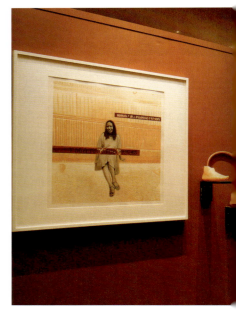

《猜猜你是誰》展出於「心靈再現」展 / 高雄市立美術館 / 2000
Guess Who You Are exhibited in *"Journey of the Spirit: Taiwanese Women Artists and Contemporary Representations"* exhibition / Kaohsiung Museum of Fine Arts / 2000

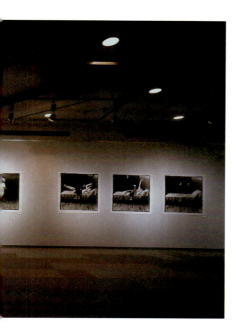

1999 | Becomes a researcher at the Taipei City Government Department of Cultural Affairs Provisional Office, in charge of preparational affairs for the Department of Cultural Affairs |

Hou becomes a researcher appointed by the Department of Cultural Affairs Provisional Office and the Department of Cultural Affairs between April 1999 and December 2000.

An interview by chief curator of Yokoham Musuem of Art Taro Amano *The Everyday of a Female Artist is a Continuous Battle,* is published in issue 18 of *déjà-vu bis* in May, with Iizawa Kotaro as the chief editor.

Hou participates in the group exhibition *Visions of Pluralism-Contemporary Art in Taiwan 1988-1999* at the National Art Museum of China (Beijing) in October.

2000 | Presents work *Japan-Eye-Love-You* for the first time at the gallery in Japan's Yokohama Museum of Art |

Hou participates in *How to Use Women's Body, Transfiguration of Sex, Gender, Nationality* at Ota Fine Art in Tokyo in March.

She also participates in group exhibition *Close-Up* at the University Gallery of the Emily Carr Institute of Art and Design in Vancouver, Canada, in July.

Solo exhibition *Japan-Eye-Love-You* is presented at a gallery in Japan's Yokohama Museum of Art, and *Take a Picture, It Lasts Longer* at Portside Gallery in Yokohama (two solo exhibitions are also held in Yokohama) in September. She then participates in the *Very Fun Park* exhibition at Hong Kong Arts Centre in September.

Hou becomes an adjunct lecturer at Fu Jen Catholic University Department of Communication Art from September.

Hou participates in the *Journey of the Spirit: Taiwanese Women Artists and Contemporary Representations* exhibition at the Kaohsiung Museum of Fine Arts in December.

Hou resigns from position at Taipei City Government Department of Cultural Affairs at the end of the year.

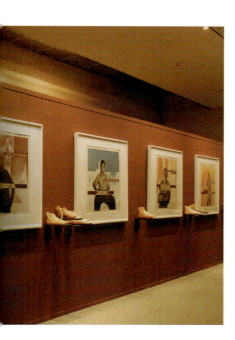

2001

|臺北當代藝術館「輕且重的震撼」開幕（與賴瑛瑛、藍文郁共同策劃）|

2月16日，「文化空間再造國際研討會」之研習營擔任現場口譯（由藝術村聯盟理事Katheryn Reasoner及埃克米基金會Jonathan Harvey主講「藝術村規劃」）。

3月17日，演講「身體的魔咒展：講談『琳‧碧安』的作品」，於國際視覺藝術中心。

5月，策劃「輕且重的震撼」，於臺北當代藝術館，為開幕首展。

9月起，擔任輔仁大學進修推廣部哲學系兼任講師，教授「影像美學」。

2002

|開始參與「閒置空間再利用」案例的調查與研究。完成首件公共藝術作品《快樂是什麼》|

9月起，擔任國立臺灣藝術大學傳統工藝系兼任講師。

9月，參與中國大陸「平遙國際攝影大展」，於山西展出。

10月，參與「夢02」展，英國倫敦紅樓軒基金會主辦。

11月，「幻影天堂——臺灣當代攝影新潮流」聯展，於大趨勢藝術空間。《浴火鳳凰展翅——臺北市立建成國中新建工程公共藝術圖輯》出版。

12月，《文化空間創意再造——閒置空間再利用‧國外案例彙編》、《快樂是什麼》出版。

- 擔任文建會委託淡水文化基金會《文化空間創意再造：推動閒置空間再利用‧國外案例彙編》研究員。發表〈閒置空間再利用為博物館的經營條件：美國案例觀察篇〉、〈藝術家的社會實踐——藝術村經營與規劃的美國觀點〉兩篇專文。

《快樂是什麼》/ 侯淑姿攝 / 2002
What Is Happiness / photo by Hou Lulu Shur-tzy / 2002

2003

|主持「閒置空間再利用六個試辦點調查研究及評估案」計畫|

1月11日，擔任國巨科技藝術節現場口譯，紐約Location One藝術總監Heather Wagner 談紐約科技藝術。

3月14日，演講「女性影像書寫」，於國立陽明大學通識教育課程。

11月8、9日，「回首臺灣百年攝影幽光專題展」學術研討會，於國家圖書館會議廳舉行，擔任藍柏特（Lambert van der Aalsvoort）〈臺灣早期攝影探尋〉論文發表口譯（翻譯、座談）。

- 國立臺灣美術館典藏《猜猜你是誰》（五件）。

2001

| The opening ceremony of *The Gravity of the Immaterial* at MOCA Taipei (co-organized with Lai Ying-ying and Lan Wun-yu) |

Hou acts as interpreter for *Planning Artist Villages* for Artist Village Alliance director Katheryn Reasoner and Exme foundation Jonathan Harvey at the workshop of The International Conference for Rebuilding Cultural Spaces Workshop on February 16.

Hou becomes an adjunct lecturer at the philosophy department of Fu Jen Catholic University Department of In-service and Continuing Education in September.

2002

| Begins participating in the investigation and research on cases of repurposing idle spaces. Completes first public art work *What Is Happiness* |

Hou becomes an adjunct professor at the National Taiwan University of Arts Department of Traditional Craft in September.

Hou participates in China's *Pingyao International Photography Festival* in September.

Hou participates in the *dream 02* exhibition, organized by the Red Mansion Foundation in London, UK, in October and the group exhibition *The Heaven of Illusions: New Trends of Contemporary Photography in Taiwan* at the Main Trend Gallery in November.

Hou publishes *What Is Happiness* in December.

- Serves as a researcher for Tamsui Culture Foundation's "Creative Programming in Reuse of Spaces: An International Perspective" (commissioned by the Council for Cultural Affairs), in charge of investigation and writing about cases in the U.S..

2003

| Holds Survey and Assessment of Six Adaptaive Reuse Pilot Sites commissioned by Cuoucil of Cultural Affairs, Executive Yuan |

Acts as interpreter for the Yageo Tech-Art Festival on January 11 as well as Lambert van der Aalsvoort's paper presentation *Examining the Early Photography Works of Taiwan* at the Retrospective of One Hundred Years of Taiwan Photography Academic Conference on November 8 and November 9.

- *Guess Who You Are* (5 pieces) enters the collection of the National Taiwan Museum of Fine Arts.

2004

| 開始高雄大學的專任教職,主持「攝影類檔案保存修復方法之研究」計畫 |

1月,擔任國立故宮博物院南部分院規劃諮詢委員(2004-2008)與工作小組委員。

4月,參與「正言時代」展,於美國康乃爾大學強生美術館。

5月,參與「非關真相:九十年代至今華人觀念攝影展」,於香港中央圖書館。

6月5日,參與《同質異現的華人當代藝術》座談會,於香港藝術館。

7月28日,演講「公共藝術設置與民眾參與」,文建會2004年公共藝術實務暨國際研討會。

8月,南下高雄大學任教。

11月,擔任檔案管理局「攝影類檔案保存修復方法之研究」計畫主持人。

- 出版:《攝影類檔案保存修復方法之研究》。

2005

| 首次發表《亞洲新娘》系列作品。主持「高雄縣傳統工藝保存現況(第一階段)調查研究」 |

3月,發表〈站在轉捩點上的臺灣故宮博物院——談南部分院的願景與規劃〉,《建築師雜誌》刊出。

6月,參與「Work, Labor」展,於奧地利Galerie im Taxispalais, Innsbruck。

7月,演講「談故宮南部分院與太保市的共生關係」,於嘉義「故宮南院博物館、博覽會的發展策略與地方文化城市之建立」邀請論壇。發表〈由閒置空間再利用政策看華山的未來〉,《建築師雜誌》刊出。

8月6至7日,教授「照片保存DIY工作坊」,於國立文化資產保存研究中心籌備處。

10月31日至11月24日,舉辦「越界與流移:亞洲新娘之歌——侯淑姿攝影展」,於清華大學藝術中心。

2006

| 主持「美濃紙傘調查」計畫,主持「高雄市傳統藝術普查研究計畫」,參與多次國際展覽 |

1月6日,於立法院舉辦「文化空間創造與經營」政策公聽會。

1月8日,參加中華民國文化藝術環境改造協會主辦「民間文化會議」,報告「文化空間的創造與經營」政策。

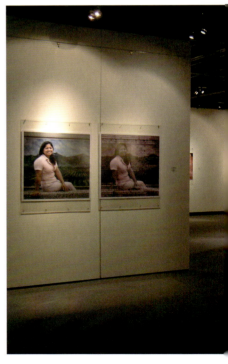

「越界與流移——亞洲新娘之歌 I」/ 侯淑姿攝 / 清華大學 / 2005
Border-crossing/Diaspora–Song of Asian Foreign Brides in Taiwan (I) / photo by Hou Lulu Shur-tzy / National Tsing Hua University / 2005

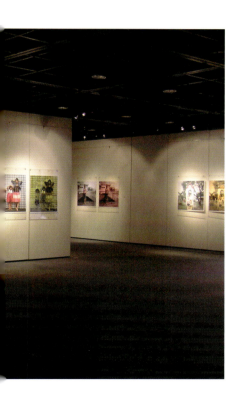

2004 | Begins a full-time teaching position at the National University of Kaohsiung and hosts the Research on Methodology of Photographic Conservation project |

Hou becomes a member of the advisory committee for planning for the Southern Branch of the National Palace Museum (2004-2008) and task force member in January.

Hou participates in the *Contemporary Taiwanese Art in the Era of Contention* exhibition at the Herbert F. Johnson Museum of Art, Cornell University, in April.

Hou participates in the *Not About 'Truth': Chinese Conceptual Photography Since the 90s* exhibition in May at Hong Kong's Hong Kong Central Library.

Hou relocates to Kaohsiung for a teaching position in August.

Hou hosts the National Archives Administration's Research on Methodology of Photographic Conservation project in November.

- Publishes *Research on Methodology of Photographic Conservation*.

2005 | Presents the *Song of Asian Foreign Brides in Taiwan* series for the first time. Hosts the Survy Project on Traditional Crafts in Kaohsiung County |

Hou participates in the *Work, Labor* exhibition at Galerie im Taxispalais, Innabruck, in June.

Hou teaches the Photography Preservation DIY Workshop at the Provisional Office of the National Center for Cultural Heritage on August 6 and August 7.

Hou holds the *Border-crossing/Diaspora: Song of Asian Foreign Brides in Taiwan-Hou Lulu Shur-tzy Photography Exhibition* at the National Tsing Hua University Arts Center between October 31 and November 24.

2006 | Hosts the Field Research on Meinumg Oil-paper Umbrellas, Survey Project on Traditional Arts in Kaohsiung City. Participates in multiple international exhibitions |

Hou holds a Creating and Managing Cultural Spaces policy public hearing at the Legislative Yuan on January 6.

3月，參與「臺灣當代藝術特展──巨視・微觀・多重鏡反」展，於國立臺灣美術館。

5月，「Work, Labor」展，於愛爾蘭科克大學的路易斯・格魯克斯曼藝廊（Lewis Glucksman Gallery, University College Cork）。

9月，「Work-Slavery，Equal and Less Equal」，於聖山美術館（Museum on the Sean），耶路撒冷。

擔任國立高雄大學95年度獎勵大學教學卓越計畫子計畫五計畫主持人。

10月20日，參加國立臺灣大學圖書館主辦「老靈魂新方向：老照片的過去、現在與未來」國際研討會，發表演講「攝影類檔案的保存與修護」，這是第一次與英國衛爾康圖書館（Wellcome Library）人員接觸，並與國內多位從事老照片保存的文史研究者共同討論臺灣老照片史料保存和研究的起點。

11月，「Work, Labor」展，於英國貝爾法斯特的歐慕巴茲藝廊（Ormeau Baths Gallery, Belfast）。

- 出版：《油紙傘：美濃紙傘匠師技藝》。

2007

11月，參與「Inart 開幕首展」於臺南Inart Space加力畫廊。

持續進行《亞洲新娘之歌》系列的訪談與拍攝。

2008

｜獲亞洲文化協會（ACC）獎助赴越南拍攝｜

3月29日，擔任Ellen Pearlman發表〈Contemporary Chinese Women Photographers and Issues of Identity and Infringement〉的引言人與口譯，於中華攝影教育學會2008國際學術研討會。

5月，「越界與認同──亞洲新娘之歌 II」個展，於高苑科技大學藝文中心。

5月7日，擔任「越界與認同──亞洲新娘之歌 II」個展座談會與談人。

- 獲亞洲文化協會（ACC）獎助，於暑假前往越南，進行《亞洲新娘之歌 III》的拍攝，造訪分布於胡志明市、茶榮省、薄寮省、永隆省、西寧省等地的七位外配的父母與家人，並拜訪相關機構。

The *Work, Labor* exhibition is held at the Lewis Glucksman Gallery, University College Cork, in May, the exhibition *Work-Slavery, Equal and Less Equal* at the Museum on the Sean, Jerusalem, in September.

Hou participates in an international seminar on Old Photographs as a Fundamental Part of Culture Patrimony: hosted by the National Taiwan University Library, presenting the talk *The Preservation and Conservation of Photographic Archives*. This is the first time Hou interacts with the staff of the UK's Wellcome Library, and Hou proceeds to discuss the starting point for preserving and researching historic photographs and materials with several cultural researchers in Taiwan.

Exhibition *Work, Labor* at Ormeau Baths Gallery in Belfast, UK, in November.

- Publishes *The Craftsmanship of Meinong Paper Umbrellas*.

2007

Hou continues with interviews and photograph sessions for the *Song of Asian Foreign Brides in Taiwan* series.

2008

| **Receives a grant from the Asian Cultural Council (ACC) and travels to Vietnam for a photography session** |

Solo exhibition *Border-crossing/Cultural Identities: Song of Asian Brides (II)* is held at the Kao Yuan University Art and Culture Center in May.

Hou is a panelist at the *Border-crossing/Cultural identities–Song of Asian Brides (II)* solo exhibition talk on May 7.

- Hou receives a grant from the Asian Cultural Council (ACC) and travels to Vietnam during the summer vacation and commences the photograph session for *Song of Asian Foreign Brides in Taiwan (III)*.

2009

|復活節受洗，成為基督徒。倡議左營眷村保存，並進行研究與遊說。協同主持「左營眷村空間基礎資料與活化再利用屬性分析研究計劃」|

3月8日，發表〈越界與流移——亞洲新娘之歌 II〉以及〈越界與認同——亞洲新娘之歌 III〉，於中華攝影教育學會國內學術研討會。

7月，「望向彼方：亞洲新娘之歌 III——侯淑姿個展」，於臺北藝術大學關渡美術館展出。此展並舉辦論壇，主題：「由《望向彼方——亞洲新娘之歌 III》的作品探討其中臺越婚姻關係圖像的意義」，活動由台新銀行文化藝術基金會贊助辦理。

8月，參與「她的第一次個展——臺灣當代女藝術家的回顧與前瞻」聯展，於臺北中正紀念堂三樓藝廊。

12月4日，發表〈流移／認同／望向彼方：亞洲新娘之歌三部曲〉於「『移動與自書』——當代女性影像／文學／藝術的跨界再現」學術研討會。

- 高雄市政府文化局委託「左營眷村空間基礎資料與活化再利用屬性分析研究計畫」，擔任協同計畫主持人。
- 高雄市立美術館典藏：《窺——Flower》五件，《窺——Banana》五件。

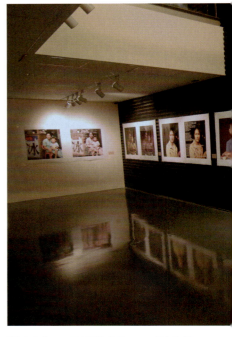

「望向彼方——亞洲新娘之歌 III」／侯淑姿攝／關渡美術館／2009
Look toward the Other Side–Song of Asian Foreign Brides in Taiwan (III) / photo by Hou Lulu Shur-tzy / Kuandu Museum of Fine Arts / 2009

2010

|於高美館創作論壇展出《亞洲新娘之歌》作品。主持「高雄市眷村女性生命史紀錄計畫」。升等為助理教授|

7月，由策展人黃孫權策劃，以「亞洲新娘之歌」為題的創作「望向彼方：亞洲新娘之歌——侯淑姿個展」，於高雄市立美術館展出。此展根據情境式與觀照式的設計，透過臺越婚姻中的七個家族的圖像與文本，讓人們去讀一個個故事，一個個真實的家庭片段的當下，從而圖繪一個集體卻互異的亞洲女性生命歷程。展場中搭建了一間仿越南新娘原生家庭的家屋，開幕當天邀請多位受訪外配及孩子們共同參與論壇。

10月，參與「臺灣報到：臺灣美術雙年展2010」於國立臺灣美術館展出。

12月，參與「香港攝影節2010：四度空間——兩岸四地當代攝影展」，於香港藝術中心。

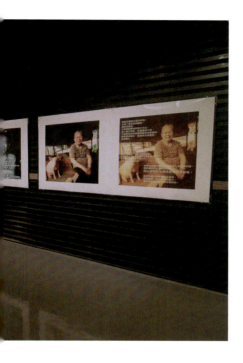

2009 | Hou is baptized as a Christian on Easter. Proposes the initiative for Zuoying Military Dependents' Village and participates in research and lobbying. Becomes a co-host for the "Basic Information on Zuoying Military Dependents' Village and Repurposing Attribute Analysis Research Project" |

Hou presents *Border-crossing/Diaspora: Song of Asian Foreign Brides in Taiwan (I)* and *Border-crossing/Cultural Identities: Song of Asian Brides (II)* at the Chinese Society of Photographic Education's Academic Conference in Taiwan on March 8.

Hou Lulu Shur-tzy Solo Exhibition: Look toward the Other Side-Song of Asian Foreign Brides in Taiwan (III) is held at the Kuandu Museum of Fine Arts of Taipei National University, along with a forum, in July.

Hou participates in a conference on December 4 and presents "Diaspora/Identity/Look toward the Other Side–Song of Asian Foreign Brides in Taiwan (III)" at the "Self-Writing in Diaspora: Border Crossing and Contemporary Women's Film/Literature & Artistic Presentations" academic conference.

- Hou hosts as co-project director the Analysis and Research Projcet on Space Information and Adaptive Reuse Attribute of Military Dependents' Villages in Zuoying, commissioned by the Kaohsiung City Government Bureau of Cultural Affairs.

- *Take a Picture, It Lasts Longer—Flower* (5 pieces) *and Take a Picture, It Lasts Longer—Banana* (5 pieces) enter the collection at Kaohsiung Museum of Fine Arts.

2010 | Presents works from the *Song of Asian Foreign Brides in Taiwan* series at the Kaohsiung Museum of Fine Arts Forum for Creativity in Art. Hosts the "Kaohsiung City Military Dependents' Villages Female Life History Documentation Project." Becomes an assistant professor |

Themed *Song of Asian Foreign Brides in Taiwan,* the *Look toward the Other Side: Song of Asian Foreign Brides in Taiwan–Hou Lulu Shur-tzy Solo Exhibition*, curated by Huang Sun-quan, is presented at the Kaohsiung Museum of Fine Arts exhibition in July. The family house of a Vietnamese bride is constructed in the exhibition room. Several immigrant spouses and children who were interviewed attend the opening ceremony.

- 黃孫權發表〈夫／家／國間的女人們：當女性主義者遇到「她者」的對話〉，刊登於《望向彼方：亞洲新娘之歌——侯淑姿個展》。
- 高雄市文化局委託「高雄市眷村女性生命史紀錄計畫」，擔任計畫主持人。
- 出版：《望向彼方：亞洲新娘之歌——侯淑姿個展》，高雄市立美術館出版。

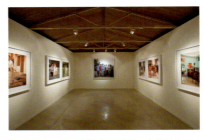

「望向彼方」個展創作論壇現場 / 高雄美術館 / 2010.7.3
Look toward the Other Side forum scene / Kaohsiung Museum of Fine Arts / 2010.7.3

2011

|「望向彼方：亞洲新娘之歌——侯淑姿個展」入圍「第九屆台新藝術獎」|

2月，參與「故事顯影——當代臺灣攝影十人展」，於高雄市立美術館展出。

3月，參與臺北市立美術館為慶賀建國百年舉辦之「時代之眼——臺灣百年身影」展，以《亞洲新娘之歌》系列作品參加聯展，作品收錄於《時代之眼：臺灣百年身影》專書。

4月，參與「第九屆台新獎入圍特展」（林平策展），於高雄市立美術館。

9月，參與「兩邊看：辛亥革命一百周年當代藝術特展」於美國東密西根大學畫廊（University Gallery, Eastern Michigan University）與密西根大學（University of Michigan）展出。

11月5日，指導學生「老時光，好時光——眷村影像展」，於臺北四四南村信義公民會館展，並舉辦座談會。

- 「望向彼方：亞洲新娘之歌——侯淑姿個展」展覽「第九屆台新藝術獎視覺藝術類入圍」（前五名）。作品收錄於《第九屆台新藝術獎》，台新銀行文化藝術基金會編印。
- 「望向彼方：亞洲新娘之歌——侯淑姿個展」獲選為2010年藝術家雜誌票選年度公辦十大好展覽第九名。

- Huang Sun-Quan publishes "Women in-between Husband / Family / Nation: A Dialog when a Feminist Encounters 'The Female Other'" in *Look toward the Other Side: Song of Asian Foreign Brides in Taiwan-Hou Lulu Shur-tzy Solo Exhibition*.
- Hou holds the Kaohsiung City Military Dependents' Villages Female Life History Documentation Project, commissioned by the Kaohsiung City Government Bureau of Cultural Affairs.
- Publishes *Look toward the Other Side: Song of Asian Foreign Brides in Taiwan-Hou Lulu Shur-tzy Solo Exhibition*, published by the Kaohsiung Museum of Fine Arts.

《望向彼方》展出於台新獎入圍特展 / 高雄市立美術館 / 2011.5
Look toward the Other Side exhibited at Taishin Art Award shortlisted special exhibition / Kaohsiung Museum of Fine Arts / 2011.5

2011

| *Look toward the Other Side: Song of Asian Foreign Brides in Taiwan-Lulu Shur-tzy Hou Solo Exhibition* is shortlisted for *the 9th Taishin Arts Award* |

The *Song of Asian Foreign Brides in Taiwan* series participates in the *Eye of the Times: Centennial Images of Taiwan* exhibition at the Taipei Fine Arts Museum in March, which is curated by Chuang Ling and Jhang Cang-song and commemorates the centennial anniversary of the R.O.C.

Hou participates in *The 9th Taishin Arts Award Exhibition* at the Kaohsiung Museum of Fine Arts in April.

Hou participates in *Looking Both Ways: A Contemporary Art Exhibition Coinciding with the Centennial of the Xinhai Revolution* at the University Gallery of Eastern Michigan University and the University of Michigan in September.

Hou tutors student's *Old Times, Good Times: Military Dependents' Villages Image Exhibition* and talk held at the Taipei City Si Si Nan Village Xinyi Assembly Hall on November 5.

- *Look toward the Other Side: Song of Asian Foreign Brides in Taiwan-Hou Lulu Shur-tzy Solo Exhibition* is shortlisted for the 9th Taishin Arts Award: Visual Arts (top five) and is listed in 9th place in *Artist* magazine's Ten Best Publicly-funded Exhibitions in 2010.

2012

| 《望向彼方：亞洲新娘之歌》的〈阿戀〉系列於日本四個美術館共同策劃的大型亞洲女性藝術展展出。主持「旗山地區古物調查計畫」。出版總結二十餘年創作的作品集《女性影像書寫——侯淑姿影像創作集（1989-2009）》|

3月24日，擔任中華攝影教育學會2012國際學術研討會「數位攝影的發明對攝影藝術的衝擊」，Abigail Solomon-godeau演講「Photography after Photography」即席口譯。

9月，參與「連結亞洲——活在疆界的女子們1984-2012」（Women in-between: Asian Women Artists 1984-2012）聯展於日本福岡亞洲美術館。

11月，同一展覽於日本沖繩縣立美術館展出。本展由日本四座美術館共同策劃，經歷四年的籌備，並於亞洲各國進行田野調查，呈現了亞洲十六個國家、五十位女性藝術家的一百一十一件作品，為超大型亞洲女性藝術展。侯淑姿為臺灣唯一獲邀展出的女性藝術家。

作品收錄於《アジアをつなぐ－境界を生きる女たち1984-2012》，福岡アジア美術館，2012。

12月16日，受邀於沖繩縣立美術館「連結亞洲——活在疆界的女子們1984-2012」展覽研討會（From Asia to Okinawa and Okinawa to Asia）進行專題演講「望向遠方：臺灣亞洲新娘之歌」（Look toward the Other Side: Song of Asian Foreign Brides in Taiwan）。

12月23日，演講「2012臺北雙年展主張重新觀看當代藝術」，於北美館。

- 出版：《女性影像書寫——侯淑姿影像創作集（1989-2009）》。

《女性影像書寫——侯淑姿影像創作集（1989-2009）》/ 2012
Female Image Writing-Lulu Shur-tzy Hou's Photography Work (1989-2009) / 2012

2012

| The *A-lian Series* from *Look toward the Other Side–Song of Asian Foreign Brides in Taiwan (III)* is presented at the largescale exhibition featuring female Asian artists co-organized by four art museums in Japan. Hosts the Investigative Project on Antiquities in the Qishan Area. Publishes *Female Image Writing-Lulu Shur-tzy Hou's Photography Work (1989-2009)*, a collection featuring the works created over the past two decades. |

Hou acts as interpreter for Abigail Solomon-Godeau's speech *Photography after Photography* at the Chinese Society of Photographic Educations 2012 International Academic Conference on the Impact of the Invention of Digital Photography on Photographic Art, on March 24.

Hou participates in the *Women in-between: Asian Women Artists 1984-2012* exhibition at the Fukuoka Asian Art Museum in Japan in September.

The same exhibition is held at the Okinawa Prefectural Museum and Art Museum in November. The exhibition is a large-scale event co-organized by four art museums in Japan featuring female Asian artists. Hou is the only female Taiwanese artist to be included.

Hou is invited to give the talk on *Look toward the Other Side: Song of Asian Foreign Brides in Taiwan* at the From Asia to Okinawa and Okinawa to Asia conference for the *Women in-between: Asian Women Artists 1984-2012* exhibition at the Okinawa Prefectural Museum and Art Museum on December 16.

- Publishes *Female Image Writing-Lulu Shur-tzy Hou's Photography Work (1989-2009)*.

福岡亞洲美術館「連結亞洲──活在疆界的女子們」展參展藝術家合影 / 2012.9.9
Women in-between exhibition at the Fukuoka Asian Art Museum / 2012.9.9

2013 ｜首度發表高雄左營眷村作品《我們在此相遇》，為《高雄眷村三部曲》之首部曲｜

1月，參與「連結亞洲——活在疆界的女子們1984-2012」（Women in-between: Asian Women Artists 1984-2012）展，於日本栃木縣立美術館展出。4月，同一展覽於日本三重縣立美術館展出。

1月7日，參與「談女性藝術過時了嗎？當代女性藝術的轉向」座談會，藝術家雜誌社主辦。

3月8日，參與四方報與時報出版社合作出版的《離／我們的買賣，她們的一生》新書發表會，講題「販賣的幸福？從『越南新娘仲介』的那塊招牌談起」。

4月15日，受邀參與「眷村文化保存」諮詢會議，黃煌雄、葛永光主持，於監察院。

6月，「我們在此相遇」個展，於臺北大趨勢畫廊展出。

8月，發表〈女性觀點與影像〉於《藝術家》第459期。

11月9日，擔任文化部文化資產局、國防部、臺灣研究基金會共同主辦「臺灣眷村文化與保存——檢討與展望」研討會與談人，於臺灣大學物理凝態館國際會議廳。

12月9日，參與「活眷村如何可能？高雄市明德新村設立眷村文化保存區之願景與展望」公聽會，於高雄市議會。

- 《女性影像書寫——侯淑姿影像創作集（1989-2009）》，獲金點設計獎。
- 黃明川導演，執導拍攝《當代藝術身影——侯淑姿》，2013高美館視覺藝術影像資料庫。
- 日本福岡亞洲美術館典藏，《望向彼方：亞洲新娘之歌——黃氏戀系列》六件。

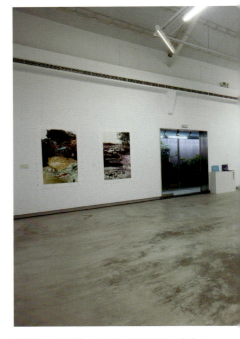

《我們在此相遇》展出於大趨勢畫廊／臺北／2013
Here Is Where We Meet at Main Trend Gallery / Taipei / 2013

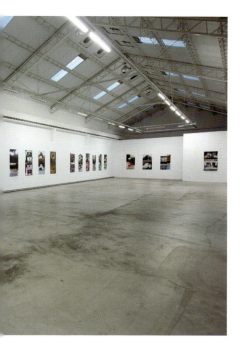

2013 | Presents *Here Is Where We Meet*, which features works on the Zuoying Military Dependents' Village in Kaohsiung. The work is the first part of *A Trilogy on Kaohsiung Military Dependents' Villages* |

Hou participates in the *Women in-between: Asian Women Artists 1984-2012* exhibition at the Tochigi Prefectural Museum of Fine Arts in January. The same exhibition is held at the Mie Prefectural Art Museum in April.

Hou is invited to participate in "The Preservation of Military Dependents' Villages" consultant committee at The Control Yuan hosted by Huang Huang-hsiung and Ge Yong-guang on April 15.

Hou holds solo exhibition *Here Is Where We Meet* at Taipei's Main Trend Gallery in June.

Hou serves as a panelist for the Culture and Preservation of Taiwan's Military Dependents' Villages: Review and Outlook conference organized by the Ministry of Culture Bureau of Cultural Heritage, Ministry of National Defense, and Taiwan Research Foundation at National Taiwan University on November 9.

Hou participates in the public hearing "How to Make Living Military Dependents' Villages Possible? The Vision and Outlook of Establishing a Military Dependents' Village Cultural Preservation Area in Kaohsiung City's Mingde New Village" at the Kaohsiung City Council on December 9.

- Director Huang Ming-chuan directs and films *Figures in Contemporary Art*: *Hou Lulu Shur-tzy* for the 2013 Kaohsiung Museum of Fine Arts' Audio-Visual Archives.

- *The Series of Huang-shih Nien, Look toward the Other Side- Asian Foreign Brides in Taiwan* (6 pieces) enters the collection at the Fukuoka Asian Art Museum.

2014 | 日本橫濱黃金町駐村及展覽。年初母親過世,臨終前受洗為基督徒。主持「文化景觀鳳山黃埔新村再利用規劃研究計畫」|

6月,參與「女人一家:以亞洲女性藝術之名」展覽,於高雄市立美術館。8月,參與「界:臺灣當代藝術展1995-2013」聯展,於美國康乃爾大學強生美術館展出。

8月,因竹圍工作室/高森信男的推薦,進駐於日本橫濱黃金町藝術村(Koganecho Bazaar Artist in Residency),由山野真悟(Shingo Yamano)負責規劃,以「藝術與社區共生」為目標,重新整頓鐵道高架下的空間,讓藝術家在此生活、創作並擁有實質的交流和社會經驗。侯淑姿同時參與「黃金町市集2014:虛構的亞洲聚落」(Koganecho Bazaar 2014: Fictive Communities Asia)展出,此展由旅居加拿大的策展人原萬希子(Makiko Hara)共同策劃。

神奈川8月22日新聞〈黃金町市集2014:虛構的亞洲聚落〉除了報導「黃金町市集2014」,同時包括橫濱美術館的「2014橫濱三年展」和Bank Art 兩個重要展覽,目的是為了互相了解中、日、韓、臺各自的文化,其中報導了來自臺灣的侯淑姿攝影作品《我們在此相遇》。

10月,參與聯展「與社會交往的藝術:香港/臺灣交流展」,於香港浸信會大學視覺藝術學院展出。

12月,參與「與社會交往的藝術:香港/臺灣交流展」於高雄駁二藝術特區C5倉庫展出。

- 高雄市政府文化局委託「文化景觀鳳山黃埔新村再利用規劃研究計畫」,擔任計畫主持人。
- 擔任文化部搶救攝影資產諮詢委員會委員。高雄市歷史博物館104年傳統藝術民俗及有關文物審議會大會委員。
- 高雄市立美術館典藏:《我們在此相遇——殷陳城蘭系列》(四件)。
- 出版:《我們在此相遇》,連結點藝術工作室。《老時光,好時光:左營眷村影像書》。

《我們在此相遇》展出於日本黃金町 / 2014
Here is Where We Meet exhibited at Koganecho / Yokohama, Japan / 2014

2014 | Residency and exhibition in Koganecho in Yokohama, Japan. Hou's mother passes away at the beginning of the year. Hosts the "Cultural Scene Huangpu New Village Repurposing and Planning Research Project" |

Hou participates in the *Jie (Boundaries): Contemporary Art from Taiwan* group exhibition at the Herbert F. Johnson Museum of Art, Cornell University, in August.

Through the recommendation of Bamboo Curtain Studio's Takamori Nobuo, Hou participates in the Koganecho Bazaar Artist in Residency in August. Hou also participates in the *Koganecho Bazaar 2014: Fictive Communities Asia* exhibition, which is co-organized by Canada-based curator Makiko Hara.

The Kanagawa news report on August 22 "Koganecho Bazaar 2014: Fictive Communities Asia" not only features *Koganecho Bazaar 2014* but also Yokohama Museum of Art's two major exhibitions: *The 2014 Yokohama Triennale* and *Bank Art*, which includes Hou's photography work *Here Is Where We Meet*.

Hou participates in the *Art as Social Interaction · Hong Kong/Taiwan Exchang* group exhibition at the Hong Kong Baptist University Academy of Visual Arts in October.

- Hou holds the Cultural Scene Huangpu New Village Repurposing and Planning Research Project commissioned by the Kaohsiung City Government Bureau of Cultural Affairs.
- Hou becomes a member of the Ministry of Culture Property Rescue Consultant Committee.
- The series of *Yin Chen Cheng-lan, Here Is Where We Meet* (4 pieces) enters the collection at Kaohsiung Museum of Fine Arts.
- Publishes *Here Is Where We Meet* (Connection Point Art Studio), *Old Times, Good Times: Military Dependents' Villages Image Book*.

2015

｜首度發表高雄黃埔新村作品《長日將盡》，為《高雄眷村三部曲》之二部曲｜

1月，參與「南方上岸：2015影像典藏展」，於高雄市立美術館展出。

10月，「長日將盡：侯淑姿個展」，於臺北非常廟畫廊（VT Art Salon）展出。

- 發表〈望向彼方──亞洲新娘之歌〉，《與社會交往的藝術──香港臺灣交流展》。
- 高雄市政府文化局委託計畫主持，「文化景觀鳳山黃埔新村再利用規劃研究計畫」（未出版）。

2016

1月，參與「張李德和暨臺灣女性藝術展」，於嘉義市文化局。

1月30日，發表〈與社會交往的台灣當代女性藝術──女性攝影與社會〉，張李德和暨臺灣女性藝術展座談會手冊。

5月，發表〈眷改條例下的左營眷村文化保存工作的困境與展望〉，收於《海市蜃樓V：台灣閒置公共設施抽樣踏查》。

10月2日，主講「攝影的女力思考──從女性影像書寫談起」，於高雄市立美術館。

11月，「我們在此相遇──侯淑姿個展」，於政治大學藝文中心展出。

12月25日，參與「謎樣的記憶：從敘事軌跡探視艋舺」展（王俊琪策展）「從身體圖像到勞動身體」論壇，於剝皮寮歷史街區。

- 《我們在此相遇》作品收於《認定特定非営利活動法人黄金町エリアマネジメントセンター》，2016。
- 擔任文化部國家攝影文化中心搶救攝影資產諮詢會委員（2016.06.29-2018.06.29）。國立臺灣博物館暨國家攝影文化中心攝影資產學門典管審議小組委員。

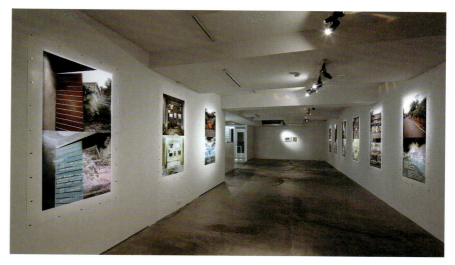

《長日將盡》展出於非常廟畫廊 / 臺北 / 2015
Holds *Remains of the Day -Hou Lulu Shur-tzy* Solo Exhibition at VT Art Salon / Taipei / 2015

2015 | **Presents *Remains of the Day*, which features Kaohsiung's Huangpu New Village and is the second part of *A Trilogy on Kaohsiung Military Dependents' Villages* |**

Hou holds *Remains of the Day - Hou Lulu Shur-tzy Solo Exhibition* at VT Art Salon in October.

- Hou hosts the Cultural Scene Huangpu New Village Repurposing and Planning Research Project, commissioned by the Kaohsiung City Government Bureau of Cultural Affairs (unpublished).

2016 *Here Is Where We Meet: Lulu Shur-tzy Hou Solo Exhibition* is held at the National Chengchi University Art and Culture Center in November.

Publishes *Predicaments and Prospects of the Cultural Preservation of Zuoying Military Dependents' Village Under the Act for Rebuilding Old Quarters for Military Dependents* in May, which is included in *Mirage: Disused Public Property in Taiwan*, edited by Yao Jui-chung.

- Hou becomes a member of the Ministry of Culture National Center of Photography and Images Photography Property Rescue Consultant Committee and a member of the National Taiwan Museum and National Center of Photography and Images Photography Property Collection Review Committee.

2017

| 完成《高雄眷村三部曲》之第三部曲《鄉關何處》，於高美館創作論壇完整發表 |

1月14日，民視異言堂製作播出，《請眷待我的家（上）、（下）》，民視電視台。

3月，參與「微光闇影」聯展，於臺北市立美術館展出。

7月，「鄉關何處：高雄眷村三部曲——侯淑姿個展」（黃孫權策展），於高雄市立美術館展出。7月8日，參與「鄉關何處：高雄眷村三部曲——侯淑姿個展」論壇座談，於高雄市立美術館。

8月26日，公視電視播出，《藝術家侯淑姿的眷村三部曲》，《藝術很有事》第3集。

9月9日，參與「鄉關何處：高雄眷村三部曲——侯淑姿個展」導覽講壇，於高雄市立美術館。

11月29日，公共電視，「獨立特派員」製作，《沒有將軍的將軍村》，《獨立特派員》第522集。

- 「鄉關何處：高雄眷村三部曲——侯淑姿個展」獲選為2017年藝術家雜誌票選年度公辦十大好展覽第六名。

- 獲列於華敏臻（Michelle Vosper）所編著《創作無界：中國、香港、澳門和臺灣的女藝術家》（Creating across Cultures: Women in the Arts from China, Hong Kong, Macau and Taiwan）一書，East Slope Publishing Ltd.（Muse, HK）出版，為十六位傑出華人女性藝術家中之一。

- 出版：《鄉關何處：高雄眷村三部曲——侯淑姿個展》。策展人黃孫權發表，〈鄉關何處——侯淑姿與她的高雄眷村三部曲〉於《鄉關何處：高雄眷村三部曲——侯淑姿個展》畫冊。

- 國立臺灣美術館典藏：《窺》〈Body Bounding〉，《窺》〈Body Writing〉。

《鄉關何處》展出於高雄市立美術館 / 2017
Out of Place exhibited at Kaohsiung Museum of Fine Arts / 2017

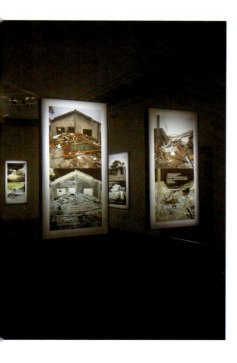

2017

| Completes *Out of Place*, the third part of *A Trilogy on Kaohsiung Military Dependents' Villages*. *Out of Place* is presented at the Kaohsiung Museum of Fine Arts Forum for Creativity in Art. |

Please Treat My Home with Fairness (One)(Two) is produced by and broadcasted on Formosa Television's Yi-Yan-tang on January 14.

Hou participates in the group exhibition *Faint Light, Dark Shadows* at the Taipei Fine Arts Museum in March. *Out of Place: A Trilogy on Kaohsiung Military Dependent's Villages—Hou Lulu Shur-tzy Solo Exhibition* is held at the Kaohsiung Museum of Fine Arts in July.

Hou participates in the *Out of Place: A Trilogy on Kaohsiung Military Dependent's Villages—Hou Lulu Shur-tzy Solo Exhibition* forum at the Kaohsiung Museum of Fine Arts on July 8.

Artist Hou Lulu Shur-tzy's Military Dependents' Villages Trilogy, the third episode of *Inside the Arts,* is broadcasted on Taiwan Public Television on August 26.

General Village Sans the General, episode 522 of *IN-NEWS*, is broadcasted on Taiwan Public Television on November 29, produced by IN-NEWS.

- *Out of Place: A Trilogy on Kaohsiung Military Dependent's Villages—Hou Lulu Shur-tzy Solo Exhibition* is listed in 6th place in Artist magazine's Ten Best Publicly-funded Exhibitions in 2017.

- Listed alongside 16 outstanding female Asian artists in *Creating across Cultures: Women in the Arts from China, Hong Kong, Macau and Taiwan*, edited by Michelle Vosper and published by East Slope Publishing Ltd. (Muse, HK).

- Publishes *Out of Place: A Trilogy on Kaohsiung Military Dependent's Villages—Hou Lulu Shur-tzy Solo Exhibition*. Curator Huang Sun-quan publishes *Out of Place—Hou Lulu Shur-tzy and Her Trilogy on Kaohsiung Military Dependents' Villages* in a catalog.

- Works *Take a Picture, It Lasts Longer—Body Bounding* and *Take a Picture, It Lasts Longer—Body Writing* enter the collection at the National Taiwan Museum of Fine Arts.

2018 |《高雄眷村三部曲》作品首度於東京都寫真美術館展出，升等為副教授|

7月，參與「關鍵：2017新進典藏」聯展，於高雄市立美術館展。

8月，升等副教授。

8月18日，擔任公共電視「藝術為何有事」座談會與談人，於臺北市立美術館。

9月，參與「台湾写真表現の今（Inside/Outside）」展，於日本東京藝術大學美術館陳列館展出。9月15日，擔任東京藝術大學「台湾写真表現の今（Inside/Outside）」展覽座談與談人。

10月，參與「關於愛，我略知一二：論亞洲當代攝影」（I Know Something About Love, asian contemporary photography），2日於日本東京都寫真美術館展出，展期至11月25日。此展以「愛」為主題，呈現了來自日本、韓國、中國、臺灣、新加坡的六位女性攝影家的作品，笠原美智子於展覽畫冊中以「凝觀歷史」的角度，對侯淑姿的作品做了深入的探討。

作品收錄於《愛についてアジアン・コンテンポラリー》，東京都寫真美術館，2018。

10月4日，擔任東京都寫真美術館「關於愛，我略知一二：論亞洲當代攝影」（I Know Something About Love, asian contemporary photography）展覽座談講者，與金玉善（Kim Oksun）女士對話。

- 出版：《鄉關何處：高雄眷村三部曲——侯淑姿眷村女性影像書寫作品集（2010-2017）》。
- 直轄市定古蹟原大阪商船會社臺北支店修復再利用暨攝影文化中心工程案公共藝術設置計畫執行小組委員。

《高雄眷村三部曲》於東京都寫真美術館展出 / 日本 / 2018
A Trilogy on Kaohsiung Military Dependents' Villages exhibited at Tokyo Photographic Art Museum / Japan / 2018

2019 |《長日將盡》作品赴韓國及美國展出，《高雄眷村三部曲》作品獲東京都寫真美術館典藏。|

1月，參與「府城榮光：臺南美術館開館展」，於臺南美術館一館展出。

2月，「移動與遷徙：從地方到他方的故事——臺韓國際當代藝術交流展」，於高雄市立美術館展出。

《長日將盡》於高雄市立美術館「移動與遷徙——從地方到他方的故事：臺韓國際當代藝術交流展」展出 / 2019
The *Remains of the Day* exhibited in *Moving and Migration – Stories from a Place to Other* at Kaohsiung Museum of Fine Arts / 2019

2018 | *A Trilogy on Kaohsiung Military Dependents' Villages* is exhibited for the first time at the Tokyo Photographic Art Museum. Hou becomes an associate professor |

Hou becomes an associate professor in August.

Hou becomes a panelist for the *Inside/Outside* exhibition talk at Tokyo University of the Arts on September 15.

Hou participates in *I Know Something about Love: asian contemporary photography* (curated by Kasahara Michiko) in October, held at the Tokyo Photographic Art Museum between October 2 and November 25. The exhibition features the topic "love" and showcases works from six women photographers from Japan, Korea, China, Taiwan, and Singapore. Kasahara Michiko engages in in-depth research on Hou's works from the perspective of "gazing at history" in the exhibition catalog.

Works included in *I Know Something about Love: asian contemporary photography*, Tokyo Photographic Art Museum, 2018.

Hou converses with Oksun Kim at the *I Know Something about Love: asian contemporary photography* exhibition talk at Tokyo Photographic Art Museum.

- Publishes *Out of Place: A Trilogy on Military Dependents' Villages in Kaohsiung—The Discourses of Lulu Shur-tzy Hou's Female Image Writings (2010-2017)*.

2019 | Work *Remains of the Day* is presented in Korea and the U.S. *A Trilogy on Kaohsiung Military Dependents' Villages* enters the collection at the Tokyo Photographic Art Museum |

Moving and Migration: Stories from a Place to Other, is held at the Gyeonggi Museum of Modern Art in July. *Crisis of Now: Contemporary Asian Photography*, is held at PhotoNOLA in the U.S.

Hou speaks at the *Crisis of Now: Contemporary Asian Photography, Part II* exhibition and talk at Gallery UNO on December 11 during PhotoNOLA.

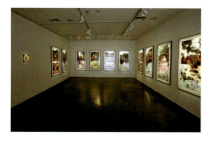

《長日將盡》於韓國京畿道美術館「移動與遷徙──從地方到他方的故事：臺韓國際當代藝術交流展」展出 / 2019
The *Remains of the Day* exhibited in *Moving and Migration – Stories from a Place to Other* at Gyeonggi Museum of Modern Art / 2019

7月,「移動與遷徙:從地方到他方的故事——臺韓國際當代藝術交流展」,於韓國京畿道美術館展出。

12月,「現實的危機——亞洲當代攝影展」(Crisis of Now: Contemporary Asian Photography),於美國PhotoNOLA紐奧良攝影節展出。12月11日,擔任美國紐奧良攝影節UNO畫廊「現實的危機—亞洲當代攝影展Ⅱ」(Crisis of Now: Contemporary Asian Photography, Part II)展覽暨座談會講者。

- 東京都寫真美術館典藏《我們在此相遇——勵志新村系列》六件、《鄉關何處——建業新村系列》四件。
- 「左眷啟航,藝想起飛」提案獲高雄市政府文化局「左營海軍眷村發展藍圖創意設計競賽」第一名。

2020
- 臺北國際影像藝術節Photo One之「專家面對面」(Portfolio Review)專家。
- 高雄市立美術館典藏《望向彼方:亞洲新娘之歌——貴孝系列》。

2021　11月20日,「茶几漫談:在開始——藝術進駐的開端」座談會講者,於臺北國際藝術村。

11月26日,「為什麼我們要了解二二八」工作坊講者,於臺北二二八紀念館。

12月,參與「感知棲所:關鍵典藏2019-2020」展,於高雄市立美術館。

2022　4月10日,亞歷桑納大學創意攝影中心國際線上研討會特別講座:攝影師作品發表與談人。

5月,作品發表於《攝影訪談輯5》。

9月,出版《鄉關何處:高雄眷村三部曲——侯淑姿眷村女性影像書寫作品集》(論述集+作品集三冊)。

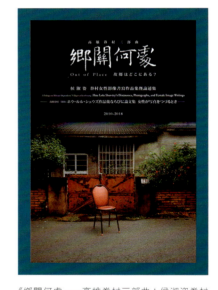

《鄉關何處——高雄眷村三部曲:侯淑姿眷村女性影像書寫作品集暨論述集》/ 2022
Out of Place : A Trilogy on Military Dependents' Villages in Kaohsiung: Hou Lulu Shur-tzy's Discourses, Photographs and Female Image Writings / 2022

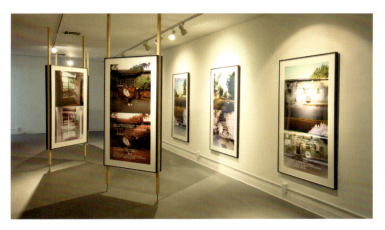

Kaohsiung's Huangpu New Village held at PhotoNOLA in USA / 2019

- *Here Is Where We Meet: The Lizhi New Village Series* (6 pieces) and *Out of Place: The Jianye New Village series* (4 pieces) enter the collection at Tokyo Photographic Art Museum.
- Hou's proposal for "Artistic Dream of Zuoying Military Dependents' Village" receives first prize from the Kaohsiung City Government Bureau of Cultural Affairs' Zuoying Navy Dependents' Village Development Blueprint Creative Design Competition.

2020　*Look toward the Other Side–Song of Asian Foreign Brides in Taiwan (III)—The Kuei-hsiao Series* enters the collection at the Kaohsiung Museum of Fine Arts.

2021　Hou speaks at the Tea Table Forum: Artist Residency in Taiwan: Beginning. Development. Future at Taipei Artist Village on November 20.

2022　Hou presents photography works and serves as a panelist at the Center for Creative Photography International Online Conference Special Session, University of Arizona, on April 10.

Hou's works are published in *PHOTO-LOGUES V*, in May.

Publishes *A Trilogy on Military Dependents' Villages in Kaohsiung The Discourses of Hou Lulu Shur-tzy's Female Image Writings* (Taipei: ARTouch; essay collection and three volumes of catalog) in September.

侯淑姿簡歷

1962 年出生於嘉義，臺灣
現居住於高雄，臺灣

個展選錄

2017	「鄉關何處：高雄眷村三部曲——侯淑姿個展」，高雄市立美術館，高雄，臺灣
2016	「我們在此相遇：侯淑姿個展」，政治大學藝文中心，臺北，臺灣
2015	「長日將盡：侯淑姿個展」，非常廟畫廊，臺北，臺灣
2013	「我們在此相遇」個展，大趨勢畫廊，臺北，臺灣
2009	「望向彼方：亞洲新娘之歌 III」個展，臺北藝術大學關渡美術館，臺北，臺灣
2008	「越界與認同：亞洲新娘之歌 II」個展，高苑科技大學藝文中心，高雄，臺灣
2005	「越界與流移：亞洲新娘之歌 I」個展，清華大學藝術中心，新竹，臺灣
2000	「Japan-Eye-Love-You」個展，橫濱美術館畫廊，橫濱，日本
1997	「窺」個展，帝門藝術教育基金會，臺北，臺灣

聯展選錄

2019	「移動與遷徙：從地方到他方的故事——臺韓國際當代藝術交流展」，京畿道美術館，安山市，韓國
2018	「I Know Something about Love : asian contemporary photography」展，東京都寫真美術館，東京，日本
2014	「與社會交往的藝術：香港／臺灣交流展」，香港浸信會大學視覺藝術學院，香港
2014	「界：臺灣當代藝術展 1995-2013」聯展，康乃爾大學強生美術館，美國
2012	「Women in-between: Asian Women Artists 1984-2012」展，福岡亞洲美術館，福岡，日本
2011	「時代之眼——臺灣百年身影」展，臺北市立美術館，臺北，臺灣
2000	「心靈再現：臺灣女性當代藝術展」，高雄市立美術館，高雄，臺灣
1997	「盆邊主人‧自在自為：亞洲當代女性藝術家」，臺北縣新莊文化藝術中心，新莊，臺灣

作品典藏

2020	《望向彼方：亞洲新娘之歌——貴孝系列》，高雄市立美術館，高雄，臺灣
2019	《我們在此相遇——勵志新村系列》六件、《鄉關何處——建業新村系列》四件，總計十件作品，東京都寫真美術館，東京，日本
2014	《我們在此相遇——殷陳城蘭系列》，總計四件作品，高雄市立美術館，高雄，臺灣
2013	《望向彼方：亞洲新娘之歌——黃氏戀系列》，總計六件作品，福岡亞洲美術館，福岡，日本
2003	《猜猜你是誰》，總計五件作品，國立臺灣美術館，臺中，臺灣

Hou Lulu Shur-tzy (Hou Shur-tzy) Biography

Born in 1962 in Chiayi, Taiwan
Living in Kaohsiung, Taiwan

Solo Exhibitions (Selected)

2017	*Out of Place: A Trilogy on Kaohsiung Military Dependent's Villages–Hou Lulu Shur-tzy Solo Exhibition*, Kaohsiung Museum of Fine Arts, Kaohsiung, Taiwan
2016	*Here Is Where We Meet: Hou Lulu Shur-tzy Solo Exhibition,* National Chengchi University Art and Culture Center, Taipei, Taiwan
2015	*The Remains of the Day: Hou Lulu Shur-tzy Solo Exhibition,* VT Art Salon, Taipei, Taiwan
2013	*Here Is Where We Meet Solo Exhibition,* Main Trend Gallery, Taipei, Taiwan
2009	*Look toward the Other Side: Song of Asian Foreign Brides in Taiwan (III) Solo Exhibition,* Kuandu Museum of Fine Arts, Taipei National University of the Arts, Taipei, Taiwan
2008	*Border-crossing/Cultural Identities: Song of Asian Brides (II) Solo Exhibition,* Kao Yuan Art Center, Kao Yuan University Kaohsiung, Taiwan
2005	*Border-crossing/Diaspora: Song of Asian Foreign Brides in Taiwan (I) Solo Exhibition,* Arts Center, National Tsing Hua University, Hsinchu, Taiwan
2000	*Japan-Eye-Love-You Solo Exhibition,* Yokohama Museum of Art, Yokohama, Japan
1997	*Take a Picture, It Lasts Longer Solo Exhibition,* Dimension Endowment of Art gallery, Taipei, Taiwan

Group Exhibitions (Selected)

2019	*Moving and Migration: Stories From A Place To Other,* Gyeonggi Museum of Modern, Ansan, Korea
2018	*I Know Something about Love: asian contemporary photography,* Tokyo Photographic Art Museum, Tokyo, Japan
2014	*Art as Social Interaction: Hong Kong/Taiwan Exchange Group Exhibition,* Hong Kong Baptist University Academy of Visual Arts, Hong Kong
2014	*Jie (Boundaries): Contemporary Art from Taiwan Group Exhibition,* Herbert F. Johnson Museum of Art, Cornell University, the U.S.
2012	*Women in-between: Asian Women Artists 1984-2012 Exhibition,* Fukuoka Asian Art Museum, Fukuoka, Japan
2011	*Eye of the Times: Centennial Images of Taiwan,* Taipei Fine Arts Museum, Taipei, Taiwan
2000	*Journey of the Spirit: Taiwanese Women Artists and Contemporary Representations,* Kaohsiung Museum of Fine Arts, Kaohsiung, Taiwan
1997	*Lord of the Rim, in Herself/for Herself: Asian Contemporary Female Artists Exhibition,* Taipei County Xinzhuang Cultural Arts Center, Xinzhuang, Taiwan

Collections

2020	*Look toward the Other Side: Song of Asian Foreign Brides in Taiwan, Kuei-hsiao Series,* collected by Kaohsiung Museum of Fine Arts, Taiwan
2019	*The Series of Here Is Where We Meet: The Lizhi New Village* (6 pieces) and *Out of Place: The Jianye New Village series* (4 pieces), collected by Tokyo Photographic Art Museum, Japan
2014	*The Series of Yin Chen Cheng-lan, Here Is Where We Meet,* collected by Kaohsiung Museum of Fine Arts, Taiwan
2013	*The Series of Huang-shih Nien, Look toward the Other Side–Asian Foreign Brides in Taiwan,* collected by Fukouka Asian Art Museum, Japan
2003	*Guess Who You Are* (5 pieces), collected by National Taiwan Fine Art Museum, Taiwan

圖版索引 LIST OF WORKS

《生命的倒影》/ 1989
The Reflection in the Lake of Life / 1989
PP.50-51

《迷宮之徑》01〈與天使的相遇〉/ 1992
The Encounter with Angel from *The Labyrinthine Path* series *01* / 1992
P.53

《迷宮之徑》02〈男人與女人〉/ 1992
The Beginning: Man and Woman from *The Labyrinthine Path* series *02* / 1992
P.54

《迷宮之徑》03〈命運〉/ 1992
Destiny from *The Labyrinthine Path* series *03* / 1992
P.55

《迷宮之徑》07〈逐出伊甸園〉/ 1992
The Expulsion from the Garden of Eden from *The Labyrinthine Path* series *07*
1992
P.56

《迷宮之徑》09〈墜落〉/ 1992
Falling from *The Labyrinthine Path* series *09* / 1992
P.57

《迷宮之徑》15〈暗黑的襲擊〉/ 1992
The Attack of Darkness from *The Labyrinthine Path* series *15* / 1992
P.58

《迷宮之徑》19〈等候飛翔〉/ 1992
Waiting to Soar from *The Labyrinthine Path* series *19* / 1992
P.59

《不只是為了女人》
〈丹妮斯‧普勒特〉/ 1993
Denise Pelletur from the *Not Only for Women* series / 1993
P.67

《不只是為了女人》
〈布魯斯‧薩佩奇〉/ 1993
Bruce Sapach from the *Not Only for Women* series / 1993
P.68

《不只是為了女人》
〈依蒂‧許若特〉/ 1993
Edie Schrot from the *Not Only for Women* series / 1993
P.68

《不只是為了女人》
〈德南‧楊絲〉/ 1993
Danan Youngs from the *Not Only for Women* series / 1993
P.69

《不只是為了女人》
〈托比‧若斯〉/ 1993
Toby Ross from the *Not Only for Women* series / 1993
P.69

《窺》〈Body Bounding 01〉/ 1996
Body Bounding 01 from the *Take a Picture, It Lasts Longer* series / 1996
P.72

《窺》〈Body Bounding 02〉/ 1996
Body Bounding 02 from the *Take a Picture, It Lasts Longer* series / 1996
P.72

《窺》〈Body Bounding 03〉/ 1996
Body Bounding 03 from the *Take a Picture, It Lasts Longer* series / 1996
P.72

侯淑姿　HOU Lulu Shur-tzy

《窺》〈Body Bounding 04〉/ 1996
Body Bounding 04 from the *Take a Picture, It Lasts Longer* series / 1996
P.73

《窺》〈Body Writing 01〉/ 1996
Body Writing 01 from the *Take a Picture, It Lasts Longer* series / 1996
P.74

《窺》〈Body Writing 02〉/ 1996
Body Writing 02 from the *Take a Picture, It Lasts Longer* series / 1996
P.74

《窺》〈Body Writing 03〉/ 1996
Body Writing 03 from the *Take a Picture, It Lasts Longer* series / 1996
P.74

《窺》〈Body Writing 04〉/ 1996
Body Writing 04 from the *Take a Picture, It Lasts Longer* series / 1996
P.75

《青春編織曲（一）》/ 1997
Labors and Labels (I) / 1997
PP.78-79

《青春編織曲（三）》/ 1997
Labors and Labels (III) / 1997
P.80

《青春編織曲（四）》/ 1997
Labors and Labels (IV) / 1997
P.81

《猜猜你是誰》〈萬淑娟〉/ 1998
Wan Shu-jyuan from the *Guess Who You Are* series / 1998
P.60

《猜猜你是誰》〈陳正文〉/ 1998
Chen Jheng-wen from the *Guess Who You Are* series / 1998
P.61

《猜猜你是誰》〈沈吳足〉/ 1998
Shen Wu-zu from the *Guess Who You Are* series / 1998
P.62

《猜猜你是誰》〈潘雪雲〉/ 1998
Pan Xue-yun from the *Guess Who You Are* series / 1998
P.62

《猜猜你是誰》〈陳春木〉/ 1998
Chen Chun-mu from the *Guess Who You Are* series / 1998
P.63

《猜猜你是誰》〈陳慧蓮〉/ 1998
Chen Huei-lian from the *Guess Who You Are* series / 1998
P.63

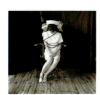

《Japan-Eye-Love-You》〈鈴木先生的醫療介入 01〉/ 2000
Mr. Suzuki's Medical Intervention 01 from the *Japan-Eye-Love-You* series 2000
P.84

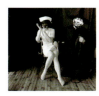

《Japan-Eye-Love-You》〈鈴木先生的醫療介入 02〉/ 2000
Mr. Suzuki's Medical Intervention 02 from the *Japan-Eye-Love-You* series 2000
P.84

圖版索引　LIST OF WORKS

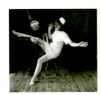

《Japan-Eye-Love-You》
〈鈴木先生的醫療介入 03〉/ 2000
Mr. Suzuki's Medical Intervention 03
from the Japan-Eye-Love-You series
2000
P.85

《Japan-Eye-Love-You》
〈鈴木先生的醫療介入 04〉/ 2000
Mr. Suzuki's Medical Intervention 04
from the Japan-Eye-Love-You series
2000
P.85

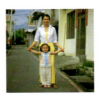

《望向彼方——亞洲新娘之歌 III》
〈黃氏戀與女兒 (A)〉/ 越南 / 2009
Huang-shih Nien and Her Daughter (A)
from the Look toward the Other Side–
Song of Asian Foreign Brides in Taiwan (III)
series / Vietnam / 2009
P.90

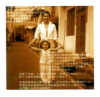

《望向彼方——亞洲新娘之歌 III》
〈黃氏戀與女兒 (B)〉/ 越南 / 2009
Huang-shih Nien and Her Daughter (B)
from the Look toward the Other Side–
Song of Asian Foreign Brides in Taiwan (III)
series / Vietnam / 2009
P.91

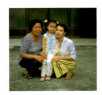

《望向彼方——亞洲新娘之歌 III》
〈黃氏戀與女兒、鄰居 (A)〉/ 越南 / 2009
Huang-shih Nien and Her Daughter and
Neighbor (A) from the Look toward the
Other Side–Song of Asian Foreign Brides in
Taiwan (III) series / Vietnam / 2009
P.92

《望向彼方——亞洲新娘之歌 III》
〈黃氏戀與女兒、鄰居 (B)〉/ 越南 / 2009
Huang-shih Nien and Her Daughter and
Neighbor (B) from the Look toward the
Other Side–Song of Asian Foreign Brides
in Taiwan (III) series / Vietnam / 2009
P.92

《望向彼方——亞洲新娘之歌 III》
〈黃氏戀越南家人 (A)〉/ 越南 / 2009
Huang-shih Nien's Family in Vietnam (A)
from the Look toward the Other Side–
Song of Asian Foreign Brides in Taiwan (III)
series / Vietnam / 2009
P.93

《望向彼方——亞洲新娘之歌 III》
〈黃氏戀越南家人 (B)〉/ 越南 / 2009
Huang-shih Nien's Family in Vietnam (B)
from the Look toward the Other Side–
Song of Asian Foreign Brides in Taiwan (III)
series / Vietnam / 2009
P.93

《望向彼方——亞洲新娘之歌 III》
〈黃氏戀越南的家 (A)〉/ 越南 / 2009
Huang-shih Nien's Home in Vietnam (A)
from the Look toward the Other Side–
Song of Asian Foreign Brides in Taiwan (III)
series / Vietnam / 2009
P.94

《望向彼方——亞洲新娘之歌 III》
〈黃氏戀越南的家 (B)〉/ 越南 / 2009
Huang-shih Nien's Home in Vietnam (B)
from the Look toward the Other Side–
Song of Asian Foreign Brides in Taiwan (III)
series / Vietnam / 2009
P.94

《望向彼方——亞洲新娘之歌 III》
〈黃氏戀越南家人〉/ 越南 / 2009
Huang-shih Nien's Family in Vietnam from
the Look toward the Other Side–Song of
Asian Foreign Brides in Taiwan (III) series
Vietnam / 2009
P.95

《望向彼方——亞洲新娘之歌 III》
〈黃氏戀越南的家〉/ 越南 / 2009
Huang-shih Nien's Home in Vietnam from
the Look toward the Other Side–Song of
Asian Foreign Brides in Taiwan (III) series
Vietnam / 2009
P.96

《我們在此相遇》〈殷陳城蘭 01〉
左營 2011
Yin Chen Cheng-lan 01 from the Here Is
Where We Meet series / Zuoying / 2011
P.102

《我們在此相遇》〈殷陳城蘭 02〉
左營 / 2012
Yin Chen Cheng-lan 02 from the Here Is
Where We Meet series / Zuoying / 2012
P.103

《我們在此相遇》〈殷陳城蘭 03〉
左營 / 2013
Yin Chen Cheng-lan 03 from the Here Is
Where We Meet series / Zuoying / 2013
P.104

《我們在此相遇》〈殷陳城蘭 04〉
左營 / 2012
Yin Chen Cheng-lan 04 from the Here Is
Where We Meet series / Zuoying / 2012
P.105

侯淑姿　HOU Lulu Shur-tzy

《我們在此相遇》〈萬海根 01〉
左營 / 2011
Wan Hai-gen 01 from the *Here Is Where We Meet* series / Zuoying / 2011
P.106

《我們在此相遇》〈回響 01〉
左營 / 2011
Echo 01 from the *Here Is Where We Meet* series / Zuoying / 2011
P.107

《我們在此相遇》〈回響 02〉
左營 / 2012
Echo 02 from the *Here Is Where We Meet* series / Zuoying / 2012
P.108

《我們在此相遇》〈回響 03〉
左營 / 2011
Echo 03 from the *Here Is Where We Meet* series / Zuoying / 2011
P.109

《我們在此相遇》〈回響 04〉
左營 / 2012
Echo 04 from the *Here Is Where We Meet* series / Zuoying / 2012
P.110

《我們在此相遇》〈回響 05〉
左營 / 2013
Echo 05 from the *Here Is Where We Meet* series / Zuoying / 2013
P.111

《我們在此相遇》〈殘響 01〉
左營 / 2013
Reverberation 01 from the *Here Is Where We Meet* series / Zuoying / 2013
P.112

《我們在此相遇》〈殘響 02〉
左營 / 2013
Reverberation 02 from the *Here Is Where We Meet* series / Zuoying / 2013
P.113

《我們在此相遇》〈殘響 03〉
左營 / 2013
Reverberation 03 from the *Here Is Where We Meet* series / Zuoying / 2013
P.114

《我們在此相遇》〈殘響 04〉
左營 / 2013
Reverberation 04 from the *Here Is Where We Meet* series / Zuoying / 2013
P.115

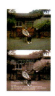

《長日將盡》〈陳景琛 01〉
鳳山 / 2015
Chen Jing-chen 01 from the *Remains of the Day* series / Fengshan / 2015
P.118

《長日將盡》〈陳景琛 02〉
鳳山 / 2015
Chen Jing-chen 02 from the *Remains of the Day* series / Fengshan / 2015
P.119

《長日將盡》〈陳景琛 03〉
鳳山 / 2015
Chen Jing-chen 03 from the *Remains of the Day* series / Fengshan / 2015
P.120

《長日將盡》〈陳景琛 04〉
鳳山 / 2015
Chen Jing-chen 04 from the *Remains of the Day* series / Fengshan / 2015
P.121

《長日將盡》〈陳景琛 05〉
鳳山 / 2015
Chen Jing-chen 05 from the *Remains of the Day* series / Fengshan / 2015
P.122

《長日將盡》〈陳景琛 06〉
鳳山 / 2015
Chen Jing-chen 06 from the *Remains of the Day* series / Fengshan / 2015
P.123

《長日將盡》〈陳景琛 07〉
鳳山 / 2015
Chen Jing-chen 07 from the Remains of the Day series / Fengshan / 2015
P.124

《長日將盡》〈陳景琛 08〉
鳳山 / 2015
Chen Jing-chen 08 from the Remains of the Day series / Fengshan / 2015
P.125

《長日將盡》〈回首 01〉
鳳山 / 2015
Recollection 01 from the Remains of the Day series / Fengshan / 2015
P.126

《長日將盡》〈回首 02〉
鳳山 / 2015
Recollection 02 from the Remains of the Day series / Fengshan / 2015
P.127

《鄉關何處》〈陳金玉與曹正綱 01〉
左營 / 2010 & 2017
Chen Chin-yu & Tsao Cheng-kang 01 from the Out of Place series
Zuoying / 2010 & 2017
P.130

《鄉關何處》〈陳金玉與曹正綱 02〉
左營 / 2010 & 2017
Chen Chin-yu & Tsao Cheng-kang 02 from the Out of Place series
Zuoying / 2010 & 2017
P.131

《鄉關何處》〈陳金玉與曹正綱 03〉
左營 / 2010 & 2017
Chen Chin-yu & Tsao Cheng-kang 03 from the Out of Place series
Zuoying / 2010 & 2017
P.132

《鄉關何處》〈陳金玉與曹正綱 04〉
左營 / 2010 & 2017
Chen Chin-yu & Tsao Cheng-kang 04 from the Out of Place series
Zuoying / 2010 & 2017
P.133

《鄉關何處》〈韓斌 01〉
左營 / 2017
Han Pin 01 from the Out of Place series
Zuoying / 2017
P.134

《鄉關何處》〈韓斌 02〉
左營 / 2017
Han Pin 02 from the Out of Place series
Zuoying / 2017
P.135

《鄉關何處》〈韓斌 03〉
左營 / 2017
Han Pin 03 from the Out of Place series
Zuoying / 2017
P.136

《鄉關何處》〈韓斌 04〉
左營 / 2017
Han Pin 04 from the Out of Place series
Zuoying / 2017
P.137

《鄉關何處》〈林陳壁修 01〉
左營 / 2010 & 2017
Lin Chen Pi-hsiu 01 from the Out of Place series / Zuoying / 2010 & 2017
P.138

《鄉關何處》〈林陳壁修 02〉
左營 / 2010 & 2017
Lin Chen Pi-hsiu 02 from the Out of Place series / Zuoying / 2010 & 2017
P.139

《鄉關何處》〈林陳壁修 03〉
左營 / 2010 & 2017
Lin Chen Pi-hsiu 03 from the Out of Place series / Zuoying / 2010 & 2017
P.140

《鄉關何處》〈默禱 01〉
左營 / 2017
Pray in Silence 01 from the Out of Place series / Zuoying / 2017
P.141

侯淑姿　HOU Lulu Shur-tzy

《鄉關何處》〈賈劍琴 01〉
左營 / 2017
Chia Chien-chin 01 from the *Out of Place*
series / Zuoying / 2017
P.142

《鄉關何處》〈賈劍琴 02〉
左營 / 2017
Chia Chien-chin 02 from the *Out of Place*
series / Zuoying / 2017
P.143

《鄉關何處》〈賈劍琴 03〉
左營 / 2017
Chia Chien-chin 03 from the *Out of Place*
series / Zuoying / 2017
P.144

《鄉關何處》〈賈劍琴 04〉
左營 / 2017
Chia Chien-chin 04 from the *Out of Place*
series / Zuoying / 2017
P.145

《鄉關何處》〈默禱 02〉
左營 / 2017
Pray in Silence 02 from the *Out of Place*
series / Zuoying / 2017
P.146

《鄉關何處》〈默禱 03〉
左營 / 2017
Pray in Silence 03 from the *Out of Place*
series / Zuoying / 2017
P.147

本書圖版索引作品依創作年代排序，惟「高雄眷村三部曲」(《我們在此相遇》、《長日將盡》、《鄉關何處》) 以作品發表的順序排列。
Apart from *A Trilogy on Kaohsiung Military Dependents' Villages* (*Here Is Where We Meet*, *Remains of the Day*, and *Out of Place*), which are arranged in the order of their release, all images in the list of works of this book are arranged in the order the works were created.

臺灣攝影家 Photographers of Taiwan
侯淑姿 HOU Lulu Shur-tzy

作　　者	侯淑姿 王雅倫 林宏璋
研究主編	王雅倫

指導單位	文化部
出 版 者	國立臺灣美術館、國家攝影文化中心
發 行 人	廖仁義
編輯委員	汪佳政 亢寶琴 蔡昭儀 黃舒屏 林明賢 賴岳貞
	尤文君 曾淑錢 駱正偉 吳榮豐 粘惠娟
諮詢委員	張蒼松 簡榮泰 王雅倫 梁秋虹 賴雯淑
審查委員	簡榮泰 張蒼松 龔卓軍 曾少千 鍾宜杰 沈柏逸 高榮禧
執行編輯	王建鈞 江訢楷
地　　址	403 臺中市西區五權西路一段2號
電　　話	04-2372-3552
傳　　真	04-2372-1195
網　　址	https://www.ntmofa.gov.tw

編輯印製	左右設計股份有限公司
專案顧問	姜麗華
專書審訂	姜麗華
叢書主編	呂筱渝
文字審校	鍾悠儀
英文翻譯	Liz（張韜）
英譯審稿	林道明
影像提供	侯淑姿
總　　監	施聖亭
執行編輯	蘇香如 洪可殷
圖片編輯顧問	鄧博仁
美術設計	吳明黛 鍾文深
地　　址	106臺北市大安區仁愛路3段17號3樓
電　　話	02-2781-0111

初　　版	2023年2月
定　　價	980 元
GPN	1011101854
ISBN	978-986-532-726-2

國家圖書館出版品預行編目資料

臺灣攝影家：侯淑姿 = Photographers of Taiwan : Hou Lulu Shur-tzy/王雅倫研究主編.主筆；林宏璋專文. -- 初版. -- 臺中市：國立臺灣美術館, 2023.02
224面 ;21.5 × 27.1公分
ISBN 978-986-532-726-2 (精裝)

1.CST: 侯淑姿 2.CST: 攝影師 3.CST: 攝影集
959.33　　　　　　　　　　　　　　111019136

國家攝影文化中心-臺北館
100007臺北市中正區忠孝西路一段70號

國家攝影文化中心-臺中辦公室
403354臺中市西區自由路一段150號5樓

國家攝影文化中心網址
https://ncpi.ntmofa.gov.tw/

* 著作權管理資訊：本書保留所有權利，欲利用本書全部或部分內容者，須徵求國立臺灣美術館同意或書面授權。
本書圖片所有權者為侯淑姿等影像提供者。

Printed in Taiwan Copyright © 2023 by National Taiwan Museum of Fine Arts All rights reserved.